Art Jewelry Today

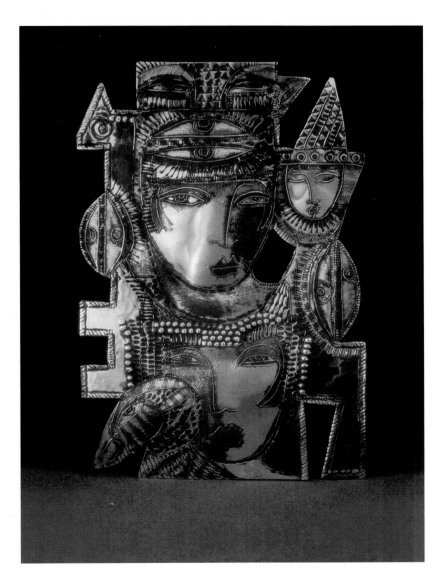

Dona Z. Meilach

4880 Lower Valley Road, Atglen, PA 19310 USA

Dedicated to artist jewelers everywhere, whose vision and technical virtuosity have created innovative directions to a traditional and ancient art.

Library of Congress Cataloging-in-Publication Data

Meilach, Dona Z.
 Art jewelry today / by Dona Z. Meilach.
 p. cm.
 ISBN 0-7643-1766-0
1. Jewelry--History--20th century. 2. Art metal-work--History--20th century.
I. Title.
NK7310 .M45 2003
739.27'09'04--dc21
 20021533435

Designed by Dona Z. Meilach
Layout by "Sue"
Type set in Van Dijk bolded/Zurich BT

ISBN: 0-7643-1766-0
Printed in China

Published by Schiffer Publishing Ltd.
4880 Lower Valley Road
Atglen, PA 19310
Phone: (610) 593-1777; Fax: (610) 593-2002
E-mail: Schifferbk@aol.com
Please visit our web site catalog at **www.schifferbooks.com**
We are always looking for people to write books on new and related subjects. If you have an idea for a book, please contact us at the above address.

This book may be purchased from the publisher.
Include $3.95 for shipping. Please try your bookstore first.
You may write for a free catalog.

In Europe, Schiffer books are distributed by
Bushwood Books
6 Marksbury Ave. Kew Gardens
Surrey TW9 4JF England
Phone: 44 (0)20 8392-8585; Fax: 44 (0)20 8392-9876
E-mail: Bushwd@aol.com
Free postage in the UK. Europe: air mail at cost.
Please try your bookstore first.

Contents

Foreword and Acknowledgments

They came in boxes via Fed X, UPS, USPS, and overnight mail envelopes. They came hand delivered to my office. They came in cardboard, cellophane, fabric, and fancy wrappings. They came in thin No 9 envelopes and in heavy notebooks, some wrapped as though they were a Brinks truck. They came from 37 of the United States and 14 countries. Each package was like receiving a gift filled with a feast for the eye, and wonderful comments to read. The statements alone would make a fascinating commentary on how today's artist jeweler's think and work. They are erudite, revealing, and inspiring.

Slides, prints, transparencies, CD's, email attachments, and Web sites to reference, illustrated an overwhelming, and infinite assortment of creative jewelry from toe rings to tiaras. By the time I began sorting and organizing, I had an estimated 3500 images from 352 artists and galleries to cull down to the 552 pieces shown. Final tally includes work from 193 artists from 14 countries. I wish I could have used something from everyone and more from each one.

I felt as though I was in a bubble bath of delights that was going to work its way over my head and inundate me. Fortunately, Sue Kaye, an artist, and former gallery owner, came to my rescue. Together we sorted, organized and, with the help of Marilyn Greber, created order out of chaos. Both women also proofread and edited the final manuscript and I cannot thank them enough. Their mantra was, "What else can I do to help?"

I am particularly grateful to Dr. Robert Liu, publisher of Ornament Magazine, whose aesthetics and photographic expertise were invaluable and enlightening. With the projector set up, his unerring taste and selections began to coalesce into a workable number of photos and an organization for the book.

Arline M. Fisch, an outstanding artist jeweler whose teaching and inspirational jewelry have left an indelible mark on the direction of contemporary art jewelry, spent almost a full day offering her insight and input.

Several artists who stopped by wondered if my ping-pong table would bear the weight of its load. I conducted interviews in person at studios, cafes, and restaurants, wherever it was convenient to meet and learn what people were doing and why. E-mail proved a boon for quick answers and for checking copy.

I am particularly grateful to the owners of the following galleries who responded to my call for photos and contacted the people they represented:

del Mano Gallery- Santa Monica, California
Facérè Jewelry Art Gallery- Seattle, Washington
Galerie Noel Guyomarc'h Bijoux D'Art- Montreal, Quebec, Canada
Glasgallerie Hittfeld- Czech Republic
Helen Drutt- Philadelphia, Pennsylvania
Katy Beh Contemporary Jewelry-New Orleans, Louisiana
Mariposa Gallery- Albuquerque, New Mexico
Martina & Co- Providence, Rhode Island
Mobilia Gallery- Cambridge, Massachusetts
Sculpture to Wear- Santa Monica, California

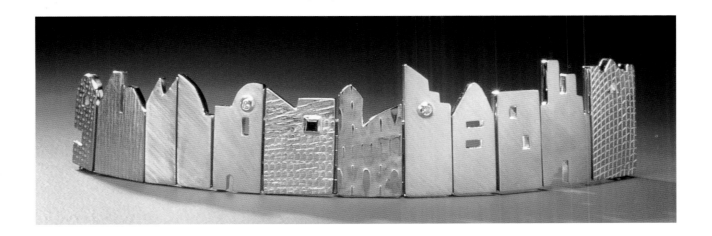

Snyderman/The Works Gallery- Philadelphia, Pennsylvania
Susan Cummins Gallery- Mill Valley, California
Sybaris Gallery- Royal Oak, Michigan
Taboo Fine Jewelry Gallery- San Diego, California
Velvet da Vinci- San Francisco, California
William Zimmer Gallery- Mendocino, California

I owe a debt of gratitude to directors of the publications and organizations who announced my needs in their pages and on their Web sites:

Jill Schrader- the Guild
John Lewton-Brain-Ganoksin
Seattle Metal Guild, Seattle, Washington
Society of North American Goldsmiths
The Anvil's Ring- Artist Blacksmiths Association of North America (ABANA)
The Canadian Guild of Crafts

My thanks to B.J. Adams, Stephen Bondi, and Willa Oren whose continuing attendance at art shows discovered artists I might not have found without them. Dee Layden let me play in her studio as she showed me how to make fused jewelry so I would know what it was all about "hands on." Wil Wakely, glass technologist, Wakely Engineering, made sure all the glass information was correct. Seymour Zweigoron, with experience in many technical subjects and a writer as well, edited the final manuscript.

Photographers Nancy Bushnell and Gerry Soifer combed through their travel slides of ethnic adornment to find just the right ones with which to open each chapter. David C. Freda photographed his incredible studio that would be any jeweler's dream workspace.

I'm fortunate that I live close to the Gemological Institute of America. The librarians at its Richard T. Liddicoat Gemological Library and Information Center were always ready to research any information I needed, and their collection of books is awesome. What they didn't have, the Carlsbad Library was able to secure for me through interlibrary loans.

My appreciation to all the instructors I've had over the years who taught me the ins and outs of various jewelry making techniques: casting, welding, glass cutting and slumping, silversmithing, and related disciplines

I'm indebted to the artists who submitted their work, for their patience and graciousness, whether or not their pieces were used. Certainly, the photographers who made the work look so beautiful are to be acknowledged and congratulated. Jewelry is difficult to photograph well.

Thanks to Nancy and Peter Schiffer and their staff. To my husband, Dr. Melvin Meilach, who insists that technology was invented to make him a computer widower, goes my infinite love and gratitude for putting up with my passion for writing books.

Dona Z. Meilach
Carlsbad, California

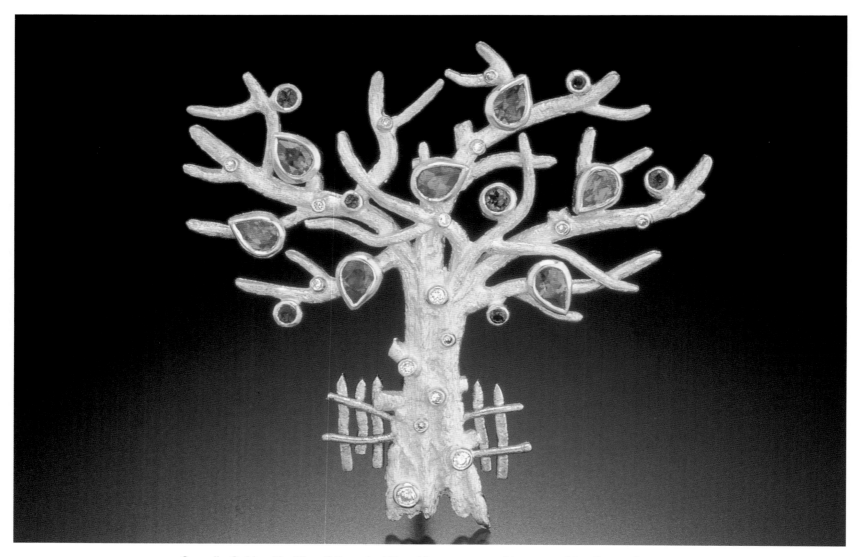

Cornelia Goldsmith. "Tree." Brooch. 18k gold, orange sapphire, emeralds, diamonds, fabricated, cast, and chased. Jewelry artists create designs from many inspirational sources. In this pin, the artist has to look no further than her back yard, or a scene along a country road, to envision a stunning design. 1.78" high, 1.71" wide. *Photo, Hap Sakwa*

MORE THAN MEETS THE EYE

Anyone walking into a department store's jewelry counter will see an unending assortment of necklaces, earrings, rings, brooches, and other jewelry in a wide and affordable price range for most people. The same person entering a fine jewelry store such as a Van Cleef & Arpels, or Cartier, will see cases of sparkling precious jewelry with diamonds, rubies, pearls, and other fine gems. Many of these very costly items may be one of a kind, fashioned by talented, usually anonymous, jewelry designers.

They will rarely find what is termed "art jewelry" in these stores. Art jewelry refers to a one-of-a-kind piece made in a studio by an artist who expresses an idea through his original design just as a painter creates a one-of-a-kind canvas, or a sculptor chisels a fine marble sculpture. Their work is in contrast to jewelry made for production, often by the hundreds, even thousands, and for a large commercial market place.

Art jewelry is most likely acquired from fine art and craft stores, jewelry galleries, at special craft fairs, and from direct commissions to the artist.

Who are the artists who create art jewelry? What concepts are in their designs? What inspires them to labor over their jewelry benches, often for weeks or months, creating jewelry for which there may or may not be a ready buyer?

These are the people you will meet in this book, the ideas behind their designs, their motivations, and the unabashed love they have for the work they have chosen to do. They are artists, sculptors, painters, delving into an incredible variety of materials and techniques.

Today's art jewelers are Renaissance artists. They know metallurgy in order to fashion gold, silver, brass, bronze, copper, platinum, steel, aluminum, and other metals into the visions they see in their mind's eye. They study gemology and lapidary, many cut and set their own stones. They know how to weld, braze, forge, enamel, cast, blow glass, use chemicals for patinas, and perform many other processes. One piece that may be only a few inches high can involve all these techniques.

As if that's not enough, artists are always seeking new methods, new tools, and innovative ways to enhance a piece. You, like they, will discover the overlay methods of kum boo, a Korean use of gold similar to gold leafing, shibuichi, a treatment of some metals that alters their colors, mokumé gané, that adds a wood grain pattern to metals. They need tools and equipment and to know how to use them.

Additionally, they know the elements of design, how to use balance, color, texture, positive and negative space, additive and subtractive ways of using the materials. Most are familiar with art history and often use ideas of the past to spark new visions for their work.

Still there is more. They know their pieces must appeal to the senses of the potential buyer; the eye, the ear, the touch, even the smell, and the sound. A piece might elicit emotions such as love, humor, cheerfulness, and nostalgia. It might contain a subtle personal statement, or conjure an image of how the wearer sees herself or himself. Very likely, it will evoke compliments and spark interest to others when the piece is worn. It should complement the wearer by its shape, size, and color.

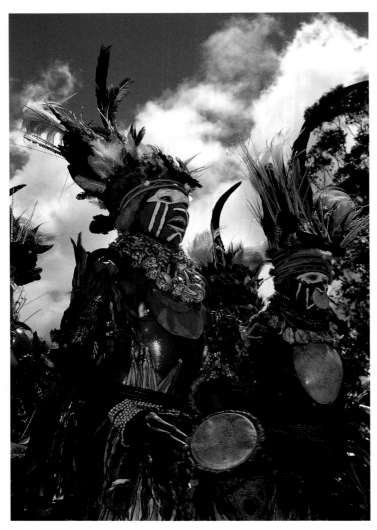

Nature and materials are highly significant in the body adornments of Papua New Guinea natives for their celebrations. Their styles, colors, materials, and how they are used provide rich idea sources for today's jewelers. *Photo, Bushnell-Soifer*

With it all, jewelers must be on top of fashion trends and the materials that people prefer. They must be able to afford and use the precious materials with which they create. Much art jewelry uses gems but in a different way and in diverse combinations than those made by and for commercial production processes. They have an indescribable warmth, a vitality, an emotion that is inexplicably established between the creator and the buyer.

Still other jewelers eschew the use of expensive gems and retain the modernist view of post World War II artists who reacted against using precious materials. Then, artists emphasized the value of beauty, hand-craftsmanship, and non-precious metals, and many adhere to that philosophy today. They may use organic and inorganic materials such as wood, pebbles, plastics, rubber, and found objects, that are assembled to make a statement.

Artist jewelers address techniques, tools, materials, and their characteristics that artists in other media may not consider. A sculptor who works in wood or stone, uses fewer materials and techniques than does a jeweler. The painter needs only canvas, brushes, paint, and relatively few other tools.

These concepts will be explored in the jewelry shown in this book. You will learn about the pieces, the techniques used, and the people behind the work. Hopefully, you will begin to look at a brooch, a ring, a neckpiece, see how it was made, and ask why. The jeweler may no longer seem an anonymous, faceless person; rather he or she will become an ally who has created an object that will be a valuable piece of your body's adornment.

When you collect or buy jewelry you will have a deeper appreciation of an object. You will wear it with a confidence and pride that grows with that knowledge. You will look beyond its existence and understand that there is so much more involved in its creation than that which meets the eye.

Who and where are these artists?

The artists who create one-of-a-kind pieces might be your neighbor working out of a garage or a small room. They are your friends, your children's friends, for jewelry making is a hobby for many, a business for others. The jewelers whose work you discover in these pages may have established studios. They may be teachers or recent graduates from university metals and jewelry programs.

Some have never taken a formal class but have taught themselves the processes involved through a proliferation of books and magazines outlining techniques. They are part time and full time jewelers who are passionate about what they do. They are always learning, always seeking, and exploring new ideas. Many attend numerous workshops taught by those who have experience empirically. They join special interest groups and societies that further their interests in a particular medium or technique.

Where and how do artists get their ideas?

Flipping through the pages on a first perusal may make you wonder, where do these people think up their ideas? What are their inspirations?

Delving into the heads of the artists and following the course of an idea from conception to birth is a tricky process. They have shared their ideas, and the following inspiration sources they tap will help you understand why and how an idea is born, developed, and executed.

Trees, fruit, flowers, animals, oceans, the sun, day and night, are all among the images that plant their seeds in an artist's subconscious. Over time, perhaps, hours, days, months, the idea germinates. It is twisted and turned over in their heads until they visualize it as a piece of jewelry. It may evolve as a recognizable object or it may be so abstract that one could never detect its inception.

A tree in anyone's back yard could have inspired Cornelia Goldsmith's *Tree* but she fashioned it into a statement that is uniquely hers. She once made production pieces with work lined up to be replicated during the day. She learned techniques and shop organization but it wasn't fulfilling and exciting. Now she has her own studio, develops original designs, and accepts commissions.

NATURE

Plants, their leaves, and flowers inspire Helen Shirk, a teacher of basic and advanced jewelry design classes at San Diego State University in San Diego, California. She will photograph a scene, develop it in a drawing, execute it in metal, and color it.

◄
The photo that became the model for Helen Shirk's jewelry. *Courtesy, artist*

►
This drawing interpreted the photo in size and scale for the final piece of jewelry by Helen Shirk. *Courtesy, artist*

Helen Shirk. The tree photo and drawing at left show how the artist develops a vision into jewelry. Brooch, silver with 14k gold. 7" long, 2" wide. *Photo, artist*

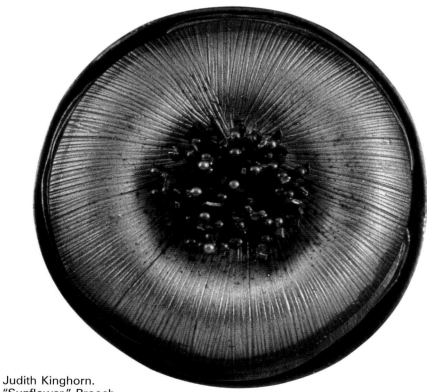

In his brooch, *Ocean Dream,* Steven Kolodny combines his jewelry expertise with his love for fossil collecting. His pieces often include items from quarries, mineral deposits, and mining operations. In this brooch, he bends the shape into a sinusoidal bend, called *anticlastic raising*. It is then raised and the ends joined to form a hollow three dimensional form. Other elements are added including the small gold balls, called "granulation."

Similar techniques are used in Susan Gallagher's *Horn of Plenty*. She partners with Stephen Kolodny but her recent signature work explores hammer texturing while simultaneously raising the metal. Many of her forms take on flower-like imagery that she integrates with clean edges and architectural elements in bold contrasts for unique effects.

Judith Kinghorn.
"Sunflower." Brooch
and pendant. Sterling silver,
24k and 22k gold. Fabricated, fused, die formed,
engraved, granulated, and oxidized. 1.01" diameter,
0.25" deep. *Photo, Michael Knott*

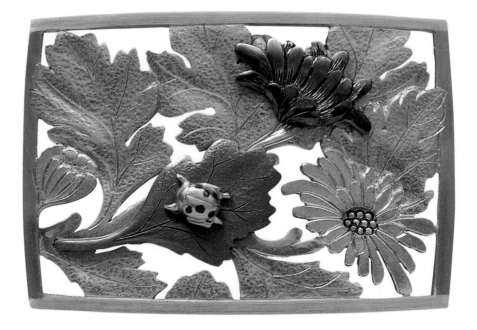

Working with gold, layering, and pierced areas, Jim Kelso's *Chrysanthemum Lady Bug* Brooch involved several techniques and materials. The gold ladybug's spots are inlaid with another metal, called *shakudo*. Leaves and flowers are carved in relief with engraved details. Copper, and the shakudo spots, were patinated using a traditional Japanese rokusho boiling bath. The processes require precision, patience, and time. This gives you some insight into the number and variety of procedures the jeweler must know how to use proficiently.

Jim Kelso. "Chrysanthemum, Lady Bug." Brooch. The ladybug of 22k gold rests on a leaf of copper among other chrysanthemum leaves and flowers. Forms are saw pierced 22k gold. Appliqués are sterling silver, copper, and 22k gold, with shakudo inlay and a rokusho patina, a traditional Japanese method for coloring copper. The bug, leaves, and flowers are engraved and carved. 1.5" high, 2.25" wide. Collection, Janet Jentes. *Photo, artist*

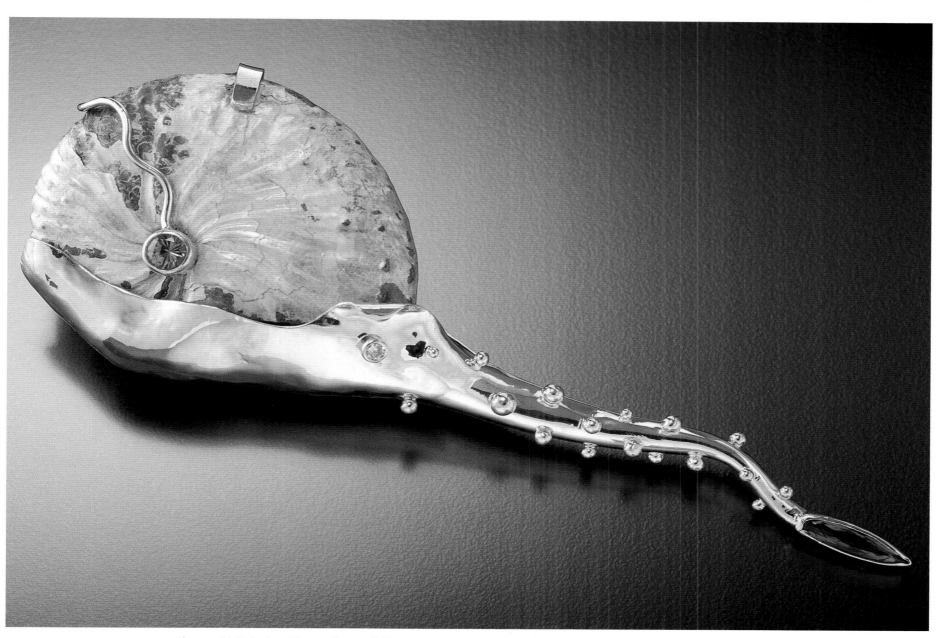

Steven H. Kolodny. "Ocean Dream." Pin and pendant. 18k gold with an ammonite fossil, pink spinel, green tourmaline. Anticlastic raising, granulated, and fabricated. 3" long, 2" wide. *Photo, Allen Bryan*

Dianne deBeixedon. "Landscape Florentine." Belt buckle inspired by nature. Lost wax casting in silver with a patina. *Photo, artist*

A trip to Italy inspired Dianne deBeixedon's landscape cuff made using the lost wax technique. She first created the piece in wax, and then built a mold around it. The wax was melted out, and molten metal was poured into the mold to replicate the lines and textures of the wax.

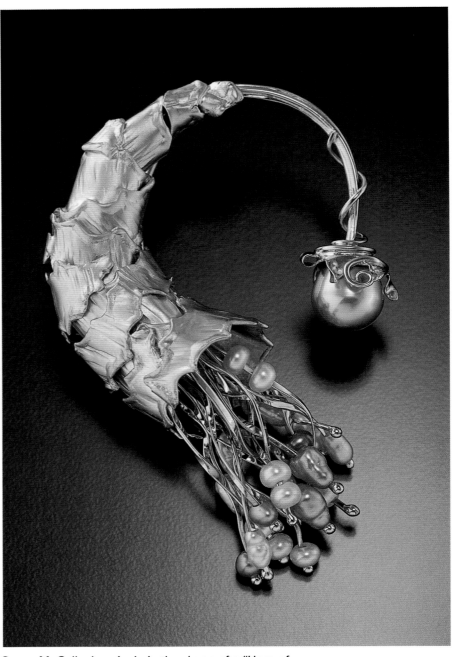

Susan M. Gallagher. A pin in the shape of a "Horn of Plenty" made of gold and filled with pink pearls. 2.25" long, 2" wide. Hammer raised and textured. *Photo, Allen Bryan*

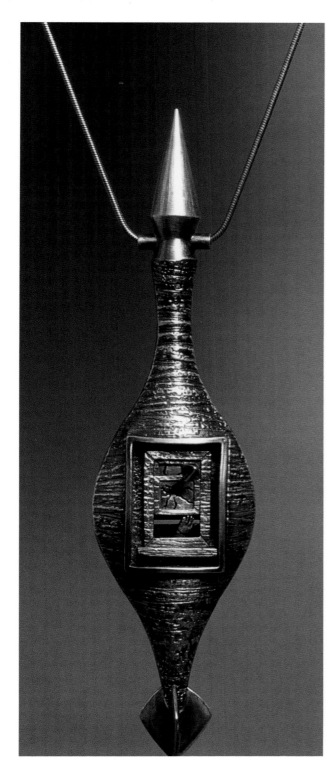

PERSONAL IMAGERY

Many artists search within themselves to evolve ideas for their jewelry. Each piece is based on some event; some inner thought. The statement is a personal image either blatantly or subtly worked into the piece. The viewer may not recognize the piece's meaning because it can be deeper than the obvious, and contain metaphors that go beyond what the eye can see.

Often the piece's title suggests the message such as Sun Hong's *Arrow Piercing my Heart*. Says Hong, "Each of my pieces is directly related to emotional, psychological, and spiritual aspects of my life experiences. The most profound impact on my work was my sister's death which has haunted me for a long time." Sometimes her work is deeply inspired by her dreams and nightmares and is influenced by surrealism. Each piece has therapeutic, cathartic, and exorcistic effects for her.

Gay sexuality and the effects of AIDS are themes that permeate the jewelry of art teacher Keith A. Lewis, of Central Washington University, Seattle, Washington. His pieces are precious, highly polished sterling silver sculptures that happen to be brooches, explicit in their details and the artist's feelings about his life and loves.

German artist, Heidi Kindelmann's multimedia pendants look like large sculptures in photographs, but they are small icons. They hang from a chain around the neck that is adjustable to the wearer's height. She refers to them as "Wearable Art-Sculptures." That description camouflages a world of hidden meanings. They represent man as symbol and metaphor. "I call them 'Talismen,'" explained Kindelmann. "They are meant to be worn as personal ritual objects imbued with mystery and individual associations.

"A Talisman, in historical times, was a magic figure, an amulet, an object that carried a guarantee of love, happiness, health, power, and wealth. My lifelong fascination with small sculptures and dolls has inspired me to make my own Talisman creations."

Kindelmann's art background and familiarity with many creative techniques play a part in how her ideas emerge. Having studied at the Academy of Applied Arts in Vienna, she has worked in painting, graphics, design, ceramics, glass painting, mosaics, stucco, and fresco. She developed a special interest in puppets and their underlying symbolism. Many of Kindelmann's pieces have movable parts. Renaissance woman capability? You bet!

◀
Sun Hong. "The Arrow Penetrating My Heart." Sterling Silver. *Courtesy, artist*

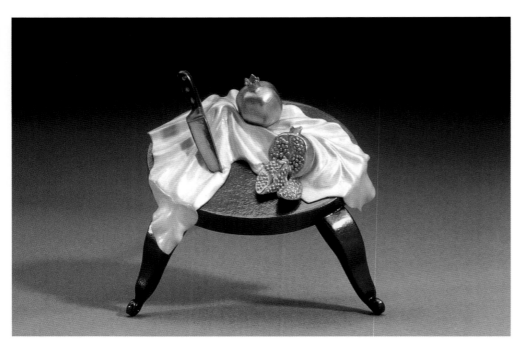

Keith A. Lewis. "Persephone's Sad Feast." The artist explains; "The work honors humanness and immersion in the sensual sorrow of the world, in the web of stories that transfix us, in the weighty import of sensual joy and the sense of brevity of living, and the collapse of life upon itself." Susan Cummins Gallery. *Photo, artist*

These artists are frank in their use of personal images. Many jewelers dig deep into their psyches for their ideas. They may incorporate personal conscious, subconscious, ethereal, and symbolic expression in their art. Additionally, certain materials are imbued with historical and ancient symbolism. Stones associated with months of the calendar have symbolic associations beyond their birth stone connotation. Carnelian, for example, is frequently known as a stone of great spirituality. It is said to be a gem with a wondrous capacity for mental and physical healing properties. Jade supposedly cures pains in the side.

Metals, too, have symbolic associations. Gold is ruled by the Sun in planetary astrology and represents an assertive, energizing element. In Western astrology, gold is associated with Leo, a creative, flamboyant personality that is enhanced by gold's shining qualities. In numerology, gold is associated with the number 2.

Silver has varying symbolic references depending upon the astrological reference you want to believe. In planetary astrology, silver represents the earth's moon that symbolizes the feminine nature of energy, which is passive and less assertive. Western astrology associates silver with Cancer and Aquarius, and it symbolizes a 25th anniversary. In numerology, it is the number 4.

▶

Keith A. Lewis. "Dark Hearts that Stain." Pin. The idea and title came from a line in a novel by British writer, Ronald Firbank, who died in 1926. The reference is that of removing the staining pollen at the center of lilies. Stainless steel, 24k gold, and garnets. 2" square. Susan Cummins Gallery. *Photo, artist*

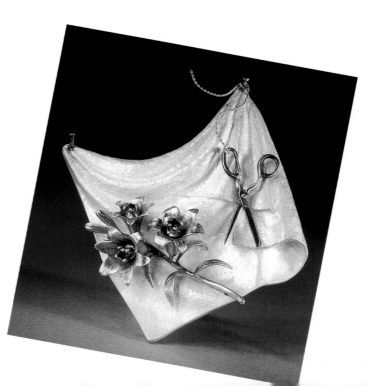

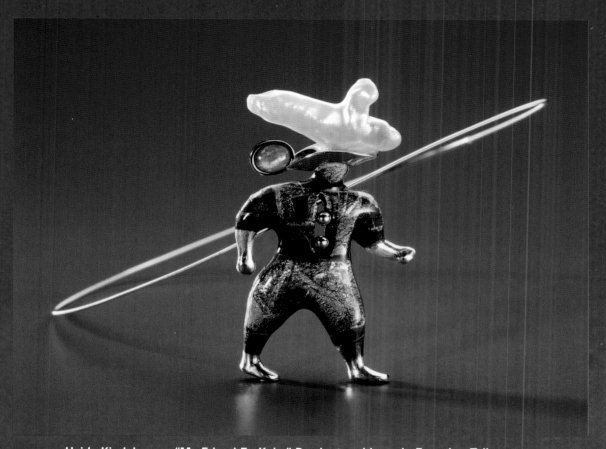

Heide Kindelmann. "My Friend En-Kaia." Pendant and brooch. From her Talisman series. The pieces, which have movable parts, are meant to be personal ritual objects imbued with mystery and individual associations. *Photo, George Meister*

HISTORY

Most artists have some art history in their backgrounds. It is natural and beneficial for them to study, and to be inspired by, the work of earlier artists from many countries. The use of ideas for art jewelry from historical sources emerged and flowered during the Arts and Crafts movement of the early 1900s. About 50 years later, the art jewelry movement in America began to swell. Schools and universities added courses in metalwork and more diversified curricula. Arline M. Fisch, teaching at San Diego State University, explored jewelry as body sculpture. Other teachers picked up on the trend; Albert Paley and Marjory Schick influenced this emergence that jumped the ocean and was caught by craftspeople in Post-war European countries. A new energy evolved on which today's art jewelers continue to build and expand in diverse directions.

Jewelry based on historical sources may involve and emulate traditional, century-old materials, designs, and techniques. Often, modern materials, such as polymer clay (PC) and Polymer Metal Clay (PMC) are used to interpret traditional techniques and styles in amazing combinations. Debra Dembowski's bead mask looks like the tesserae in the Byzantine church at Ravenna, Italy. She uses beads as ancient artisans used small pieces of tiles. The appearance from a distance fools the eye.

Joseph Snow can find an infinite source of ideas in 18th century wrought ironwork for his Heirloom collection of jewelry fashioned in gold. Myron Bikakis and Mark Johns reach into ancient and classical styles for their inspiration. They comb through books on Etruscan, Greek, and Roman jewelry for ideas, and use traditional techniques for their hand made, one-of-a-kind, updated pieces that today's wearers enjoy.

Italian jeweler, Marin Marino, finds inspiration in ancient gold designs from the Mediterranean countries, while Lezlie Jane may incorporate symbolism from Oriental cultures.

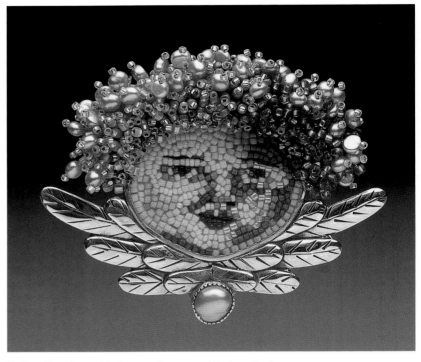

Debra Dembowski. A mosaic created in beads, has the same feeling as the Byzantine mosaics at Ravenna, Italy, done in tesserae. *Courtesy, artist*

▶
Joseph Snow. Brooch based on ironwork and stonework floral designs in historical buildings. From his Heirloom collection. 18k yellow gold, hand forged, pierced, and carved, with pearls. 2.75" long, 2" wide. *Photo, Ralph Gabriner*

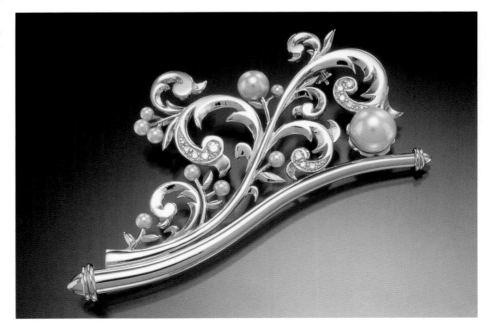

16

Myron Bikakis and Mark Johns. A gold and ruby bracelet represents designs and techniques inspired by the past, and styled for the present. 22k gold wire, 22k gold granulation, Burmese and Thai rubies. Snyderman/The Works Gallery. *Photo, Richard Jacobs*

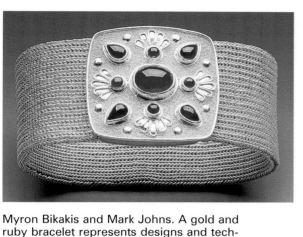

Myron Bikakis and Mark Johns. Woven mesh 22k gold necklace with fine granulation, emeralds, sapphires, and Nigerian beryl drops. The inspiration was a gold necklace with rosette and lotus from Pantikapaion, Greece, 400-380 BC, found in a book, *Greek Gold: Jewelry of the Classical World,* by Dyfri Williams and Jack Ogden. *Photo, Myron Bikakis*

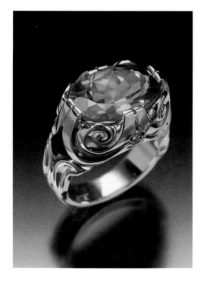

◄ Lezlie Jane. A power ring based on a carved jade unidentified burial object from China's Western Han Dynasty (206 BC-9 AD). A Tao Teh mask image is worked into the gold on each side. The 18k green gold ring is made by the lost wax casting method. Stones are a peridot, two green diamonds, and black jade. *Photo, Doug Yaple*

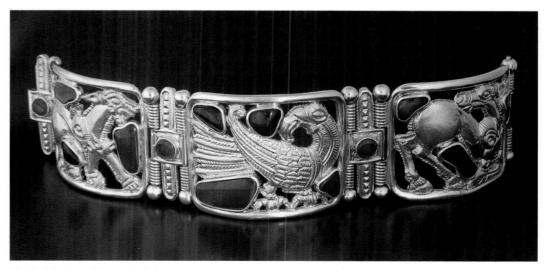

Marin Marino. "Phoenix." Ancient zoomorphic images from 5th Century BC Thracian gold jewelry are the inspiration for this modern artist's gold bracelet with cherry amber and some sterling silver. Repoussé and chasing with stone setting techniques, some cast pieces, and construction. *Photo, artist*

Marin Marino. "Lion." Gold brooch with four garnets using traditional techniques forms a modern approach to an ancient mythological image. *Courtesy, artist*

MYTHOLOGY

Images based on mythology, involving entire stories and events of a myth have been incorporated into jewelry for centuries. Many events and character in mythology are natural ideas for artists to exploit, especially if they like to tell stories through their jewelry.

They can be as fantastic as one can conjure and allow artistic imaginations free rein. Marin Marino delves into mythology for his ideas as is evident by his bracelet with winged lions. In western culture, we tend to think mainly of images from Greek and Roman mythology, such as gryphons, gods, and goddesses, but there are also Vedic and Norse mythological images to tap for ideas. One frequently finds images of Pegasus, the winged horse, on jewelry. Such pieces combine mythology, symbology, and history.

References to Greek and Roman war gods and goddesses are popular. Mars and Ares, the war gods, and Eros, the love goddess, appear in all kinds of jewelry. Often their symbols, such as the war shield, or a bow and arrow, are used.

In the same vein, there are fables and folk stories that provide abundant heroes from which to cull ideas that can be worked into exciting designs for pendants, rings, and bracelets.

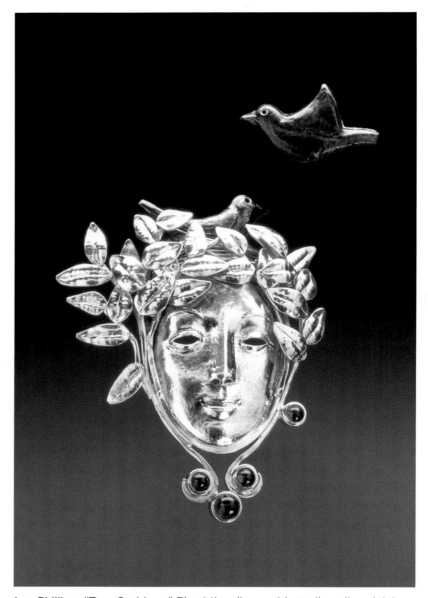

Lee Phillips. "Tree Goddess." Pin. 14k yellow gold, sterling silver (plain and oxidized black), and diopside. Repoussé, chasing, and fabrication. Approx. 2" high, 2.25" wide, 0.5" deep. Phillips states: "This was part of a series exploring nature spirits, and combining the human face with natural forms. Although it is based in ancient imagery and mythology, it is also a contemporary statement that we are, in fact, an integral part of nature; we have forgotten what the ancients knew." *Photo, Doug Yaple*

Cynthia Toops. "Havoc on the Food Chain." Polymer clay pin and pendant. A Huichol Indian micro mosaic design in beadwork inspired the technique used in this pin. It is set in a silver bezel by Chuck Domitrovich. *Photo, Roger Schreiber*

Thomas Robert Mann. "Float Heart Pin." An Oceanic mask was the take off idea for this pin. Silver, brass, bronze, aluminum, micarta, and paint. 3" high, 1" wide. *Photo, George Post*

Huichol Seed Mask. Many artists study ethnic societies and use their techniques and ideas for contemporary artwork. A Huichol Indian seed mask sparked the technique and design for Cynthia Toops' brooch, "Havoc on the Food Chain." *Photo, Dan Adams*

ETHNIC INFLUENCES

About the early 1960s, new jewelry influences appeared. People traveled more, and the earth seemed to shrink culturally. Things "ethnic" were discovered, sought, and prized. Jewelers quickly incorporated exotic ideas from other countries into their pieces. Highest on the list of items were jewelry and sculptures from Africa. Just as Pablo Picasso, Georges Braque, and their contemporaries leaped onto designs from African work in the early 1900s for their paintings, jewelers incorporated both the designs and the materials used by native craftspeople. Brightly painted large and small beads, trade beads, clay and glass beads, seashells, plant pods, and found objects appeared in Western jewelry.

African beads and designs were varied, multi-colored, different, and spectacular, but ideas from other cultures were adopted and adapted. Mayan designs that had previously influenced Art Deco architecture and styles in the late 1920s again became popular. Necklaces from Egypt, Greece, Turkey, Afghanistan, Israel, Morocco, Guatemala, China, Oceania, New Guinea, Native America, and other areas were instantly collectible

and wearable. Parts were used to fashion new jewelry statements. Necklaces, pins, earrings, and fetish figures were imported for collectors, museum shops, tourist shops, bead shops, and everywhere they could find a ready market.

Universities began offering classes in their art departments for studying ethnic cultures. People were enrolling in short courses on jewelry making and bead design. New magazines appeared devoted to the subject. Books on ethnic art and jewelry proliferated. Museums exhibited ethnic jewelry, objects, clothing, and other items of various societies.

The Huichol Indian mask inspired the technique Cynthia Toops used in creating her brooch, *Havoc on the Food Chain*. Dan Adams interpreted a Hawaiian Lei into a necklace made of lampworked glass beads.

Thomas Robert Mann's Picasso-like brooch has its origins in masks of an Oceanic group. Kandioura Coulibaly, a modern Mali artisan, uses the background of his own culture to create a new approach to the use of traditional materials and symbolism.

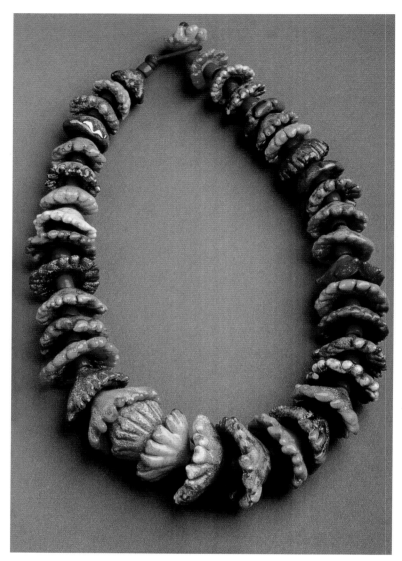

Dan Adams and Cynthia Toops. "Tropical Series #1." Necklace of lamp-worked glass inspired by a Hawaiian lei. *Photo, Roger Schreiber*

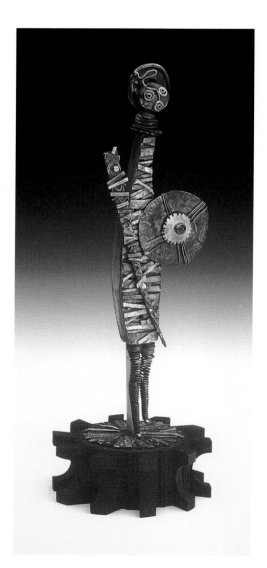

▶
Maggi DeBaecke. "Totem 1 Warrior." Brooch. Bronze, copper, brass, silver, and a found object (the gear). 6" high with stand, 1.75" wide. The piece is the result of having taken a class in African mask making. *Photo, Peter Grosbeck*

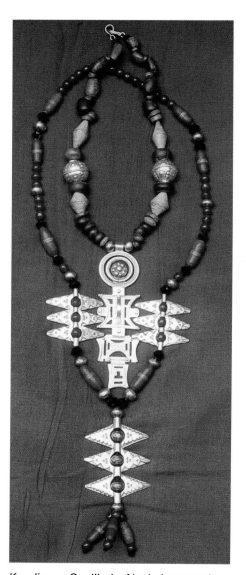

Kandioura Coulibaly. Neckpiece made with beads from Mali by an artist who designs and creates jewelry and costumes for Malian cinema, theatre, and for clients. Each bead, and the entire necklace, represents Mali symbolism and lore. *Janet Goldner Gallery. Photo, Sabine Hagmann*

MORE IDEA SOURCES

There are undoubtedly more sources for artistic ideas than there are artists. In addition to those mentioned, a jeweler may base a design on a special interest. A teapot collector might make jewelry in the form of teapots. Someone interested in horticulture might concentrate on flower shapes, and someone else may use butterflies, bugs, babies, shoes, or another area of personal interest. Artists such as Janet Kerman rely on geometric forms in an amazing variety of sizes, shapes, and relationships, both symmetrical and asymmetrical.

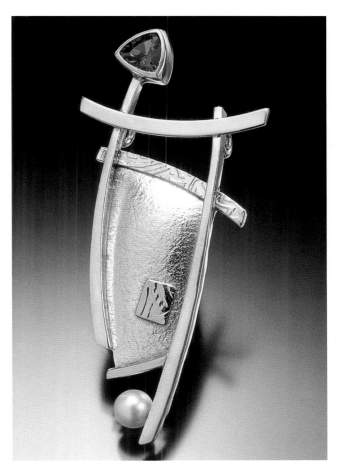

Janice Kerman. 18k gold earrings are based on geometric shapes. Each earring of the pair is different representing a design that is purposely asymmetrical, yet balanced, for greater visual interest. *Photo, Larry Turner*

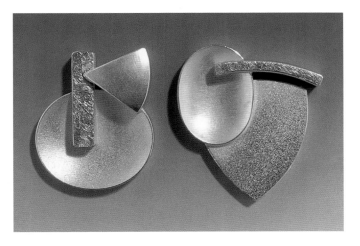

Idelle Hammond-Sass. "Spirit." Pin and pendant. 14k gold, faceted rhodolite, garnet, and pearl. Roller printing achieves the texture. The piece is shaped with a hydraulic press, and then fabricated. 3" high, 1" wide. *Photo, Ralph Gabriner*

In Idelle Hammond-Sass's *Spirit Pin and Pendant*, the "sprit" is an abstract shape that has a balance and counter balance of its elements within the piece. She concentrates on the structure and inherent architecture of the form, and various surface possibilities. She uses line to suggest tension, movement, rest, and transition from one state to another.

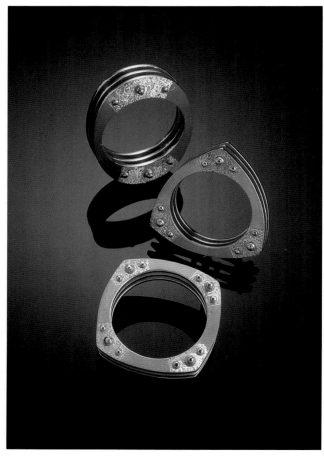

▲
Geoffrey Giles. "Circular Series #7." Brooch. Industrial objects are the inspiration both for the idea of the times, and the structure. Riveting is used to increase volume and express a technical society. Sterling silver, 14k yellow gold, smoky quartz, garnet. *Photo, Taylor Gabney*

Geoffrey Giles. "Rounding Square, Circle, and Triangle." Rings. Sterling silver, and 14k gold. Geometric shapes are the design basics. *Photo, Taylor Dabney*

Aline Gittleman. Geometric shapes and architectural construction are inspiration for a striped, sterling silver ring. Martina & Co. *Photo, Mark Johnston*

Our technical world figures into the forms and materials of many jewelers. Geoffrey Giles may represent an anachronism in that he explores the mechanical technical world in his jewelry but he uses mostly basic hand tools to create his pieces; the flexible shaft grinder is his most complex piece of machinery.

Processes also help determine how a person designs a piece. Aline Gittleman explores a folding technique interpreted into a geometric architectonic shape for her ring. Michael Good uses a geometric, and mathematic bending method, called "anticlastic," introduced into jewelry by Heikki Seppä in 1978. The metal is curved in different directions at a certain point. Good uses this for a cross that he names after Heikki. Elsewhere the same techniques are shown for earrings and neckpieces.

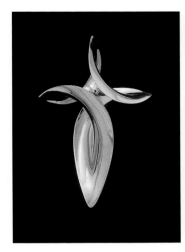

Michael Good. "Heikki's Cross." Pendant. 18k gold. Religious symbols are often a subject for jewelers. Michael Good uses the technique of anticlastic bending to fashion a cross that is flowing and smooth. *Courtesy, artist*

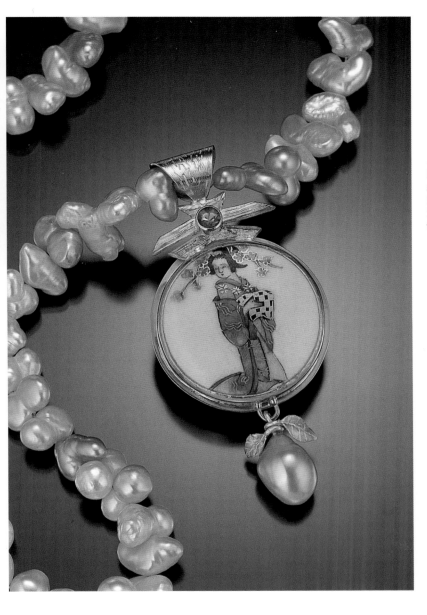

◄
Sonja Bradley. Collectible objects, such as this antique Satsuma porcelain pendant, becomes the inspiration for a new piece of jewelry. It is combined 22k, 18k, and 14k gold, Paraiba, tourmaline, and freshwater pearls. 17" long. *Photo, Ralph Gabriner*

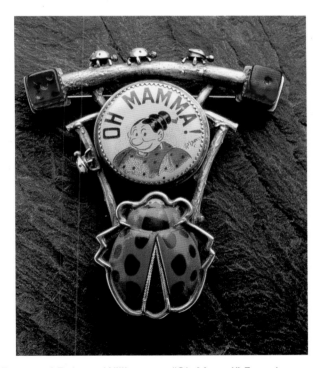

Dave and Roberta Williamson. "Oh Mama!" Found objects. Sterling silver, antique tin lapel pin, pin back button, and dice. To the Williamson's, found objects are a way of elevating the obscure to a higher level of appreciation. 2.75" high, 2.75" wide. *Photo, James Beards*

Recycled materials are the basis for Sonja Bradley's porcelain pendant that she combines with new materials. Dave and Roberta Williamson depend completely on collections of found objects they have amassed over the past 30 years. For them, it's a natural progression to use the shapes, colors, forms, and graphics from these objects in their work. They see relationships between things and try to clarify the connectedness of the different objects.

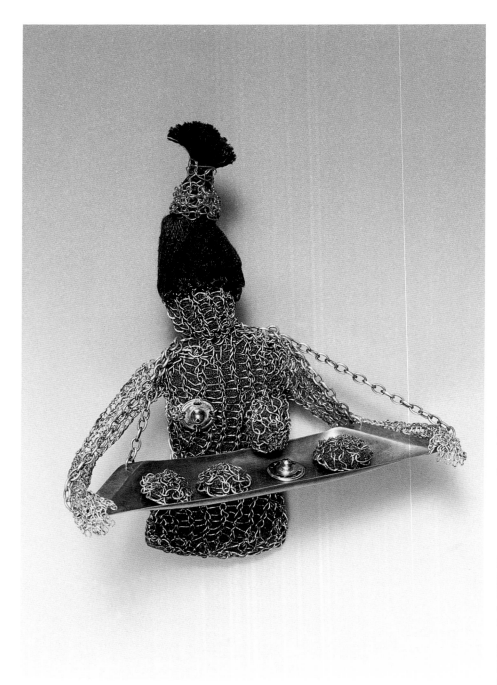

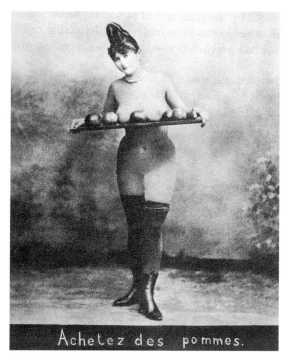

Barbara Stutman. "Stacking Reality." The 19th century anonymous photograph, (below), "Achetez des Pommes" was an inspiration for the three-dimensional brooch. The subject is breast enhancement surgery. The woman is offering 4 breasts, 2 small and 2 large, that can be removed from the tray and snapped onto her chest. The viewer or owner of the piece can choose a personal ideal of female sexual desirability. Stutman has crocheted and spool knit the assorted wires, gently shaping them as she worked. Materials are fine silver, sterling silver, nickel silver, colored copper wire, cotton thread, polyurethane and monofilament. 5.25" high, 4.5" wide, 2" deep. *Photo, Pierre Fauteux*

"Achetez des Pommes" (Buy some apples), a photograph that inspired Barbara Stutman's Brooch, "Stacking Reality." *Courtesy, artist*

Barbara Stutman exemplifies the thought and processes involved in her brooch *Stacking Reality*. A 19th century photograph sparked the idea for the piece treated with tongue-in-cheek symbolism for today's women. She combined fiber techniques, knitting and crochet, using different types and colors of metal wire. Finally, the artist, Roy, combined art history for a bracelet using an Edouard Degas painting with an architectural-like construction.

So begins your foray into the artistry of art jewelry. You will have an insight into how artists germinate ideas, their thoughts behind a piece, and how they interpret their visions into exquisite, elegant pieces of wearable art. Each work represents a much deeper concept than what you see on the piece…certainly much more than meets the eye.

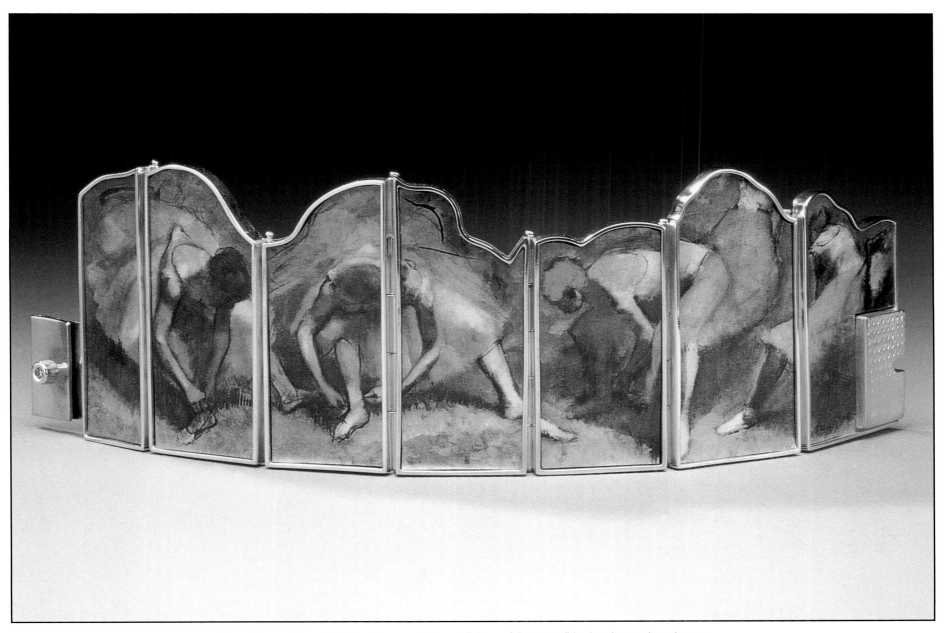

Roy. "Degas Bracelet." The Degas painting, "Frieze of Dancers," is the decorative element for a bracelet that is built up and planned much as an architect constructs a building. Roy's "architectonic bracelets" are made of fabricated silver, hand made hinges, and studded with diamonds. 7.5" long, 2.3" high. Collection: Ariane V. Grice. *Photo, Dean Powell*

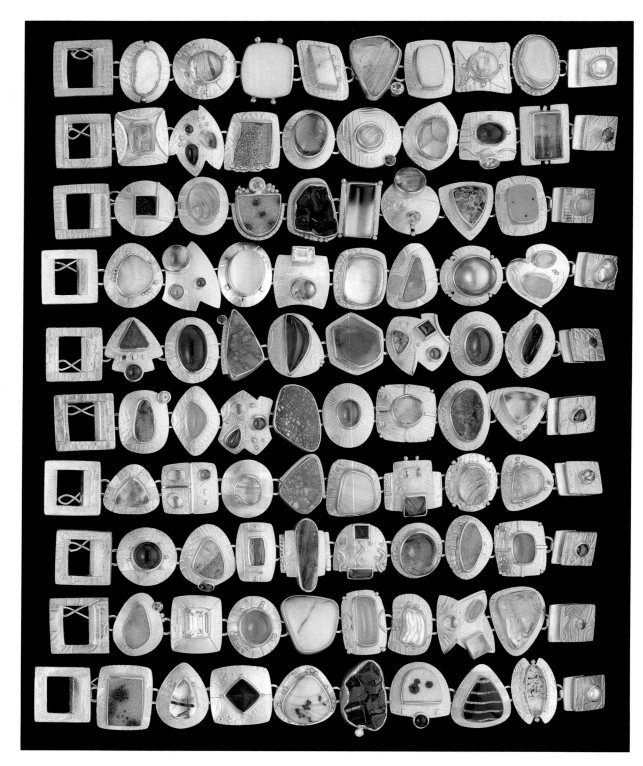

Sydney Lynch. Bracelets. Sterling silver, 18k and 22k gold with various stones. Almost every jewelry technique appears in the various elements of these bracelets. Studying the techniques and examples in this chapter, will enable you to identify them when you buy jewelry. *Photo, Rick Neibel*

HOW DOES JEWELRY HAPPEN?

You don't have to know how to build a car in order to drive it. Neither must you know how to cook to savor a good meal. Nor do you have to know how jewelry is made to enjoy wearing it. So why should you care about the techniques involved in making jewelry?

Jewelry is a small, precious item that you may buy spontaneously, or after much thought, then own for a long time. You may buy it for pure enjoyment, for the compliments and attention it will bring, or for its intrinsic value. Even if you never string a bead or bend a piece of silver, you can marvel at the work involved in the creation process. The examples shown here will add to your knowledge and appreciation of the value of jewelry.

Understanding may encourage jewelers to try methods they hadn't tackled before. Seeing the varied results from other artists' work provides a stimulating insight into their thoughts. Their techniques are like an alphabet of jewelry making; the more letters one knows, the more words they can form.

No one artist uses all the methods shown but many will use several techniques on one piece. Versatility, knowledge, and expertise sharpen over time. The more tools and techniques they have at their fingertips, the more likely they can bring their dream images to fruition imaginatively, effectively, and efficiently.

The following section describes many techniques, with examples. Some are shown in detail for a better understanding about how they happen. They are not meant to be detailed how-to procedures. There are scores of books in which any one technique is described in infinite detail with specific projects as a goal. These examples are meant to familiarize and educate the jewelry buyer, collector, and creator to better understand what they are seeing.

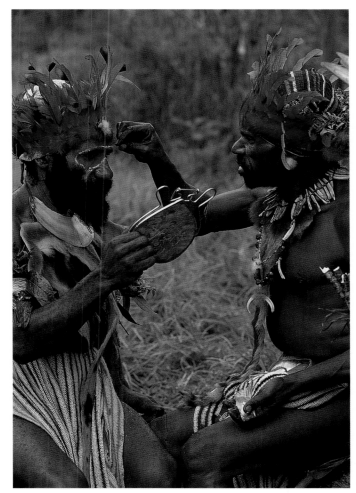

▶
Festival costumes. Papua, New Guinea dancers prepare for the Sing Sing Festival at Mt. Hagen. One man applies linear gold decoration to the other man's brow. Both are wearing adornments and jewelry made from shells, animal teeth, feathers, bones, and fur. *Photo, Bushnell-Soifer*

MATERIALS

Jewelry isn't made from thin air. It needs to have a component, a material from which it is fashioned. When asked what jewelry is made of, the usual response is gold, silver, and platinum, the precious metals. Diamonds and pearls may come to mind next. Today, those traditional materials still dominate. Additional components used are too numerous to list. Throughout these pages you will be awed by materials some people work into jewelry.

They range from a potpourri of gemstones, metals, and alloys, to found objects that might be rescued from the trash bin. To the artist, one person's trash may be another person's treasure. One could unwittingly become the buyer and wearer of some plastic or rubber they threw into the wastebasket. With imagination and manipulation, the artist has transformed something ordinary into something extraordinary.

Many artists mix materials such as silver and bronze, copper and steel, gold and silver, wood and silver, even egg shells and enamels. A special alloy of silver and copper called "shakudo," developed by the Chinese during the Han Dynasty, has a wonderful rose color tint when it's patinated with certain chemicals.

Bi-Metal, a recently developed product by Hauser and Miller, of St. Louis, Missouri, is gaining popularity because of its unique working features. Bi-Metal is produced by bonding a thin sheet of a high karat gold alloy to a thicker sheet of sterling silver. It is achieved mechanically without the use of solder. Essentially, it is a gold filled product using sterling silver for a base instead of a non-precious metal. Because there is precious metal on both sides, the artist can use the sheet to complement and contrast the beauty of both sides in a single sheet of metal. Surface treatments such as engraving, scraping, folding, and twisting can be used to accent the two surfaces.

A similar combination, developed by Charles Lewton-Brain in the mid 1980s, is called "doublee," the German word for "gold-fill' or clad metal. It, too, is a gold/silver laminate of 18k or 24k gold fused to sterling silver. Lewton-Brain used the word to differentiate the hand-made material from that produced by refiners. With these combinations, artists can create new visual impact, color, texture, and tone for their jewelry.

Recent additions to the jeweler's supply of materials are synthetics such as polymer clay (PC) and Polymer Metal Clay (PMC).

Polymer clay is baked in a home oven to harden. Polymer Metal Clay has metal suspended in the clay in an organic binder that burns away when the material is fired in a kiln at the required temperature for the correct length of time. When it is removed from the kiln it is as solid as metal. Art-

ists' experiences with these metals, and more about them can be found on Web sites listed under the product names, see Resources, page 253. There are societies devoted to each product's usage.

Often, the availability, or lack, of certain materials will suggest the type of jewelry made. Buttons may be a substitute for beads. Wire may be woven, knit, or crocheted into exquisite neckwear, bracelets, brooches, and earrings. Rubber inner tube cut up and rearranged, can simulate a feather boa. Plastic, PVC pipe, wood, linoleum, tesserae, seedpods, electronic parts, appear in examples in the book. Any material used imaginatively, cleverly, and sensitively is appropriate for jewelry.

Regardless of the materials and techniques used, one other element must be considered. Sydney Lynch explains that element as: "The joy of making things, working with the materials, and seeing raw materials transformed into a beautiful finished piece."

WHAT TO LOOK FOR
WHEN ANALYZING JEWELRY

The shape of a piece of jewelry may be among the first things to catch your eye. Is it horizontal or vertical, free form or geometric? Is it recognizable or abstract? Will it look well with whatever I plan to wear? Is it important?

Sydney Lynch's assorted jewels on the bracelets (page 26) illustrate many shapes jewelry can take, such as round, square, oval, rectangular, abstract, or shapes within shapes. Interior shapes generally are related to exterior shapes. A round cabochon is within a round outer shape, a triangular stone within a triangular shape. There's a harmonious relationship between and among the shapes.

Her pin, *Tic-Tac-Toe*, plays with design by combining four different shaped pieces within a square box that has slightly bent sides to accommodate and relate to the inner parts.

Positive- negative shapes

Tic-Tac-Toe also exhibits the principle of positive and negative spaces that, to the artist, are considered shapes. The positive shapes are the hard parts, the metal, and stones that obviously take up space. The negative shapes are the spaces between these. The negative areas must be designed as carefully as the positive shapes to accomplish a smooth transition. Usually, there is about a 2/3 to 1/3 relationship between the shapes. Positive spaces are 2/3 of the piece, the negative spaces are about 1/3. Cutout areas are considered negative shapes.

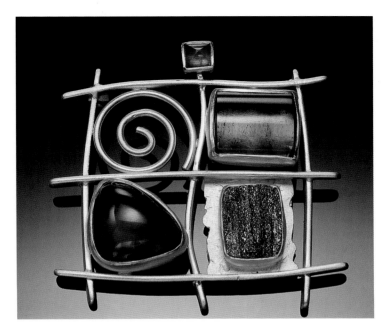

Sydney Lynch. "Tic-Tac-Toe." Pin. 18k and 22k gold,
sterling silver, with tourmaline, amethyst, and rainbow
hematite stones. 2" square. *Photo, Rick Neibel*

Additive and subtractive elements

Another important design concept is "additive and subtractive." Additive means that parts are built up, or added to one another, as in Steven H. Kolodny's *Garden Locket*.

The gold veining is "added" on, as are the diamonds. This is accomplished by "fabricating" or building up the design. If he had etched or gouged, these would be "subtractive" areas because material is removed.

Within this one piece, Kolodny has applied a variety of techniques that you may learn to recognize as you study the examples that follow.

The textured gold surface is accomplished by roller printing. Hollow shell construction is used for the fabricated locket shape. Fabrication involves adhesives, soldering or machined connectors such as screws, and other fasteners. Additionally, Kolodny cuts and finishes many of the gems he sets in. He has created the hinge for the locket that opens and closes, has beaded the double pink pearl chain, bent, and soldered parts to construct and fabricate the clasp.

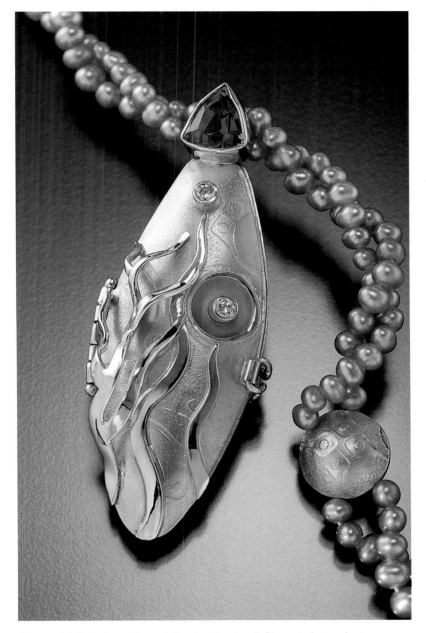

Steven H. Kolodny. "Secret Garden Locket." Closed. A pendant like this requires several techniques in addition to knowing how to work with the metals and gemstones. 14k and 18k gold, rhodolite, garnet, diamond, and a lavender fresh water pearl neck chain. When open, the interior has gold accents and a large American blister pearl set in one side. *Photo, Allen Bryan*

THE JEWELER'S STUDIO AND TOOLS

For simple brooches and necklaces, only a few tools may be needed and they can be acquired as necessary. A working space might be a kitchen table or a bridge table in the garage. Jewelers who make jewelry in earnest, require more tools and equipment.

Stationary workspace and sturdy benches are essential. Workbenches should be a comfortable height so elbows can rest on the surface. The working chair should properly support one's back.

Good, easily accessible lighting, electric outlets, and safety equipment should be near at hand.

David C. Freda's studio on the second floor of his home overlooking the hills of southern California, would be anyone's dream of an ideal work area. It is roomy and complete with an efficient workbench, lighting, storage cabinets, enameling equipment, and kilns for enameling and casting. He keeps it in perfect order at all times so he knows where things are. Tools are kept in top-notch, ready-to-use condition. Precious materials are locked in a safe in another part of the house.

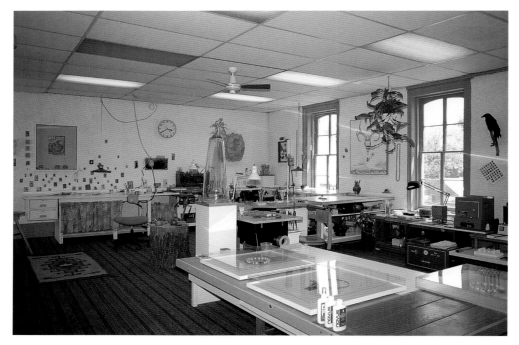

David C. Freda. An overview of David C. Freda's studio has storage cabinets, workspace, showcase, assembly areas, and good lighting. At right is the kiln for enameling, and a flexible shaft tool for grinding. *Photo, artist*

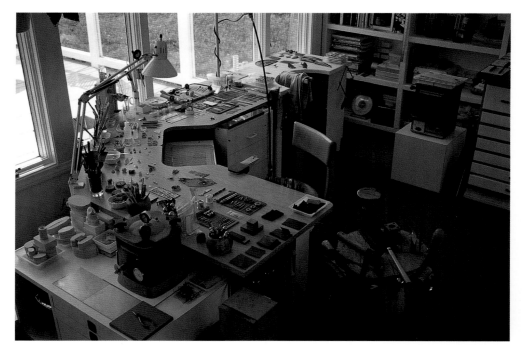

▶ David C. Freda. Freda's workbench area has a wax injector for hollow core casting, hammers, and stakes for free forming sheet metal and stock, hand tools for filing, shaping, sanding, smoothing, and other procedures. *Photo, artist*

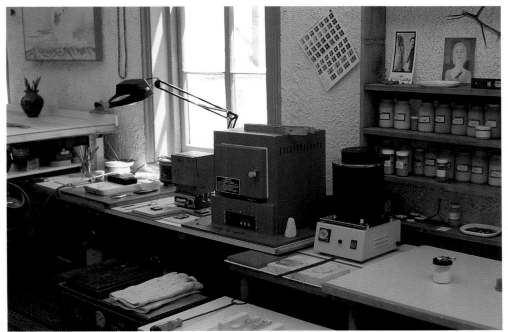

David C. Freda. Freda's set-up for casting and enameling includes 2 different sized kilns, a melting pot for hollow core casting, and a crucible for heating and pouring molten metal. Assorted powder enamels are lined up on the table. *Photo, artist*

Steven H. Kolodny relies heavily on a rolling mill for creating textures in metal. The hand cranked rolling machine is used by many jewelers for producing thinner grades of sheet metal and wire. The machine has two highly polished, smooth, hardened steel rollers next to each other.

An important Kolodny technique involves using several sheets of thin dissimilar metals soldered together. They might be silver, nickel, copper, brass, and different colors of gold. Then they are compressed to a thickness of about 1/32 inch in a rolling machine.

Pieces can be cut, soldered and sandwiched. Then other processes can be accomplished to burn through to under layers, put through the rolling mill again, textured with tools, colored with a patina, and so on until the desired texture and tone are acquired. Often, pieces must be annealed (heat softened) between steps. Finally, the piece is formed into the jewelry.

Textured paper, foil, and other materials may also be sandwiched, layered, and put through the rolling mill for unique effects. Any small particle inserted between the metal and the rollers will leave an imprint on the metals. It is ideal for creating embossed patterns on the metal.

In addition to texturing the metal, other materials can be used to make printed images on the metal. You will see jewelry in the book with imprints of feathers, fabric textures, netting screen, sequins, string, and thread, netting and chain, etc.

A grooved section of the rollers produces a corrugated effect in wires. For a corrugated effect in sheet wire, there are corrugation machines that work much like the roller machines but the rollers are shaped like corrugated cardboard. These may be used on very thin sheet metals to produce striking folded effects. The metal looks like the corrugated fasteners one gets in a hardware store but it is thinner and wider, often in silver or colored titanium that may be manipulated into different shapes.

Far Left:
Steven H. Kolodny. A rolling mill machine can produce thin gauges of sheet metal and wire. It can also be used for printing another material onto the metal. Patterns and textures can be made on metal by passing any of a variety of materials through the roller with the metal. *Courtesy, artist*

◀

Steven H. Kolodny. Soldering with a small torch is almost indispensable for joining metals to one another. A variety of adhesives is also available. *Photo, Fred Baye*

FABRICATING AND JOINING

The art jeweler usually creates, or fabricates, components that make up the final piece of jewelry. Once they are fabricated by any of the various methods that will be discussed, elements must be joined. Glue is one way of adhering parts to one another. Often adhesives are not strong or permanent enough, and may not be compatible with some materials. Then heat methods are required, such as soldering or welding. Fusing is a preferred method for adding small decorative elements. Susan M. Gallagher's *Butterfly Pendant* is composed of several fabricated parts and decorative additions joined by solder.

Pin backings usually require adhesives or solder. For some joining, screws or rivets may be used, and they can be functional and decorative.

DIE FORMING, BENDING, FOLDING, REPOUSSÉ

The practice of shaping, bending, and folding metal is ubiquitous in jewelry design. It gives jewelry a third dimension, whether it's only a slight bend or completely sculptural. There are several methods for accomplishing shaping.

Die forming involves shaping a sheet of metal over a form, or into a form, using a hammer or a hydraulic press. The "die" is the shape, or a model, that is made from a mold. It may be created by the artist from wax, clay, wood, plaster, metal, or a found object. The metal is forced into or over the mold and shaped. A hydraulic press uses pressure on the metal to shape it over the die smoothly. Pressure can vary with different weight metals. This is where some engineering expertise may be required.

Die forming works best with gentle curves and soft forms rather than crisp, hard-edged geometric shapes. Die forming stretches and compresses the metal to create the shaping. Some final hammering over an anvil may be required to finish the edges. The result is a movement of flowing lines. Susan Gallagher's *Butterfly* shape and Betty Helen Longhi's *Portals* illustrate the soft, gently curving bends that are the result of die forming. Longhi favors niobium because she likes the colors and the light weight of the metal.

▶
Susan M. Gallagher. "World of Wonders." 14k gold, black onyx, tourmaline, pearl. Multiple layer construction, die formed, and fabricated. 2.5" high, 2" wide. *Photo, Allen Bryan*

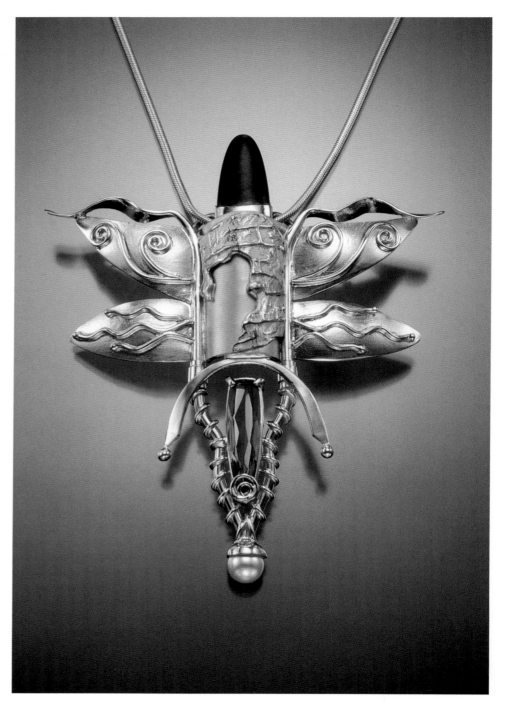

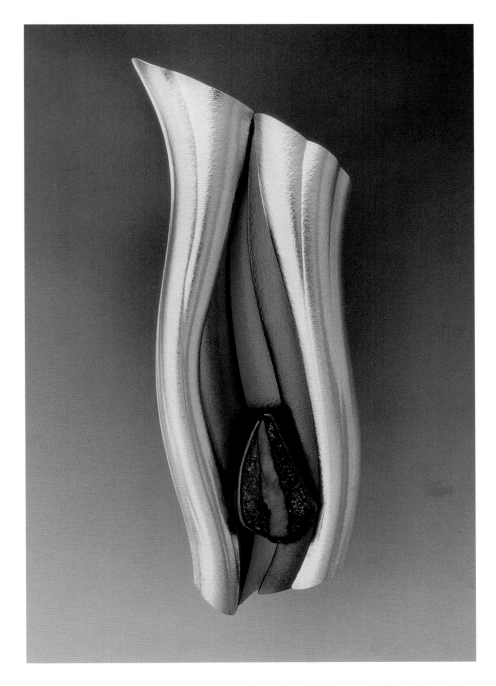

Betty Helen Longhi. "Portals." Brooch and pendant. Die formed. 18k gold, sterling silver, niobium, and boulder opal. 3.5" high, 1.25" wide, 0.5" deep. *Photo, Michael Cunningham*

Cynthia Eid. Micro-folded brooch. Sterling silver and 14k gold. This brooch began while exploring design possibilities of corrugated metal. She used various types of pliers to crimp, fold, pleat, and smock the corrugated forms. 2" high, 1" wide, 0.25" deep. *Photo, artist*

Making bends and folds are a constant source of experimentation and change to the artist. Michael Good uses the "anticlastic" fold by bending the metal in opposing directions. It is one of several mathematical methods for folding metal just as one would fold pieces of paper. The difference is that metal must often be annealed to enable the bending to continue without cracking or breaking.

Charles Lewton-Brain introduced a wavy type of bend accomplished by scoring the metal at angles, and then folding it. Bends and folds are an efficient way of creating jewelry that results in a dimensionality and depth. They create highs and shadows that lend interest to a piece.

Michael Good. Complex bending can be accomplished using a variety of mathematically planned angles. This bend, called anticlastic raising, is a Sinusoidal curve. It can be accomplished by hammering the metal over a sinusoidal stake, or with a pliers that makes concave curves and bends the metal at different angles at a specific point. *Photo, Jeff Slack*

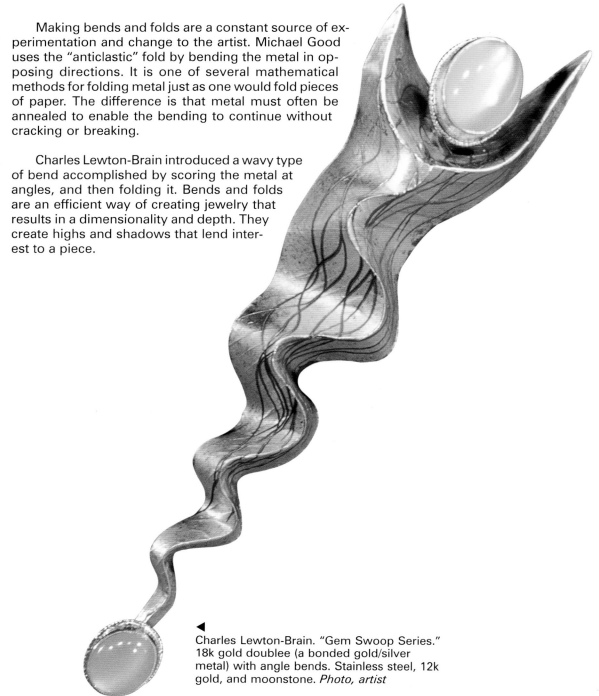

◄
Charles Lewton-Brain. "Gem Swoop Series." 18k gold doublee (a bonded gold/silver metal) with angle bends. Stainless steel, 12k gold, and moonstone. *Photo, artist*

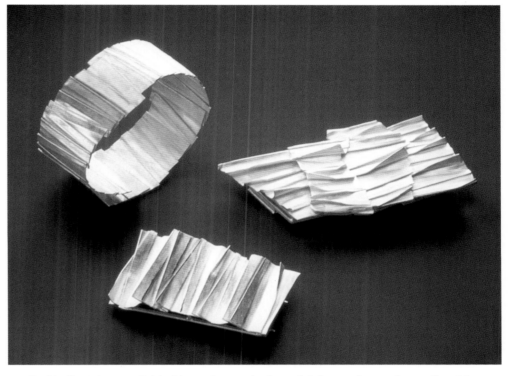

Cynthia Eid. "Sea-ish IX." Sterling folded bracelet using anticlastic folding, and then forging it into a fluid appearing form. This bracelet is folded, hammered, and formed from one sheet of sterling silver. She says, "I love the evolutionary transformation from flat metal toward an object of unity, fluidity, and serenity. Inspiration flows from my meanderings along the shores and in the sea." 4" high, 3" diameter. Mobilia Gallery. *Photo, artist*

Saskia Bostelmann. Folded brooches and a bracelet. Long pieces of very fine thin silver were folded, then burnished to make the unions tight to allow previous layers to show through. Backs and pin stems were soldered to strengthen them, create volume, and elevate the pins. *Photo, Enrique Bostelmann*

Cynthia Eid's various folded pieces are the result of seeking an evolutionary transformation of the materials through hammering, persuasion, and struggle from a flat sheet of metal toward an object of unity and fluidity. Using sea forms as her design motivation, she likes the idea that metal requires extreme force and skill to produce soft and fluid looking forms.

Countless types of folds can be made with industrial tube wringers and corrugators. Corrugated metal can be manipulated into wonderful shapes using various pliers to further crimp, fold, and pleat the silver. Corrugated silver has a structural strength that allows it to be worked more forcefully than flat sheet silver.

Saskia Bostelmann uses fine silver sheet, which is very thin, for creating the bends and shaping in her two brooches and a bracelet shown. "The metal has to be thin so it can be folded several times. It requires annealing as it is worked to prevent breaking," warns Bostelmann. For these pieces, she rolled out thin pieces of the fine silver, started folding and annealing to make the unions very tight and to let previous layers show through the silver. She constructed the backs and pin stems, and added backing to create more volume and elevate the piece slightly. The backing was soldered to the folded piece, then the pin stems soldered to that piece. The bracelet,

Dianne deBeixedon. Wings. Silver necklace repoussé and chased. *Photo, artist*

Lee Phillips. "Celestial Mask." Pin. Sterling silver, 14k yellow gold. Repoussé, chasing, etching, and fabrication. The one face lifts up and reveals another beneath. Each was shaped by hammering the metal sheet against a bowl of pitch. *Photo, Doug Yaple*

Repoussé is another technique for shaping metal. The process consists of hammering out a pattern on a metal sheet placed on a resilient base using a number of small punches. The process is done on the back of the sheet resulting in a raised, or relief, dimensional surface on the right side. After hammering the shape from one side, the sheet is reversed and details are added from the other side by chasing. Chasing is done with chasing hammers, punches, matting tools, and chisel-like tracing tools with a variety of shapes for creating indentation patterns in the metal.

For additional design elements, this front side may also be etched with chemicals and embossed with tools and stamps.

Lee Phillips *Celestial Mask* pin consists of two masks each shaped from a sheet of metal worked in repoussé over a bowl with pitch in it so the raised right side has a place for the metal to move. The top silver mask has been carefully shaped to fit over the rear face of gold. The silver mask lifts to reveal the gold face behind. Detailing was accomplished using chasing and fabrication. It was a technically challenging technique, said Phillips, because one mask had to fit over the other exactly.

Repoussé and chasing are also the techniques used in Dianne deBeixedon's silver necklace, *Wings*. The relief shapes are "raised" to stretch the metal so they protrude. Additional front detailing is done with various chasing tools.

Jayne Redman bends and assembles strips of sterling silver that have been embossed and then overlaid with strips of 24k gold. The pieces are shaped and assembled using 18k gold pegs, and the finished bead is strung on a silver neckwire.

Jayne Redman. Peony assembly. Counterclockwise. Silver pieces have been made into strips using a blanking die. The silver strips have been embossed and heat treated to bring the fine silver to the surface. Small strips of 24k gold .02 mm thick are applied to the surface of each piece that is then shaped and assembled using 18k gold pegs. *Photo, Robert Diamante*

Jayne Redman. A finished silver peony bead with gold strips overlay and a gold neck wire. The gold overlay uses the Korean kum boo technique (see page??). *Photo, Robert Diamante*

Necklace for Susan by artist blacksmith Christopher Thomson, is made of steel and brass. The steel is shaped, bent, and textured, using heat from a forge. Iron forging, not often associated with fine jewelry, becomes a viable material and procedure in the hands of someone who understands design, has the forge, and blacksmithing expertise.

Christopher Thomson. "Necklace for Susan." Forged steel, brass, and steel cable. 13.25" high, 7.25" wide. *Photo, Herb Lotz*

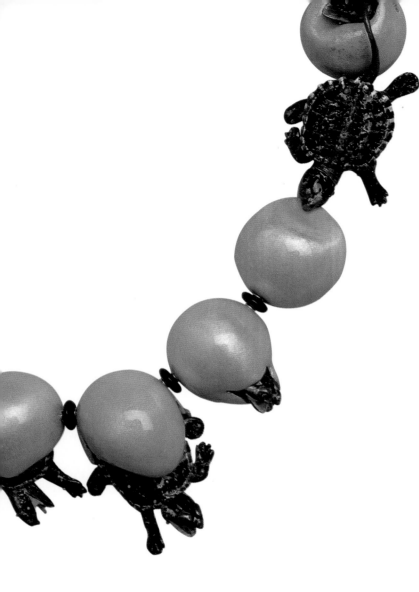

CASTING

There are many ways to cast metal into a shape. All involve using a material that can be shaped to become the model. A model has to be invested, or protected, by a shell of plaster or latex, called the mold. The mold assumes the shape of the model as it hardens. If the model is made of wax, the hardened mold is heated, and the wax burns out through sprues, which are vent holes made in the mold. With the wax burned out a cavity results in the mold. Molten metal is then poured into the cavity so the metal fills all the crevices, then allowed to cool and harden. It may be necessary to spin the mold in a centrifuge to insure that the molten metal fills the spaces completely. The mold is removed and the hardened metal is a replica of the wax model. This procedure, called "lost wax casting" or "lost wax centrifugal casting" probably is the oldest and most traditional method of making objects.

Lost wax casting has several advantages. It produces excellent surface detail. It can be used to create obscure, intricate forms that would be difficult to build and fabricate directly in metal. Once a hard mold is made, a rubber mold can be made from it. Then an infinite number of the same object can be produced. Commercially made products are often reproduced in this manner.

Lost wax casting and variations can be accomplished in a small studio with jewelry casting equipment and kilns. Large scale casting for sculpture and industrial products require larger equipment and facilities.

David C. Freda uses hollow core casting as well as lost wax casting to create his unique jewelry. His process begins with an organic object such as a soft flower, pods, tomato horn worms, etc. The object is pressed half way into soft ceramic clay, or the clay is built up around the object. After preparing the bottom half of the mold and covering the object to protect it, clay is formed over the top half of the object to create the two-part mold. When hardened, the two parts are separated and the organic object is removed.

Next, a wax model of the object is formed by pouring wax into the hardened clay mold. When that has hardened, any rough edges in the wax are cleaned up with an X-acto Knife, sand paper, or a file.

To make a final casting hollow, as in the egg shapes, a hole is made in each end of the wax model, large enough to use a syringe that will force the investment plaster or latex inside. To stabilize the investment within the shape, pins have to be inserted in the wax model using the same material as cast materials, most likely silver. The piece is then put through the casting process and burned out for four hours in the kiln. When the wax has been burned out, the hot metal is poured into the mold and allowed to cool and harden. The result is the hollow egg shape that may still require some cleaning up and fabricating. Freda colors the objects with about ten layers of enamel.

These are the basic processes used to create his *Snapping Turtle* necklace and others in Chapters 6 and 8. The natural forms of the turtles are made by the lost wax casting method. Beads, or eggs, are created using the hollow core casting method. All parts are then assembled and fabricated using various types of joinery, and mostly screws. Freda's varied backgrounds as a machinist, taxidermist, falconer, and other interests contribute to his current, successful jewelry career that began when he enrolled in a jewelry making class at a local college.

David C. Freda. "Study of Snapping Turtle." Neckpiece. (Detail.) Hollow core casting is used for the turtle eggs. The birthing turtles are made with lost wax casting. *Photo, Robert Butcher*

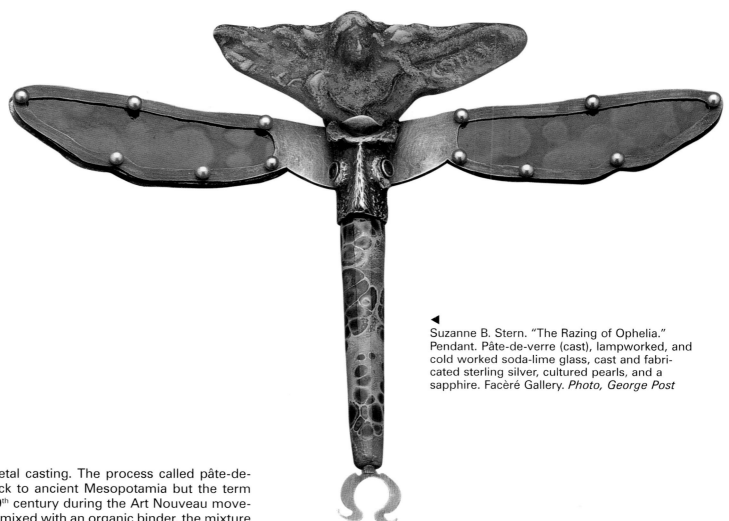

▲
Suzanne B. Stern. "The Razing of Ophelia."
Pendant. Pâte-de-verre (cast), lampworked, and
cold worked soda-lime glass, cast and fabri-
cated sterling silver, cultured pearls, and a
sapphire. Facèré Gallery. *Photo, George Post*

Glass casting is similar to metal casting. The process called pâte-de-verre, "paste of glass," dates back to ancient Mesopotamia but the term originated in France in the late 19th century during the Art Nouveau movement. Colored glass powders are mixed with an organic binder, the mixture is layered into a heat tolerant mold and fired at temperatures high enough to fuse them.

Suzanne B. Stern realized that her background in metals was so similar to the French glass casting method of pâte-de-verre that, with experimentation, she was able to achieve the colors, shapes, and forms she wanted in glass. Some of her techniques are based on enameling methods. For her original wax models, she may use a soft or a hard wax depending on the concept, and whether she feels adding details to soft wax will work better than subtracting materials from a hard wax. Her inspirations are often from nature and from literary works.

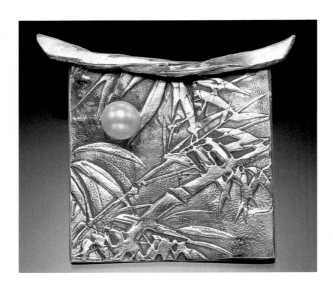

Sonja Bradley. "Bamboo Moon." Sterling silver used for lost wax casting, with hand fabrication. A 5 mm water pearl is set in and the piece is oxidized for color. 2" high, 2.1" wide. *Photo, Ralph Gabriner*

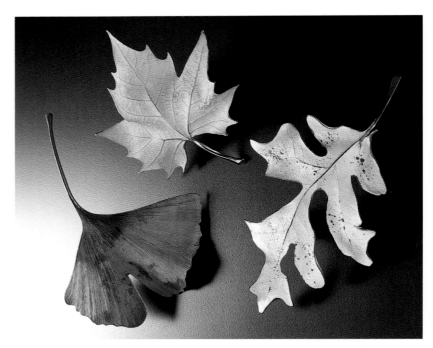

John Iversen. Nature casting, or organic casting, creates one-of-a-kind pieces from leaves, plant seeds, shells, etc. These are ginkgo, brown oxidized, 18k gold maple, and sterling silver oak. The natural object is invested in plaster, and burned out. The mold is filled with hot molten metals. After the piece is cast and cooled, the artist carves, sculpts, and details the edges and shapes. Sizes are 3" to 4" high, 2.5" to 3.5" diameter. *Photo, Manji Ishii*

John Iversen calls his method "organic casting." His mold is the object itself; a leaf, a flower, a bit of nature. He likes forms that have a fluidity and a linear character, such as gingko, maple, and oak leaves. A plaster mold is made directly from the dried leaves. No wax models are used. He casts in bronze, gold, and silver, and the leaves are "lost" or burned out (lost leaf casting?). He may color the metals by oxidizing with various chemicals, or patinas, for natural nuances.

Jewelry students may begin learning casting procedures using cuttlefish bone; a soft, chalklike material available in hardware or pet stores. The bone can be carved into, and the metal poured into the carved area to create a relief shape. Alternatively, two pieces may be put together with the shapes dug out for a two piece mold, and the metal poured directly into the bone for a three dimensional object. Another method is to pour a thin coat of silver onto the surface, let it harden then use part of the shape as a textured silver element in a piece of jewelry. Tamara Kay's bracelet, *Ocean Dream*, illustrates the texture that can be achieved with the natural lines of the cuttlefish bone.

Charcoal block is another casting material frequently used to make small balls and detail items that will be fused onto other metals as in granulation.

Almost all cast metal items need additional "clean up" work such as grinding and smoothing to remove seams and rough edges. Surface embellishments can be added, and then the piece is smoothed and polished.

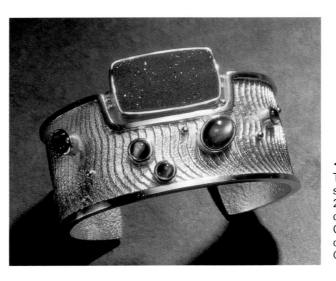

Tamara Kay "Ocean Breeze." Cuff style bracelet in sterling silver and 22k gold using cuttlefish bone casting, and hand fabrication. Quartz drusy and Brazilian Labradorite stones. Collection, Judith Garnil. *Photo, James Barker*

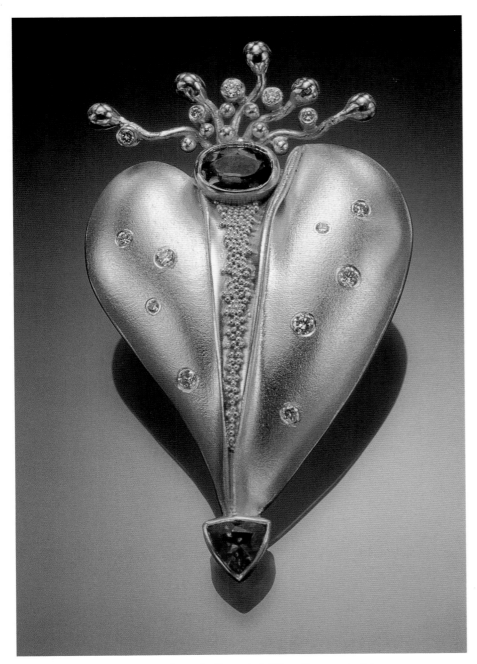

Cornelia Goldsmith. "Heart Brooch. Growth." 18k yellow and pink gold, tourmalines, diamonds, granulation, fabricated, fold formed, and die formed. 2.15" high, 1.25" wide. *Photo, Ralph Gabriner*

SURFACE TREATMENTS, TEXTURES, and COLORS

Intrepid jewelers are constantly experimenting with new procedures and perfecting them for their own ideas and esthetics. They may use ancient techniques in new ways, or in traditional ways as did jewelers centuries ago. Recognizing these techniques in old and contemporary jewelry, will help you appreciate the knowledge and expertise required to create fine jewelry.

Granulation, reticulation, kum boo, shibuichi, shakudo, mokumé gané, and patinas, are techniques for texturing and coloring metals.

Many textures are achieved by methods already shown such as roller printing, etching, hammering, and so forth. But there are more. They may be used singly or in combination with other techniques.

GRANULATION

Granulation consists of tiny metal beads that are adhered to a metal surface by heat fusing. The beads, in different sizes, may be cast in a charcoal block, or purchased ready to use. They adhere to the metal by fusion using solder, a torch, or a kiln under controlled heat. Depending on the metals, some preparation with pickling solutions may be required.

Cornelia Goldsmith's *Heart* brooch has granulation down the center in different sizes. The tiny, slightly different sized beads are placed so they form a shape and seem to pour from the top to the bottom of the piece. They provide a visual and a tactile contrast to the smooth gold.

Granulation represents the seeds on a plant for the silver brooch aptly titled *Sprout* by Judith Kinghorn. Larger spots and shapes of gold are fused onto the body of the form, and areas are oxidized for dark shadings.

An edging pattern is achieved on Barbara Heinrich's earrings using 18k gold granulation. The tiny balls rim the bottom of the gold, around the diamonds, and on the earring loop. They carry out the look of the pearls on the drop strands, so the materials are different, but harmonious.

At the workbench, granulation requires a steady hand, a variety of tools, and good vision to place the small beads on areas of a piece of jewelry. In Barbara Heinrich's Studio, a jeweler is shown working with granulation. A ring is held by a pair of tongs. The bead is placed on a ring's surface and welded. Another ring in the background has been granulated and is cooling. Grinding, shaping, and holding tools are nearby on the workbench. See page 42.

Granulation satisfies the concept of an additive design process because material is added to the surface.

Judith Kinghorn. "Sprout." Brooch. Sterling silver, 24k, and 22k gold. Fabricated, fused, die formed, embossed, granulated, and oxidized. 2" high, 1.5" wide. *Photo, Michael Knott*

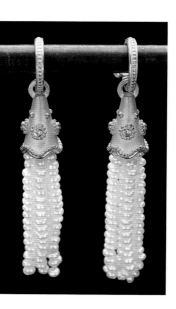

▶
Barbara Heinrich Studio. A pair of earrings has edging of 18k gold granulation. Granulation also surrounds each of the surface set diamonds. *Photo, Tim Callahan*

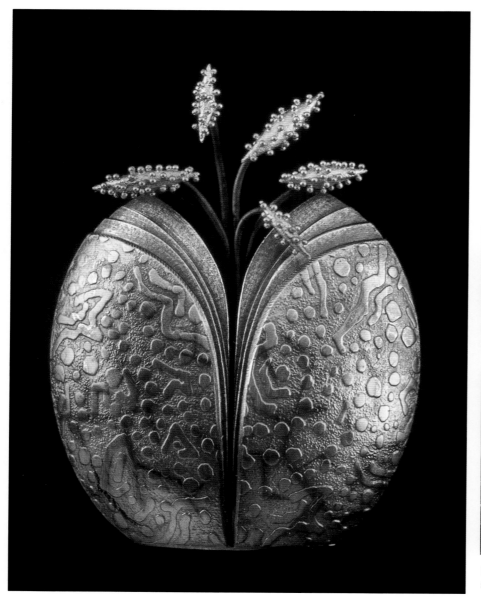

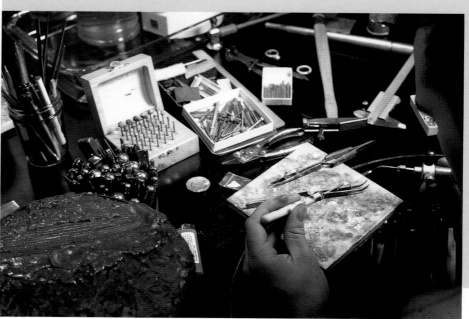

Barbara Heinrich Studio. Tiny beads of 18k gold granulation must be carefully soldered on, each one individually. *Photo, Barbara Heinrich*

RETICULATION

Reticulation is neither additive nor subtractive: it involves the manipulation of the metal by heat that produces a wavy appearance on the surface. Reticulation is defined as "the pattern or formation of a network." In reference to metal. the process of reticulation works well with silver, gold, and copper alloys that can develop a skin layer with a higher melting point than its interior plus have good flow-ability. The sheet metal to be reticulated can be rectangular or precut into the shapes desired to enhance the reticule patterning.

Paulette Myers. "Sentinel: Soul keeper." Neckpiece. Sterling silver, and reticulated silver, with a lapis lazuli stone. 6" high, 2" wide, 2" deep. *Photo, artist*

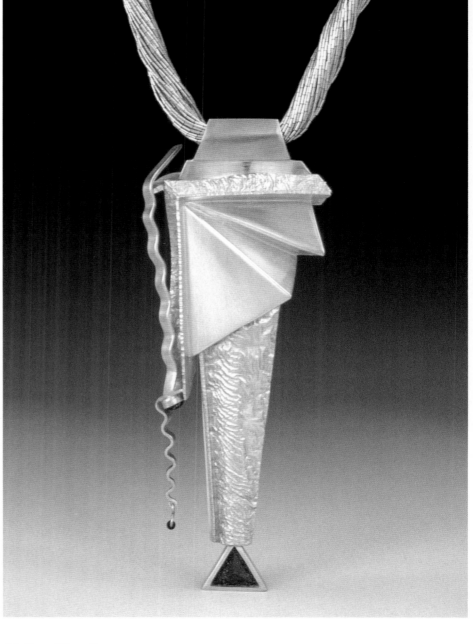

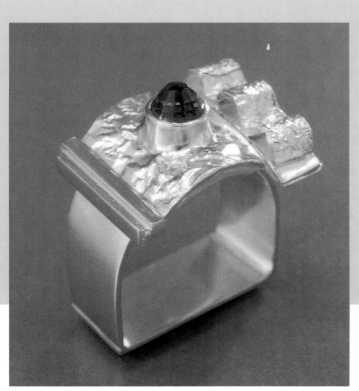

◄
Paulette Myers. "Transport." Ring. 18k yellow gold, reticulation, fabrication, and a garnet stone. 0.9" high, 0.75" diameter. *Photo, artist*

The surface of a piece of silver, for example, has a higher melting point than its copper-silver alloy interior. When the thin outer surface is heated with a torch, the surface beneath begins to soften, melt and bubble, causing ripples in the upper surface.

The process may require 4 or 5 heats, being careful not to overheat the metal to the point where it will break. The piece must be annealed, and then quenched between heats. As this process continues, a layer of fine silver builds up, and oxidization occurs on the metal's surface.

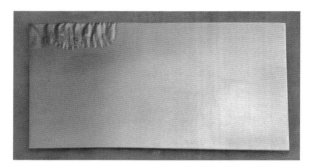

1. The sheet metal is cut to the desired shape(s) and placed on a Fiberfrax (a refractory material) surface for heating.

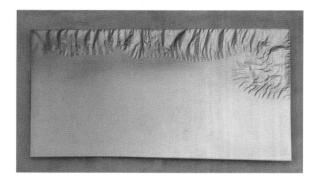

2. Using the silver alloy #820 or #800, the first step requires four or five heats with an annealing flame to develop the protective skin, bringing it to the annealing temperature each time, while being careful not to overheat the metal. With this silver alloy only, the metal needs to be quenched between heatings in an acid solution called pickle. Other alloys mentioned should not be quenched in the pickle solution between heatings, since the pickling solution would remove their protective oxide layer.

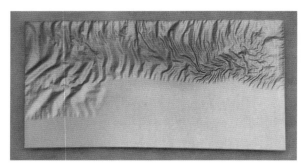

3. Completing this first stage, the silver alloy has now developed a "fine silver" incasement which has a higher melting point than its copper-silver alloy interior.

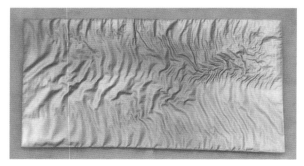

4. The next step involves heating the sheet metal with the torch using an oxidizing flame, slowly moving the flame across the metal's surface at the speed of the locally responding reticulation. The interior metal begins to liquefy while the skin incasement holds the metal in sheet form.

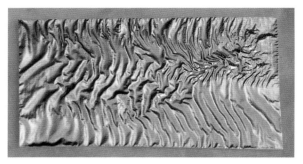

5. The final effect is wave-like, causing a rippling pattern, with the reticule formation directly related to the row structure developed by the path of the torch flame.

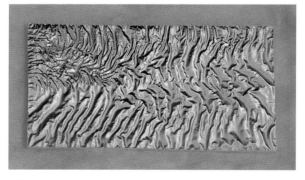

6. The texture on the back is the reverse. After the piece is cooled, cleaned in the acid solution, and washed with soap and water, it is ready to be fashioned into jewelry through sawing, piercing, forming, roller printing, and/or fabrication. *Photo series, Paulette Myers*

Paulette Myers' ring, pendant, and brooch illustrate the result of the reticulation process on silver, and how it can be used.

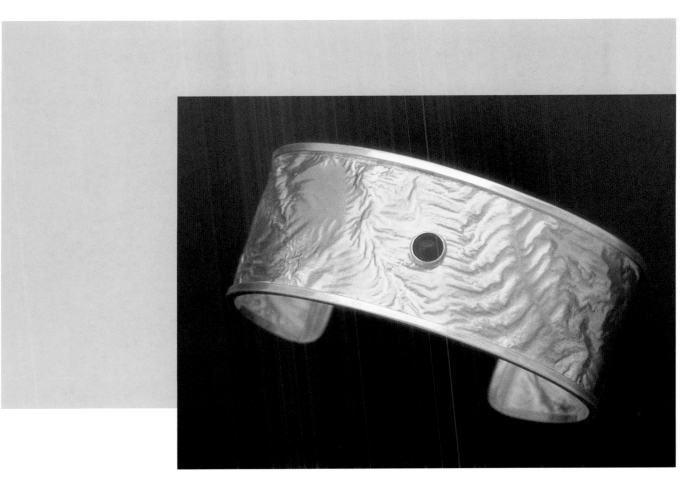

Diane Petersen. "Fault Lines." Cuff. Reticulated gold gives the cuff a textured surface. A ruby cabochon is set in a silver bezel, and edges are finished with bands of silver. *Photo, artist*

◄
Paulette Myers. "La Grande Jatte 1." Sterling silver, reticulation silver, iolite stones, and 24k gold *kum boo*. 4" high, 0.75" wide, 0.5" deep. *Photo, artist*

COLORING

Coloring on metal enjoys time tested methods, but new looks, materials, and the artists' ever present need to innovate and experiment have brought about exciting applications. Paints, colored pencils, patinas, and enamels are most common. However, jewelers have dipped into techniques used by artists in other cultures. The concept isn't so much what they use but how they use it.

Kum boo

Kum boo (also spelled keum boo, and kum bu) is the process of applying 24k gold foil to silver. Kum boo, adapted from Korean jewelers, has become popular among Western jewelers. So far, it is applied mostly onto silver, though there are historical references to adhering gold to iron, steel, platinum, and to itself. Says Jayne Redman; "It can quickly add a gold look to jewelry without adding a gold cost for either the jeweler or the customer. Whatever the cost in time, materials and effort, kum boo delivers a priceless look to jewelry."

Kum boo involves laying strips of gold foil on the metal, much as one would use gold leaf. The foil, however, has to be adhered to the metal surface under heat, quenched in water, and the steps repeated several times. The temperature has to be the correct heat or the gold will not adhere. Jayne Redman shows the principle of applying kum boo.

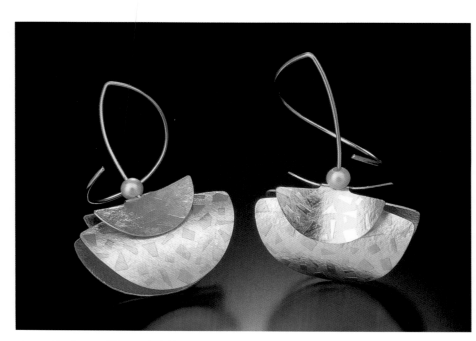

Jayne Redman. "Begonia." Earrings. Hand fabricated and embossed 18k gold with oxidized fine silver kum boo overlay. *Photo, Robert Diamante*

Jayne Redman. The kum boo overlay process is similar to gold leafing. Parts are cut out, the gold strips are laid on the parts, heated to fuse them, and then the pieces are fabricated. *Photo, Robert Diamante*

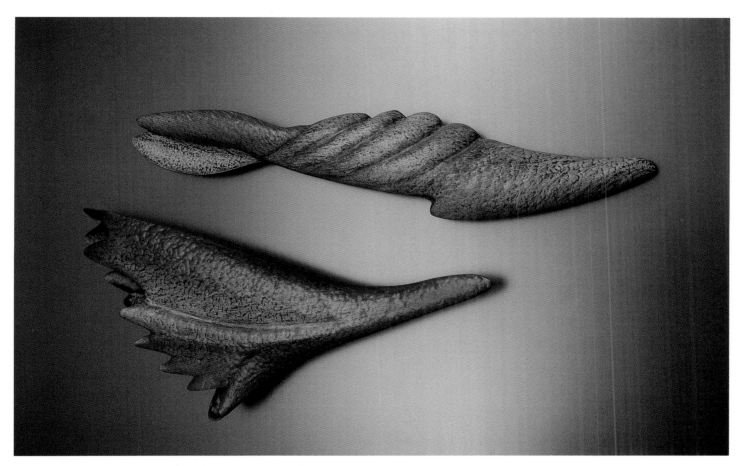

Helen Shirk. "Blue Pod" and "Red Pistil." Brooches. Copper has been shaped using repoussé techniques.The copper is lightly sandblasted to yield a textured surface that will hold the colored pencil she uses for subtle blending. The pieces are dipped into a patina of liver of sulfur solution to darken any uncolored areas. *Photo, artist*

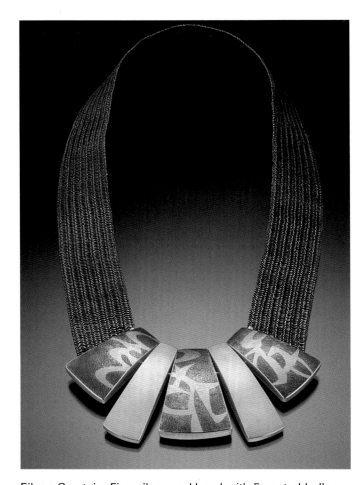

Eileen Gerstein. Fine silver neckband with 5 central hollow formed sterling silver pieces. Three have kum boo overlays in 24k gold and the two plain pieces are 22k Bi-Metal. The silver wire neckband is made by knitting as one would work with fibers. *Photo, Hap Sakwa*

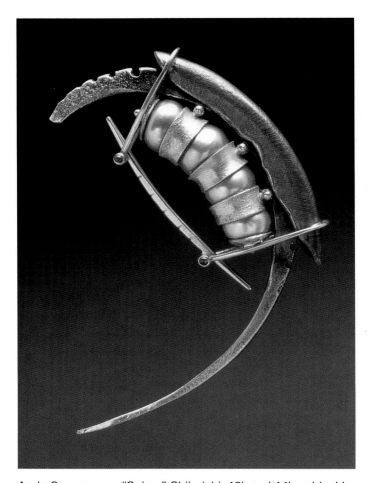

Andy Cooperman. "Spine." Shibuichi, 18k and 14k gold with pearls and rubies. The shibuichi is the black, dark arching form with a bit of bronze wrapped in among the layers. *Photo, Doug Yaple*

Shakudo and shibuichi are alloys that reportedly were used in China during the Han Dynasty. Pre-Columbian metalsmiths used a similar alloy. Later, the Japanese used it in their sword making.

Shakudo

Shakudo contains 4% fine gold on a copper base. It handles much like copper, and the color is similar after it is patinated. Oxidization solutions can yield a range of exciting tones without affecting the gold content. High, deep color tones can be achieved that work well as a contrast to other metals.

Shibuichi

Shibuichi is a classic Japanese alloy containing 25% or 15% silver on a copper base. Both shakudo and shibuichi are a creamy pink color in their natural states. They take patination beautifully in a wide range of colors such as gray, sky blue, and pale greens. Using different patina mixtures can yield colors that are particularly adaptable to jewelry.

Mokumé gané

One other technique for coloring metal is mokumé gané. The process creates the grain appearance of wood on metal. It was first developed in Japan by Denbei Shoama, a 17th century master metalsmith, to use in samurai sword making. The traditional blacksmith method is time consuming and laborious, but modern jewelers have simplified the process for their use on a smaller scale. It still takes several steps and much patience.

For mokumé gané, very thin layers of different metals are soldered together, then passed through the rolling mill to reduce its thickness. The unique patterns are created by hand carving and drilling down through the layers, and then passing the sheet between the rollers again to flatten out the edges around the carved areas. The process of carving and rolling is repeated many times to create the finished patterns that resemble wood grains.

PATINAS

When metal is exposed to nature's elements, oxidation occurs. Rust is oxidation and it illustrates the effect of carbon, oxygen, and water. You've probably seen bronze sculptures with a green patina acquired by exposure to weathering.

In the jeweler's studio, a patina is used to alter the color of metal by dipping the object into a chemical bath, or by spraying, or wiping it onto the metal. Artists have learned to control oxidation for specific coloring on the metals they use. Even with control, a patina may vary depending on its slag content, the metal, alloy, and weather.

Gold is difficult to oxidize, silver oxidizes easily in tones of gray or black. Patinas work best on metals with a high copper content. Copper, bronze, and brass accept the widest range of patinas. Often the same effect can't be achieved twice. The same chemicals affect different metals differently at different times and temperatures. Even then, most patinas will change with time, usage, and even the chemical balance of the wearer.

Patina chemicals release toxic or corrosive fumes and must be used in well-ventilated areas. After cleaning, the metal surface is prepared by pickling with acid, by sanding, grinding, filing, wire brushing, or sandblasting.

The piece can be left at room temperature or heated before it is dipped into the chemical solution, or the solution may be sprayed or brushed on. It can be placed in a vacuum-tight container or airtight plastic bag with an open dish filled with the patina chemical. There are so many ways the metal can be set up to become oxidized that the jeweler learns mostly by experimenting. Several types of waxes or sealers are available that will protect and help prolong the surface's color life.

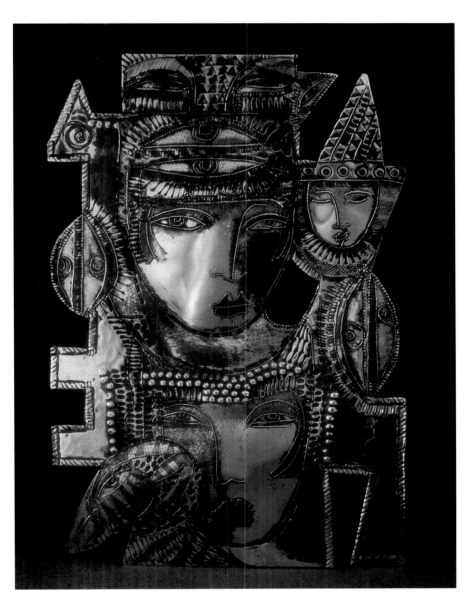

Susan Brooks. Sterling silver brooch formed using repoussé, chasing, and engraving for the raised and indented surfaces. Dark shadow areas are created with a patina that yields depth and contrast. *Photo, Kate Cameron*

ENAMELING

Enameled jewelry is enjoying a resurgence in popularity though it has been around for centuries. Enameling is the process of applying small granules of enamel to metal and firing it at high temperatures. Basically, it is glass on metal.

Ever since people discovered that silica turns to glass when heated in extreme temperatures, some forms of glass on metal have been produced. We know that from museum examples of pieces from early Egyptian, Greek, Celt, China, and Japanese cultures. Byzantine, Renaissance Italy, France, Russia, and 18th Century England all had enamel work. However, it was Louis Comfort Tiffany, working in New York, who changed the direction of enamel jewelry designs at the beginning of the 20th Century by using Art Nouveau elements and adding unusual materials into and under the surfaces.

Enamels are ground from clumps of glass. They come in colors and powders that are translucent, opalescent, or opaque. With judicial mixing, and firing many layers, one at a time, color depths and tonal effects can be achieved.

There are six basic enameling techniques that have been used for generations and are easily identified when you know their characteristics.

Basse-taille

The French word meaning "low cut," *basse-taille* describes a style that dates back to Renaissance Europe. The metal surface to be enameled is textured and transparent enamels are applied over the complete surface. As light hits the metal through the transparent layers, there is an illusion of depth, like looking at an object through water. The under texture may be carved, etched, chased, or worked with any of the silversmith techniques.

Cloisonné

The term comes from the French word, *cloison,* meaning an "enclosed cell or area." To create the cells, a flat wire standing on its side is adhered to a copper disc that is the base of the jewelry. After the cells are filled in with enamels, heated, melted, cooled, and finished, the wire edge leaves an attractive line in the surface.

Cloisonné can be concave, convex, or flat. In concave cloisonné, each cell has less enamel in the center than near the wire, giving each cell a concave appearance.

In convex cloisonné, the enamel is slightly rounded in each cell. It forms slight mounds above the cloisonné wires for a more sculptural feel and look to the piece.

Flat cloisonné is probably the most popular of the three types. After firing, the enamels are flattened with a smoothing stone so that wires and the enamel are the same level. A flat surface may be coated with paste wax to give it a gloss. Some are finished by grinding and polishing as with a lapidary stone. A "flash firing" will also yield a glossy surface that can be polished with appropriate polishing compounds.

Champlevé

Champlevé is similar to *basse-taille* but differs in how the enamel is applied. Instead of making cells with wire dividers, the backing material is carved and the resulting cells have a thick metal edge.

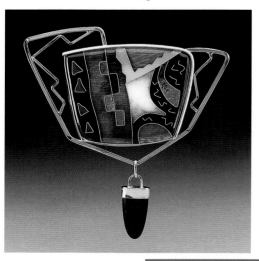

◄ Lisa Hawthorne. Cloisonné enamel pin with 18k and 24k gold, and a black onyx drop. *Photo, artist*

► Jan Smith "Flocked Red Rectangle with Gold Lines and Pearls." Champlevé enamel over copper with sterling silver, 22k gold, and pearls. *Photo, Doug Yaple*

Diane Echnoz Almeyda. Plique-à-jour pendant. 18k gold. *Photo, Ralph Gabriner*

Grisaille

Grisaille comes from the French word, "gray." In this technique, only black and white enamels are used. Usually the background is black, covered with several layers of white that are fired between layers. As the enamel is built up, it produces shades of gray.

Limoges

Limoges is named for a small town in Southern France that became known for a new enameling technique in the late 15th Century. Artists there began painting with enamel on top of the enameled surface in very fine detail. Their stunning results, named for their town, have been admired, further explored, developed over time, and become very valuable.

Plique-à-jour

Plique-à-jour translates to "light of day." It is made without any backing metal so when you look through the enamel layers, it appears more like stained glass than cloisonné. Because light must pass through the enamel, there is no metal backing. Preparing the enamel for the process requires time and patience.

See Chapter 8 for additional enameling examples.

Alex and Mona Szabados. "The Four Seasons- Fall." Locket. Transparent enamel over gold and silver foil on a copper base. Opaque and opalescent enamels and ceramic pigments are added for color. A diamond, opal, and sapphire add to the elegant richness. The piece is hinged and opens. A gold setting edges the piece. *Photo, George Post*

To create negative shapes within a piece of jewelry, areas must be removed without making cuts in the surrounding metal. The most obvious method would be to punch a hole in the material. But punching a hole doesn't remove metal, it simply moves the molecules, squeezes them together, and leaves a jagged edge. Therefore, tools are needed to perform the task cleanly. These are saws, punches, and stamps.

A jeweler's saw is among the essential tools on the jeweler's workbench. Besides cutting pieces of metal from sheets, it is invaluable for removing metal from within a form to create a negative shape. The saw has a u-shaped frame and a removable blade. The blade can be placed within a hole started with a drill or punch. The blade is re-connected to the frame so that an interior piece of metal can be sawn and removed.

After all the spaces are made, edges have to be filed, sanded, smoothed, and polished.

When many spaces have to be made, a stamping die may be used. This can be either a hand process where each space is cut out by hand using a saw or stamping die. Die stamping requires a positive and negative unit, called a punch and a matrix. The punch fits perfectly into the matrix to produce a sharp outline. The metal is placed over the matrix, which is a perforated block, and the punch is hammered into the metal, forcing the piece of metal from the sheet into the matrix.

Using a diestamp requires an even pressure over the surface to be removed. The removed piece is called the blank. Often the blank is a round circle that can be shaped into a hemisphere so that two together can be soldered into a ball. Blanks can also be pierced and used as a flat bead.

When multiple piercing pieces are required, a die-stamping press may be used. The press is designed to pierce or punch out many shapes at once for an entire piece of jewelry, a process used for commercially produced, multiple pieces of jewelry. The artisan may employ a die-stamping press and have an assortment of dies in different shapes that are used frequently.

Tami Dean's *New Circle* brooch illustrates piercing using repeat triangles. Her rings, too, have triangular piercing along with cut out lines. Positive shapes of triangles are added to the rings for depth, additional design, and tactile elements. The brooch also has stone settings. Dean, who has traveled to Africa and Mexico, is stimulated by a variety of ethnic images that she consciously uses in her designs.

Jim Kelso's brooches, inspired by natural forms, rely heavily on removing areas of the metal with a saw, resulting in a variety of interesting shapes that play off one another, and as a contrast to the positive shapes. Each cutout area is meticulously planned on a drawing, transferred to a template, and then to the metal, before he begins to saw.

Barbara Heinrich's brooches, on page 54, have pierced areas in the shapes of hieroglyphs, they also illustrate the use of stone setting with the cutout elements.

Tami Dean. "New Circle." Brooch. Sterling silver, 18k yellow gold, amethyst, spinel, and an opal. Pierced, embossed and fabricated. 2.5" high, 1.7" wide, 0.5" deep. *Photo, Hap Sakwa*

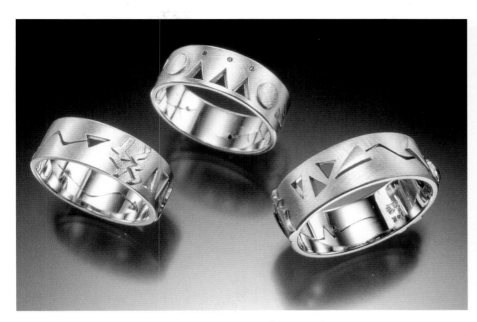

Tami Dean. Rings that have been pierced and fabricated. Triangular shapes have been cut out and longer geometric shapes are laid onto the surface. *Photo, Hap Sakwa*

▶
Jim Kelso. "Siberian Iris." Brooch. 22k gold and sterling silver patinated. Sawing and piercing. 2.25" high, 1.25" wide. *Photo, artist*

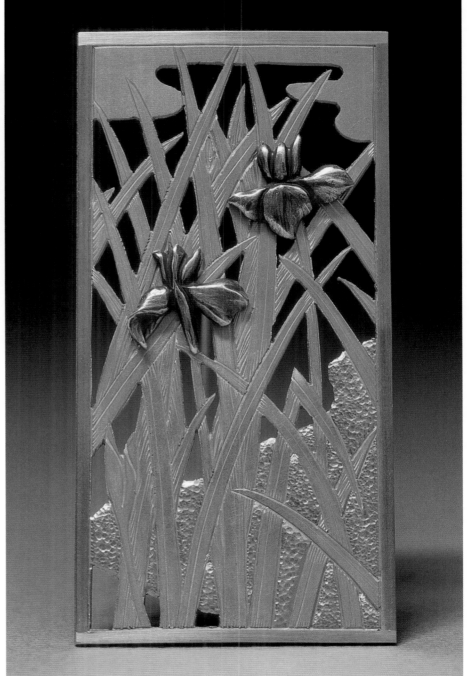

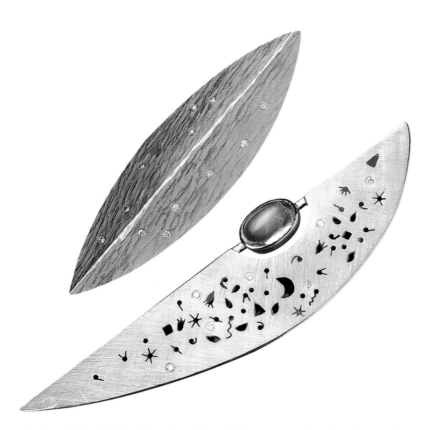

Barbara Heinrich Studios. Two 18k gold brooches showing diamonds set with prongs. The blue moonstone is set in a bezel. Both brooch pieces are bent. The top piece is reticulated for texture. The bottom piece is smooth with pierced shapes that represent hieroglyphs. The pieces illustrate only a few of the many techniques used by artist jewelers. *Photo, Tim Callahan*

STONE SETTING

The jeweler who adds stones to jewelry has to have a knowledge of gemology, and lapidary, along with myriad other disciplines that are brought to the workbench. Many know their stones in depth. Others know enough to work with what they like, and how to determine a stone's quality and value. Some become so imbued with the study of stones and gems they become proficient at cutting and polishing stone from pieces of rock.

Most important is knowing how to set stones onto a piece of jewelry. If they don't know how, or lack the expertise to do it themselves, there are jewelers who specialize only in setting stones.

For the buyer or collector of jewelry, learning about gems can be a fascinating hobby that will also make an educated buyer. It's not unusual to see a buyer at a fine jewelry counter using a jeweler's loupe or a magnifying glass.

There are two basic types of stones: a cabochon and a faceted stone.

The cabochon has a smooth domed or flat surface and may be cut into an oval, round, curved, triangle, teardrop, or other shape.

A faceted stone has a flat face with sides cut in a variety of angles designed to reflect light in different ways. Some are cut with straight sides, others in conical shapes. Diamonds are almost always faceted and may be a square, diamond, heart, rectangle, round, or other geometric shape.

Settings may vary. The *bezel* is made of a strip of metal that surrounds the stone and is fused to a flat surface. *Prongs* are a claw-like setting made from sheet metal or wire, and often used for faceted stones. This setting raises the stone above the surface and allows light to penetrate and reflect from all sides. It displays the beauty of the cut stone and its faceting.

Stones may also be inlaid. Some are set in clusters or in a line close to one another, called pavé.

In a *pavé* setting, many stones are set close together so very little metal shows. It suggests that the object is "paved" with stones. Small holes are made in the metal and flanged sides are bent up to hold the stone.

A stone may also be put in a "box" setting so it sits down into the metal, or it can be framed all around. Traditional methods can be changed as the jeweler sees fit, and that can make the setting permanent. There are no rules that say one type of stone must be placed in one type of setting or another.

On her *King's Ring*, Cornelia Goldsmith combines both cabochon and faceted stones in bezels. The different colored, round and square shaped stones, are on a surface encrusted with varying sized granulation.

Cedrick Jihanian's stunning cuff, *Sea of Light*, won the World Facet Award for 2002 in the International Jewelry Design Competition. It has 1012 stones set in 18k yellow gold and sterling silver. The settings are *pavé,* and bezels, using blue sapphire, violet amethyst, ice blue topaz, white and chocolate diamonds, and orange chalcedony, in an undulating pattern evoking an ocean wave.

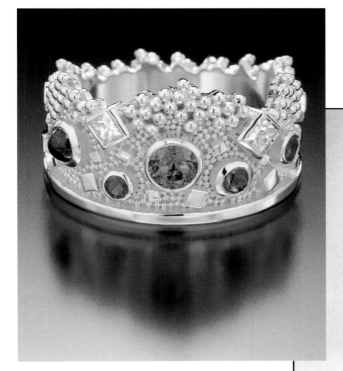

Cornelia Goldsmith "King's Ring." Granulation and stone setting make up the rich surface of this 18k gold ring. Stones include a sapphire, rubies, and diamonds. Granulation is added in different sizes and shapes. *Photo, Hap Sakwa*

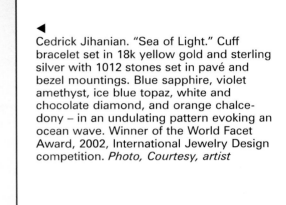

◀ Cedrick Jihanian. "Sea of Light." Cuff bracelet set in 18k yellow gold and sterling silver with 1012 stones set in pavé and bezel mountings. Blue sapphire, violet amethyst, ice blue topaz, white and chocolate diamond, and orange chalcedony – in an undulating pattern evoking an ocean wave. Winner of the World Facet Award, 2002, International Jewelry Design competition. *Photo, Courtesy, artist*

Todd Reed's hollow formed and fabricated bracelet has uncut diamond cubes set in claw-like notched bezels with each stone on pins attached to the base. He often uses a large number of diamond cubes in one piece of jewelry to create a mosaic like effect. He says, "With repetition also comes order. The mosaics of perfectly cubic diamonds have a strong sense of order. I like to contrast this order with a non-geometrical looseness in the final piece of jewelry."

Todd Reed. A bracelet with uncut diamond cubes attached to a hollow formed bracelet. Each gold cube is attached with a pin. Techniques are forging and fabricating using silver, 22k and 18k gold. *Photo, Azad*

Preparing a stone and setting it

Bill Gallagher illustrates the steps required for preparing a cabochon and setting it into a bezel to create a pendant. *Photo series, Gene Ogami*

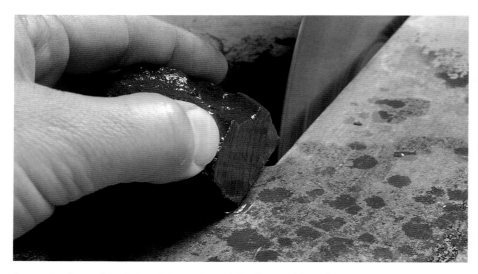

A rough piece of lapis lazuli is cut into 1/8" slices with a diamond-edged blade cooled either with water or oil.

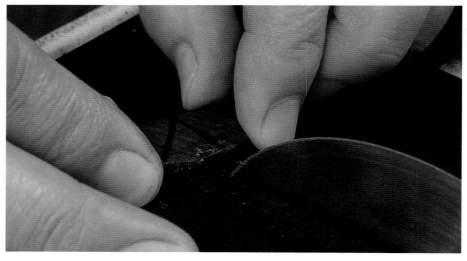

The slice is cut into smaller chunks close to the desired final shape.

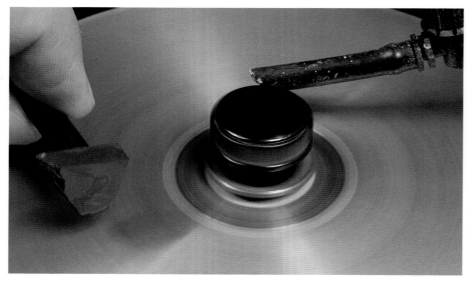

The chunk of lapis is glued onto a plastic stick, called a "dop stick," then shaped by grinding on a spinning diamond disc, rinsed, and cooled with water.

After using several progressively smoother diamond discs, the cabochon is polished on a felt disc with diamond paste.

A design is planned, combining other stones. A narrow strip of pure silver sheet is fitted and formed around each stone to create the bezel.

The bezels are soldered onto a sheet of sterling silver using an acetylene torch. Holes are drilled to create loops.

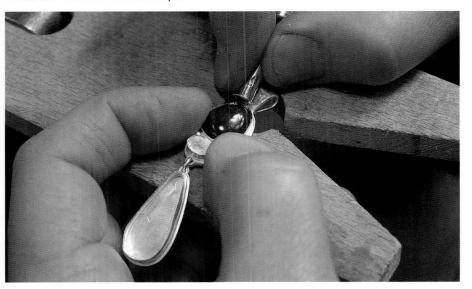

The bezels are cut out with a jeweler's saw.

After forming the bale, the two elements are joined with a jump ring. Pushing the bezel edges onto the stone using a bezel pusher sets the cabochons.

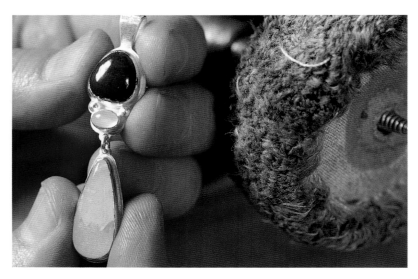

◀
With the stones set, the pendant is ready for polishing. A final polish with jewelers' rouge results in a beautiful piece of jewelry.

Zaffiro. Jack and Elizabeth Gualtieri. "Svetlana." Ring. The high bezel holds the blue beryl above the fabricated ring, rich with 22k white gold granulation. It is built up to give an architectural feeling to the piece. *Photo, Daniel Van Rossen*

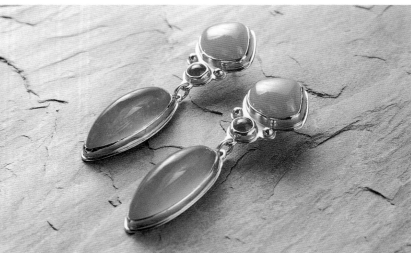

Bill Gallagher. Earrings using the same processes as shown. 14k and 22k gold, bustamite, ruby, and chalcedony. Chalcedony's translucency gives it a different look when set in silver versus gold. Silver gives it a cool, icy look. Light reflecting off yellow metal gives it a warmer, more lavender tone. Collection, David and Karen Aeppli. *Photo, Gene Ogami*

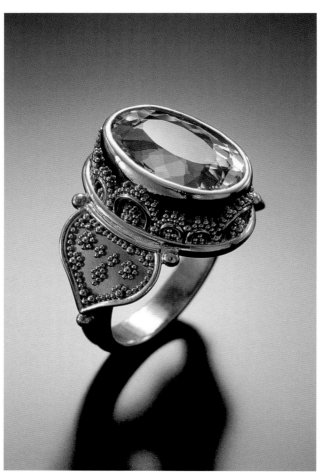

58

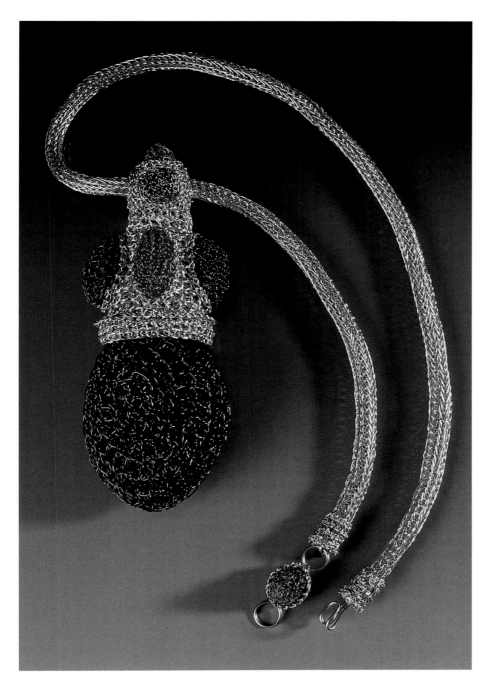

FIBER TECHNIQUES

The use of fiber techniques in contemporary jewelry owes much of its popularity to the work of Arline M. Fisch, an innovative jeweler and teacher with an international reputation. Bored while on a freighter trip, she asked the ship's captain if he had any material she might use. He gave her a spool of radio wire. Thus, her odyssey into jewelry using fiber techniques began. From it evolved her inspirational book, *Textile Techniques in Metal.*

Fisch notes that using textile techniques is not new. She cites several historical precedents. There are examples from pre-Columbian times, from Finland in the 1200s, from ethnic cultures such as the Ashanti region of Ghana, the Baule tribe on the Ivory Coast, and Nigeria. Examples of bobbin lace from Early America, lace from South Dakota, and Mexico, and a crown adornment from China's Sung Dynasty support her premise that people have used many fiber techniques in metal for a long time and in many cultures.

Fisch shared these finding with students and other craftspeople. Spurred by Fisch's own examples, jewelry enthusiasts picked up knitting, crochet, weaving, basketry, and other techniques of the fiber artist. A new chapter in the history of contemporary jewelry had begun.

Examples that follow here, and in Chapter 9, illustrate jewelry made by several methods associated with fibers. Strips of almost any metal can be used for weaving, braiding, and caning. Wires thin enough for coiling, twisting, twining, and looping are used. Any techniques learned, and tools used in other jewelry making, can be creatively adapted to fiber jewelry. Some metals will require annealing to prevent them from breaking when knitted, crocheted, woven, or knotted. Flat metal strips and wire can be made thinner, longer, and more malleable if they are put through a rolling mill. (See page 31).

Barbara Stutman's crocheted and spool knit wire pendant was influenced by royal jewelry combined with ethnic touches. Spool knitting is something many people learned as children, but jewelers use it for making chains. It consists of placing nails or brads around one end of a spool, or a circle of wood with a hole in the center. The thread or wire is looped over each nail in turn, row-by-row, resulting in a tubular chain-like material forming down through the hole in the spool's center.

Barbara Stutman. Pendant. Crochet and spool knitting with coated colored art wire. The pendant is crochet; the chain is spool knit. *Photo, Paul Fournier*

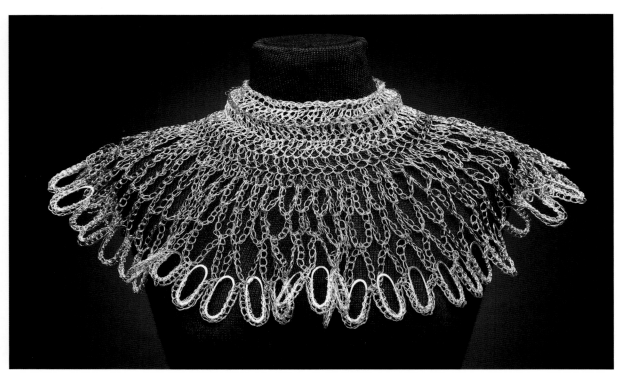

Arline Fisch's crocheted collar, *Lacy Net*, combines fine silver and coated copper wire. The piece is shaped to lay on the neck as would a collar made of fibers. Wire ovals are worked into the central bottom loops to help the piece retain its shape, and to add a solid visual element to the lacy texture. It represents an example that continues to inspire people to create jewelry using textile techniques.

Arline M. Fisch. "Lacy Net." Crochet collar. Fine silver, coated copper wire. 19" outer diameter, 8" diameter at neck. *Photo, William Guilette*

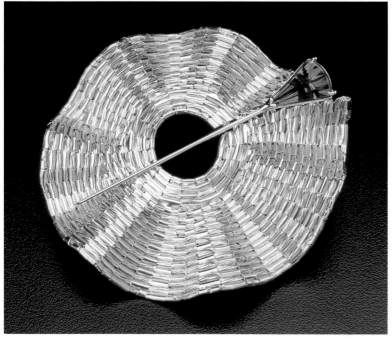

► Barbara Berk. "Small Ripples Brooch." 18k gold, hand woven. A 12 mm faceted Citrine ball tops the separate stickpin, which is the attachment mechanism for the brooch. 2.25" high, 1.1" wide, 0.7" deep. *Photo, Dana Davis*

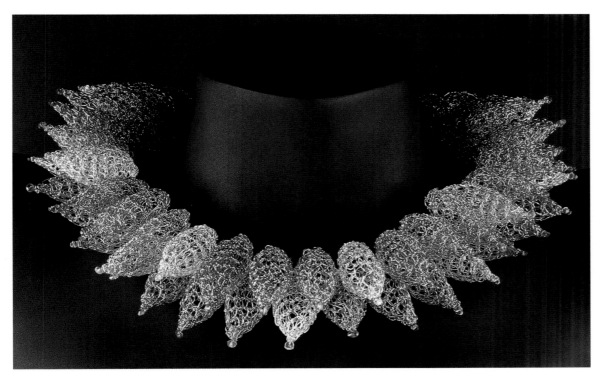

Sandra Manin Frias. "River Boat from the Amazon Forest." Pendant. Knit gold wire interior in a gold frame with faceted semiprecious aquamarine. Facérè Jewelry Art Gallery. *Courtesy, artist*

Reina Mia Brill. "Eye Candy." Neckpiece. Hand knit coated copper and silver plated wire, peridot, iolite, citrine, pink tourmaline and magnets. *Photo, artist*

Barbara Berk. "Interlocking Hearts with South Sea Pearls." (Detail). Platinum wire woven by hand using the soumak technique. The centerpiece functions as a clasp and is designed so it is detachable and interchangeable. Shown with tanzanite beads. *Photo, Dana Davis*

Sandra Manin Frias. Ring. 22k and 18 carat diamond. Coiled gold wire basketry weave is used for the ring body. Facérè Jewelry Art Gallery. *Courtesy, artist*

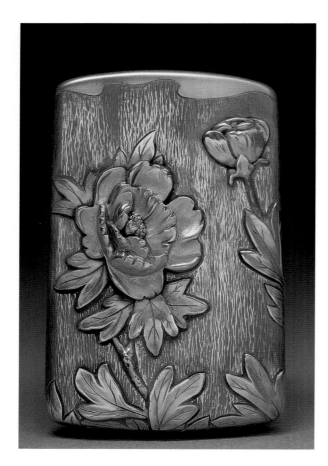

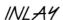
Jim Kelso. "Japanese Summer Peony." Sterling silver and 18k gold. Inlay techniques. 2.25" high, 1.3" wide. Collection, Sarah Hasson. *Photo, artist*

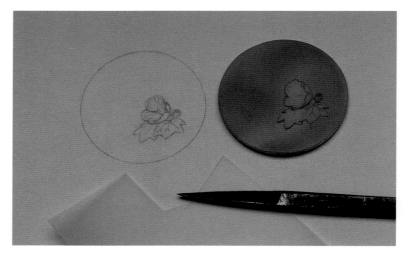

1. A metal disk is cut from a sheet of shibuichi, a metal alloy that is pinkish in its raw state. A wooden form is used to shape the disc into a dome.

INLAY

Inlay is a process by which different metals can be laid into a base piece of metal to produce intricate patterns and designs that may be flat, and in low and high relief.

In the following series, Jim Kelso uses all three stages of inlay to create a sculptural depth to a two dimensional surface. He describes the basic inlay and finishing methods used for the *Mallow Flower* pin shown in the final illustration. The flower is made of pure silver with leaves and background of dark *shibuichi*. The rim is ebony with a gold inner frame. The round flowers are *shakudo* with gold accents. In addition to high inlay and flat inlay, the piece also required engraving, carving, polishing, and patination. 2.5" diameter. *Photo series, Jim Kelso*

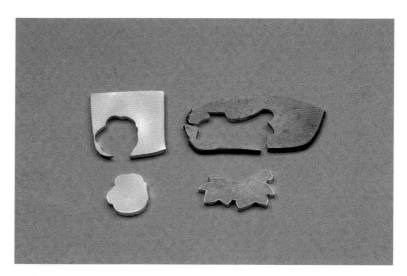

2. The original drawing, at left, is traced onto Mylar. Patterns of the inlay pieces are cut and placed on a sheet of metal.

3. The flower shapes are cut from a sheet of silver. The leaves are cut from a sheet of shibuichi.

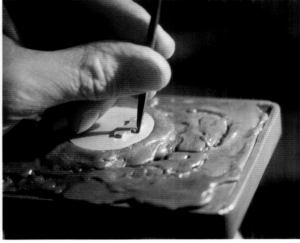

5. A bed of pitch is used to hold the disk in place (pitch is pine tree resin). The scribed areas are chiseled out with a variety of tools and burrs. A lip is raised to hold the inlays in place without using solder or adhesives.

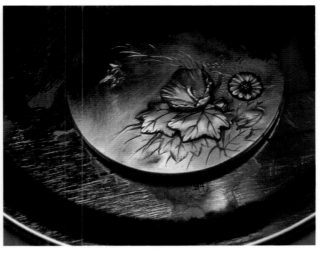

7. Traditional Japanese patination procedures are used for these multi-colored pieces. The piece is finely polished then immersed in chemicals to yield the final coloring. The original pinkish color of the raw shibuichi now has a gray hue.

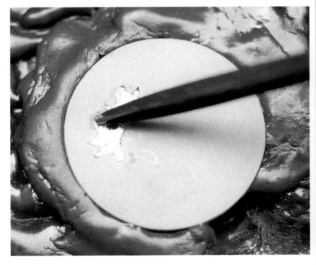

4. Pieces are positioned on the base piece and their outlines scribed with a needle.

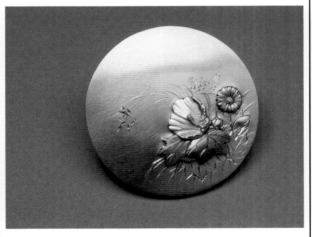

6. Details are accomplished with a variety of chisels. Background texturing is also done at this stage.

8. Jim Kelso. "Mallow Flower." The final piece in high and low relief is beautifully textured, engraved, and colored. 2.5" diameter. Collection, Janet Jentes. *Photo series, artist*

Dan Adams and Cynthia Toops. Tabular bead necklace. Beads are made of polymer clay, lampworked glass, and African trade beads. The Venetian glass beads traded to West Africa in the 19th and early 20th Centuries inspired the design. *Photo, Roger Schreiber*

BEADS, CHAINS, HINGES

Beads worn as adornment are widespread in every culture and age. Probably the earliest beads were made from seeds and shells. That tradition continues, but people have a wider choice of materials today. Beads can be anything and everything from bottle caps to precious metals, as examples throughout the book will attest.

The materials and their combinations will surely inspire today's jewelers to extend their thinking beyond objects they normally use.

Polymer clay (PC) and Polymer Metal Clay (PMC), along with a variety of synthetic materials not necessarily made for beading, can offer new opportunities for expression and production. Don Adams and Cynthia Toops have carried the use of PC to new expressive heights, often basing their pieces on natural images and ethnic sources.

Chains are an integral part of beads and necklaces because they are needed to suspend the pieces around the neck. A "chain" could be something as simple as a piece of string, natural fiber, or a wire. But an actual chain is a woven length of material that has dimensionality. Chains can be very delicate or thick inter-looped pieces of bent metal. In its simplest form, a chain is a series of loops. Chains can be minimal or complex and make a statement on their own.

Ideally, a chain's design and weight should be closely related to the piece it holds. Clunky pendants and beads call for heavier chains than delicate small jewels that might hang from a thin gold looped chain.

Chain making is an art unto itself. Some jewelers specialize in making only chains that they sell to other art jewelers. Chris Hentz is so well known for his chains in silver and gold that many jewelers credit their chains to him.

A few jewelers make their own chains. Most chains that are sold with production jewelry are mass-produced and may be stamped out of the materials.

Hand made chain can also become part of a pendant, a bracelet, and a brooch. When a design calls for chain, it behooves the artist to learn how to make the links in different loop styles.

Along with the necessity for chains is the need for clasps and hinges. They can be a simple hook and loop, or a spring ring and loop. A fishhook clasp and a box clasp are efficient and esthetic.

Some jewelers like to have total creative output for an entire piece. Rather than buy clasps and hinges commercially, they learn to make them. They are able to have these findings integrate perfectly with the piece of jewelry. Often they are a feat of engineering in near microscopic images of larger mechanical items. The fully handmade jewelry, integrating the center of interest, and the findings, tests the patience and expertise of the jeweler. It is a joy to behold, to own, and to wear.

Mary Kanda. Glass beads are set like mosaics, grouted with tile grout, and framed with silver. *Photo, Dean Powell*

Gerda Rasmussen. Tassels, wrapping, beads, sewing, and knotting techniques are all included in this wild array of colors, and fibers that combine, rough and smooth textures. *Photo, Dona Meilach*

► Patty Cokus. "Haiku Necklace." (Detail). Blown glass bead, paper, and silver on a sterling cable. *Photo, Doug Yaple*

Maxine Yablonski. A flat peyote stitch is used for the base of this beaded bracelet. Sculptural parts are layered, strung, and attached to the base. The concept is to work as you go, designing for high and low areas for the sculptural effect. The design is dictated by the work and the beads used. *Photo, Wendy McEahern*

▶ Christopher A. Hentz. Different styles of hand made chain necklaces in sterling and 14k gold. *Photo Ralph Gabriner*

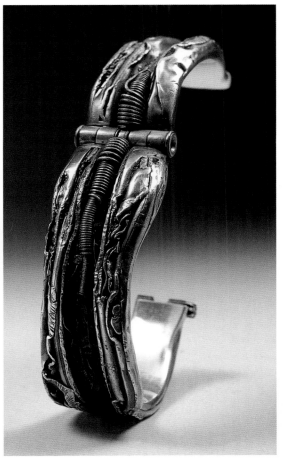

Suzanne B. Stern. "Woman's Work Series." The clasp is the pendant. It is made of metalized Pyrex, lampworked soda-lime glass, cast sterling silver, a cultured pearl, and a sapphire. The chain is made using spool knitting. The beads were first threaded onto the 28 gauge fine silver wire and slid up as the knitting progressed. Pyrex tubing was bent and used for a sub structure to keep the delicate knitted portions from stretching and sagging with the weight of the large center bead pendant. *Photo, George Post*

Steven H. Kolodny. Hinged bracelet with an opal and diamonds. *Photo, Allen Bryan*

Suzanne B. Stern. Detail of the clasp (above).

Nathan Blank. "Rooted Migraine." Bracelet detail showing the hinge with the spring element that becomes part of the design. Sterling and fine silver, copper, brass, steel springs, and guitar string. *Photo, artist*

Jennifer A. Dawes. Three rings with stones set in a channel, so that they move with the hand. Other pieces have flowers and stones that spin *Photo, Hap Sakwa*

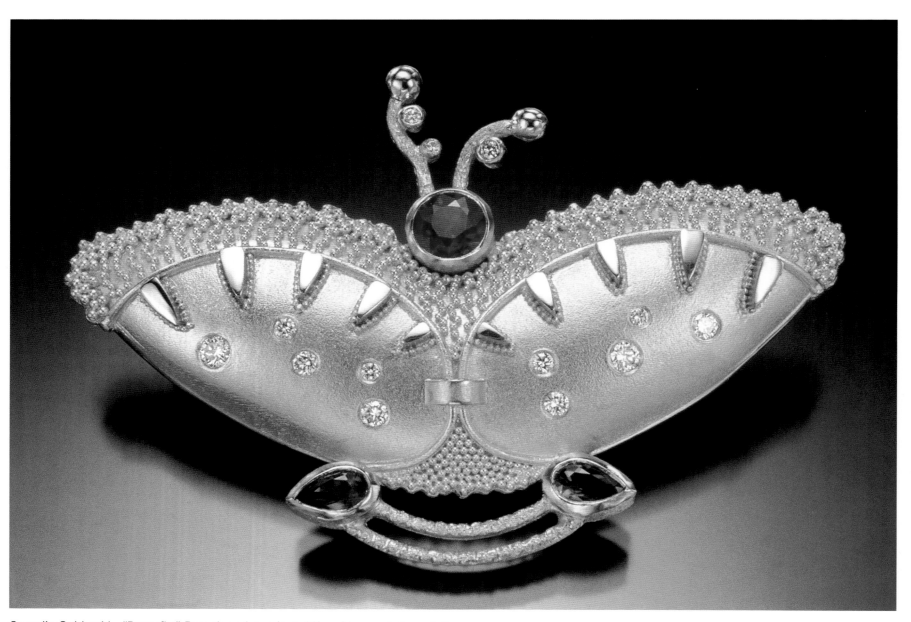

Cornelia Goldsmith. "Butterfly." Brooch and pendant. 22k gold granulation, platinum, 18k ruby, sapphires, diamonds, fabricated, and die formed, with 22k gold granulation. The inspiration is obvious. 1.5" high, 2.23" wide. *Photo, Ralph Gabriner*

Chapter 3
MOSTLY GOLD

What is there about gold that makes it so valuable and in such great demand? Gold is considered the king, the most noble, of all the metals because of its stable, non-corrosive, non-toxic, long lasting qualities.

Gold, probably one of the earliest metals known to man, is one of few metals found in its native state. It is easy to recognize by its yellow color and weight. In its pure or fine state, gold is too soft to use for jewelry and dentistry, the two things for which it is best known. To make it stronger for many purposes, it is alloyed, or combined, with other metals such as copper, silver, nickel, and zinc. Each of these combinations produces a gold with particular characteristics, such as color, melting points, hardness, ductility, and malleability.

White gold, for instance, contains platinum and palladium and has a higher melting point than pure gold. It is whiter than platinum and darker than sterling silver. It must be heated and annealed evenly as it is worked, or it has a tendency to crack. Adding silver or silver plus cadmium and zinc makes green gold. Yellow gold has silver and copper added. If a larger percentage of copper is added, the gold will have a reddish hue. Each of these alloys has working, melting, and malleability uniqueness. Is it any wonder that the jeweler must be part metallurgist?

Compared to most other metals, gold is scarce, therefore more costly as its demand increases. In addition to its beauty, it has superior electrical conductivity, malleability, and resistance to corrosion. These qualities make it essential to the manufacture of electronic products and equipment, including computers, telephones, cellular phones, and home appliances. The space program relies on gold's high reflective powers for shielding and protecting space vehicles from solar radiation. Industrial and medical lasers use gold-coated reflectors to focus energy. This precious metal performs far beyond its role as a jeweler's metal.

Another factor? Gold is biologically inactive, which means people are not allergic to it. Therefore, it is invaluable for medical research, for treating arthritis, and other intractable diseases.

All these incomparable characteristics add up to an appealing material for jewelers to use. It doesn't corrode. It is highly resistant to ordinary solvents. Gold scrap can be melted and reused without loss of materials. It can be oxidized to alter its color. Many other metals can be oxidized to look like gold so the buyer must be wary. Gold filled and Bi-Metal products that combine gold with less costly materials result in objects with a gold appearance, that can be marketed more economically.

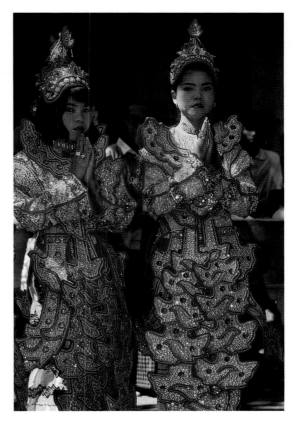

Myanmar Dancers. These beautifully adorned young women are watching their brothers at a Novitiation ceremony celebrating young boys entering the monkhood. *Photo, Bushnell-Soifer*

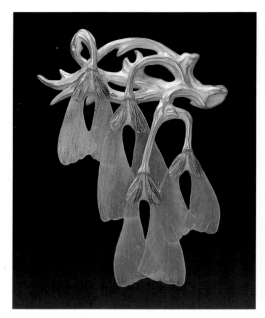

Jim Kelso. "Samsara Brooch." 18k gold, cast and chased, with carved sheep-horn. The samsara seed shape is a favorite of the artist. *Photo, artist*

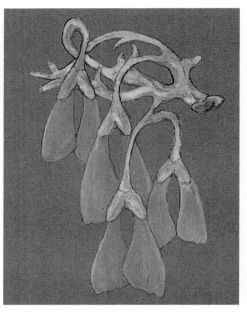

Jim Kelso. Sketch for Samsara Brooch. After a pencil drawing was made, it was interpreted in color before construction of the pin was begun. *Courtesy, artist*

Steven H. Kolodny. Pendant. 14k gold with an ammonite fossil, pearls, and a rhodolite garnet. Repoussé, fabricated, and constructed. 3" x 2". *Photo, Allen Bryan*

Considering that gold is so stable, it is not surprising that gold found in ancient burial tombs from Egypt, Colombia, Mexico, Peru, and many other places has endured. Much of it is displayed in museums throughout the world. The ability to view jewelry by ancient artisans tells researchers a great deal about their culture and their thinking. We can study their design concepts, how they used their materials, and be inspired by them.

Gold has traditionally been a symbol of wealth and status. People whose burial sites contained gold jewelry were usually royalty and high-ranking wealthy officials. Because of its value, the discovery of gold in California in the mid 1800s sparked the gold rush that opened up the West. Museums in central and northern California, especially, chronicle this period in the country's history, and display examples of gold with stories of the prospectors who searched for it. Some museums have hands-on exhibits where people can simulate the process of panning for gold.

Gold is manufactured in sheets in a variety of gauges and karats. Wire is made in round, half round, square, rectangular and special shapes. It is bonded to silver to create Bi-Metal. There are gold filled and gold plated products that make the resulting jewelry less costly than the high karat gold alloys.

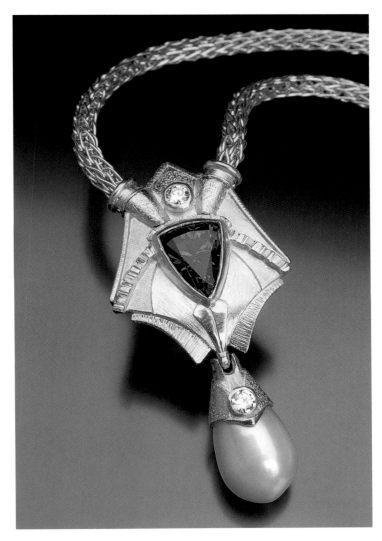

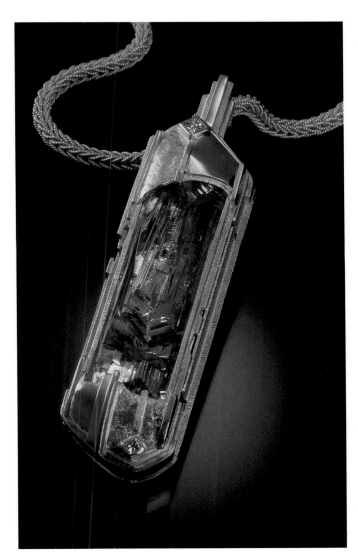

Patty Bolz. Neckpiece. 22k gold fabricated with a non-detachable hand- woven 22k chain. Tanzanite, diamonds, and an 8.01 ct. natural color fresh water pearl. A small pink sapphire is set in the back of the piece. Fabricated. *Photo, Robert Diamante*

When buying gold, or gold jewelry, its weight is expressed in "karats", not to be confused with a "carat" that is the term given to the weight of precious stones. The word karat refers to the relative purity of the gold. Pure gold is 24 karats, written as 24k. 18k gold is 75% pure gold; the other 25% is composed of different metals. 15k gold is 62.5% gold, and 8k gold is 33.33% gold.

Gold must be stamped according to the U.S. Stamping Law and, by testing, must not be less that one-half karat below its stamped content. The higher the gold content, the softer the gold. Most artisans use 14k and 18k gold because it is stronger than pure 24k gold. In some Eastern countries, 24k is used because of its bright yellow color and the belief that mixing gold with other metals violates its purity. The softer the gold, the more quickly it will show wear, but even that takes time depending on its use.

Patty Bolz. Gold pendant. Constructed and fabricated. The hinged back opens so that a strand of beads or pearls may be easily substituted for the gold chain. 22k gold with a 36.60 ct aquamarine, and a 14 ct. diamond. 2.25" high, 0.75" wide. *Photo, Robert Diamante*

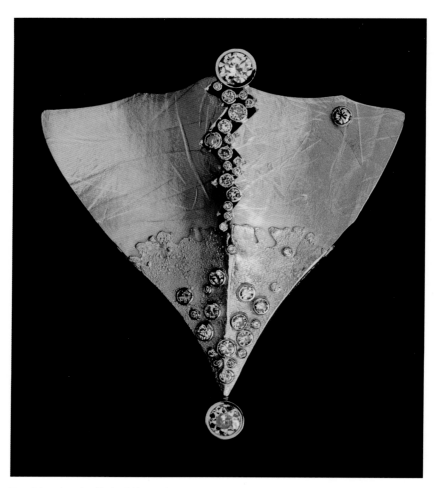

Eve Llyndorah. "Aria." Brooch. 18k gold with carved ebony, diamonds, and chrysophrase. The featherlike upward thrusting form was inspired by soaring music. The gold work is riveted to the ebony carving by fusing, piercing, and soldering wires and sheet. The various textures add movement and interest while the small diamonds catch light. *Photo, Gordon Mackenzie*

Eve Llyndorah and Ray Lipovsky. Brooch. 18k gold fillings are fused onto gold sheet and lightly beaten with a ball peen hammer. The sheet is soldered to the rest of the brooch which has been roller textured with crushed paper. Diamond settings are 18k white gold. 3" high, 2.5" wide. *Photo, artists*

Eve Llyndorah and Ray Lipovsky, husband and wife jewelers, who live on a private island off the west coast of Canada, approach their pieces from a sculptural perspective. They may use carved ebony elements or large mabé and embryo pearls set into, or riveted onto, the gold. Texture, used extensively to contrast with highly polished surface areas, may be impressed, fused, or hammered. The entire piece is hand constructed using forging, welding, and fusing techniques.

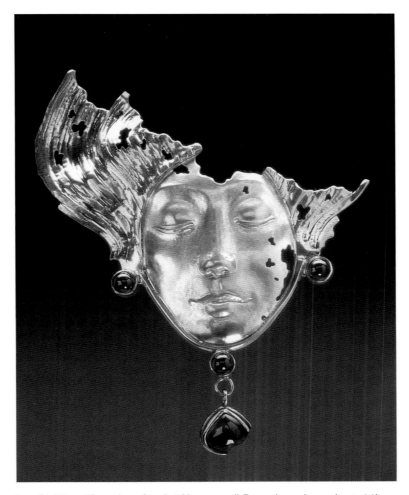

Lee Phillips. "Requiem for Art Nouveau." Brooch and pendant. 14k yellow gold, sterling silver, garnets. Repoussé, chasing, and fabrication. A tribute to the use of the human face in Art Nouveau. The two layers suggest that Art Nouveau is of the past but could inspire new forms in the present. Facèré Gallery. *Photo, Douglas Yaple*

Lee Phillips constructs and fabricates his elegant brooches in his Deer Harbor, Washington, studio. He says, "The faces are hammered out of sheets of gold or silver using the techniques of chasing and repoussé. By making the faces from sheets of metal I am able to experiment with a number of unique approaches. I can cut the faces apart and solder them together again, and combine different metals in one face. I can make 'masks' where one face looks out through the eyes of another. I can cut parts away from a face to create a composition of negative spaces, and any number of choices as I work."

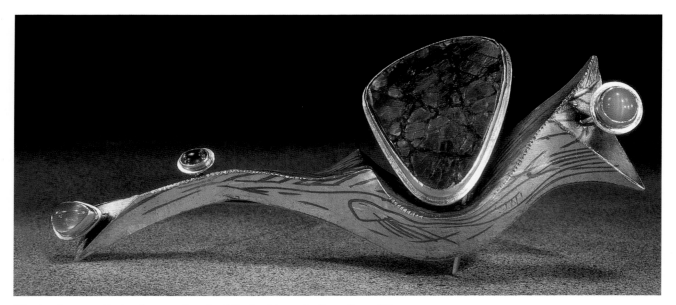

Charles Lewton-Brain. Ammonite pin. 18k doublee, sterling silver, 24k gold, ammonite fossil, moonstone, zircon, topaz. Ammonite, the largest stone, has the beautiful red and green coloring. 4.75" long. *Photo, artist*

Charles Lewton-Brain. Pin. 18k doublee, sterling silver, 24k gold, and moonstone. 3.75" long. *Photo, artist*

Barbara Heinrich Studio. Square brooch, hand fabricated in 18k gold with 16 diamonds and a pierced surface for the leaves. *Photo, Seth Tice-Lewis*

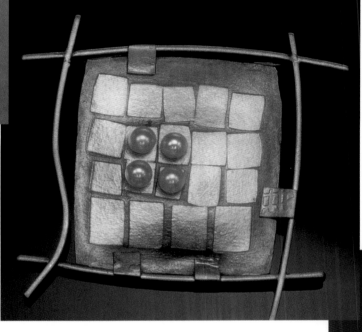

Sydney Lynch. Mosaic square pin. 22k Bi-Metal, oxidized sterling silver, and keishi pearls. 2" square. *Photo, Nick Reibel*

▶

Andy Cooperman. "Stoma." Brooch 14k and 18k gold, sterling silver, pearls, and a ruby. 3.5" high. Cooperman likes to search beneath the surface of the gold to uncover and reveal layers that he has created. *Photo, Douglas Yaple*

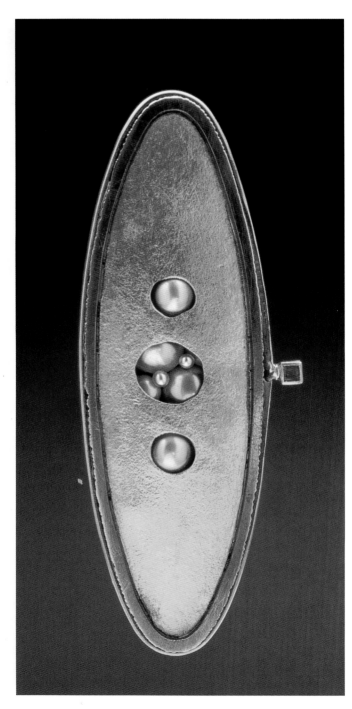

◀

Andy Cooperman. "Cushion Breach." Brooch. 14k rose, gold, copper, sterling silver, opal, and diamonds. The depletion gilding technique, involving several annealing, and pickling processes, results in this peachy tone and a fine surface. Holes burned through layers of the metals yield tactile textures and eye catching surfaces. 2.5" wide. *Photo, Doug Yapple*

▶

Barbara Heinrich Studio. 18k gold pod brooch and coordinated earrings have wavy lines and a diamond grid. *Photo, Tim Callahan*

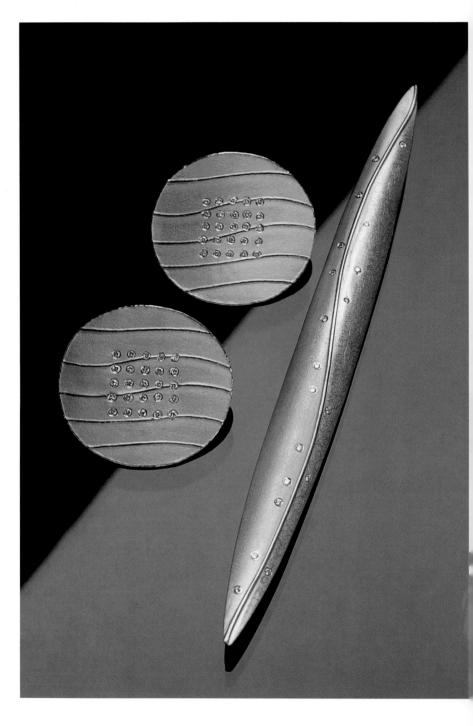

William Scholl. Pendant that converts to a pin. Fabricated 18k gold, Madagascar tourmaline. Two blue green tourmalines are removable so the piece may be used as a horizontal or vertical pin. *Photo, Ralph Gabriner*

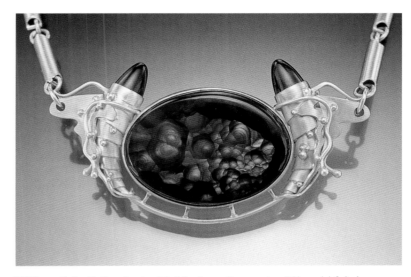

William Scholl. Pendant with Mexican fire agate, 18k gold fabricated, and two citrine cabochon stones. *Photo, Ralph Gabriner*

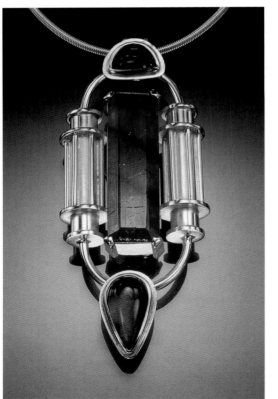

◄ William Scholl. Pendant. The same piece of jewelry with the Madagascar tourmalines attached and worn as a pendant. *Photo, Ralph Gabriner*

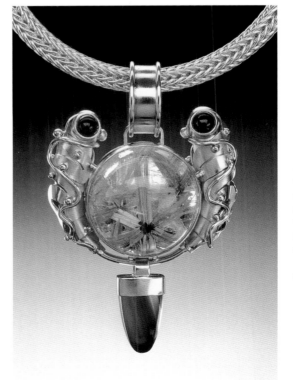

◄ William Scholl. Pendant. 18k yellow gold fabricated. The center stone is rutilated quartz with one amethyst stone on each side, and an amethyst drop. Gold mesh chain. 1.75" high. 1.5" wide, 0.75" deep. *Photo, Ralph Gabriner*

77

Tami Dean. "Horas de Oro." Necklace.
Cast and fabricated 18k and 14k yellow
gold, 14k white gold, and tourmalines.
17" long. *Photo, Hap Sakwa*

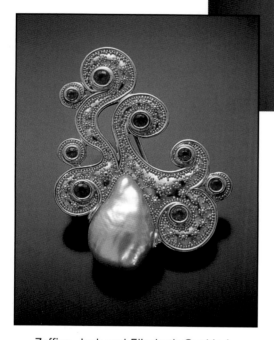

Zaffiro. Jack and Elizabeth Gualtieri.
"Oceania." Pin. Pink spinels and a
white Tennessee River cultured
pearl. Granulated 22k gold with 18k
gold. (An American Pearl
Company's Vision Award winner.)
Photo, Daniel Van Rossen

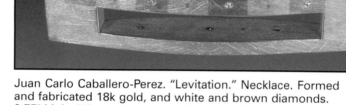

Juan Carlo Caballero-Perez. "Levitation." Necklace. Formed
and fabricated 18k gold, and white and brown diamonds.
0.75" high, 4" long, 0.5" deep. *Photo, Dan Neuberger*

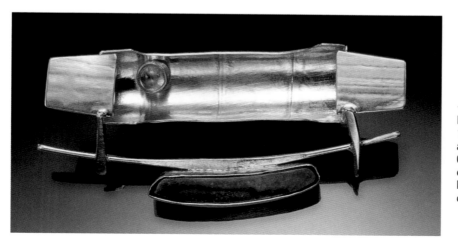

◄
Deborrah Daher. "Boat." Brooch. 22k,
18k, and 14k gold, rainbow moonstone
and a Boulder opal. 1" high, 2" wide,
0.25" deep. Fabricated from flat sheets
of metal using folding, wrapping and
layering to emphasize the plastic nature
of the materials. *Photo, Ralph Gabriner*

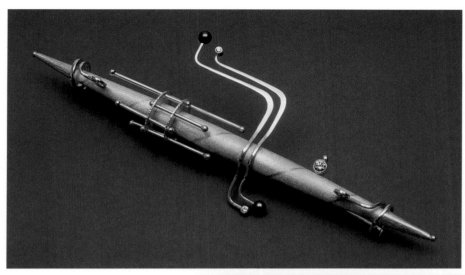

◀
Juan Carlo Caballero-Perez. "Speculum."
Brooch. Forged and fabricated 18k yellow gold
with 18k palladium white gold inlay, white and
champagne diamond, and black pearls. 2" high,
6" long, 1.25" deep. *Photo, Dan Neuberger*

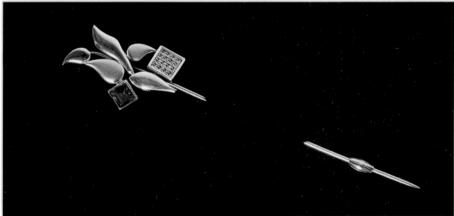

Sandra Manin Frias. "Stick pin." 18k gold.
Die formed leaves, square emerald, and
the right square is woven gold wire.
Facèré Gallery. *Photo, Carlino Amaral*

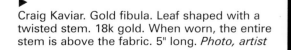

▶
Craig Kaviar. Gold fibula. Leaf shaped with a
twisted stem. 18k gold. When worn, the entire
stem is above the fabric. 5" long. *Photo, artist*

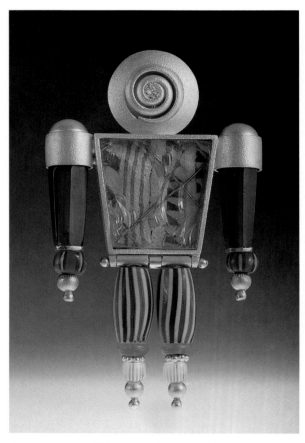

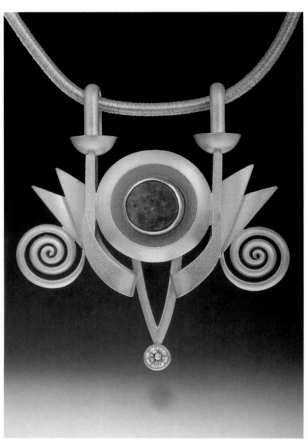

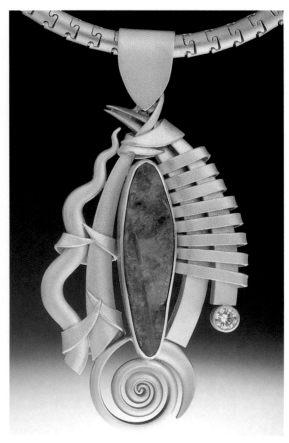

Aaron Macsai. "Diamond Head # 2." Pin and pendant. 18k gold, African trade beads, industrial glass, and a diamond. All pieces are fabricated, none are cast. The matte finish is achieved by glass bead blasting. 2.75" high, 1.5" wide. *Photo, artist*

Aaron Macsai. "Marquis Drop." Pendant. 18k gold, German cut Australian Boulder opal doublet, and a diamond. Cocoon chain by Shofar Co. of Germany. 1.5" high, 1.5" wide. *Photo, artist*

Aaron Macsai. "Assent." Pendant. 18k gold, boulder opal, and diamond. Glass bead blasted matte finish. Puzzle chain by Shofar Co. of Germany. 2.5" high, 1" wide. *Photo, artist*

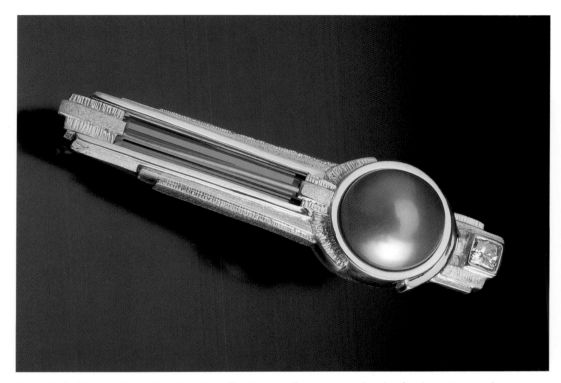

Patty Bolz. Pin and Brooch with a Brazilian tourmaline, a natural color fresh-water pearl and a .16 ct. diamond. Fabricated. 1.75" high, 0.6" wide. *Photo, Robert Diamante*

► Patty Bolz. Pin and Pendant. Fabricated 22k gold, with green tourmaline, and an orange sapphire. 1.6" high, 0.75" wide. *Photo, Robert Diamante*

Linda Weiss. Brooch alone is 18k gold with platinum accents, diamonds, and a unique tourmaline gemstone mined in Afghanistan and cut in Germany. *Photo, Hap Sakwa*

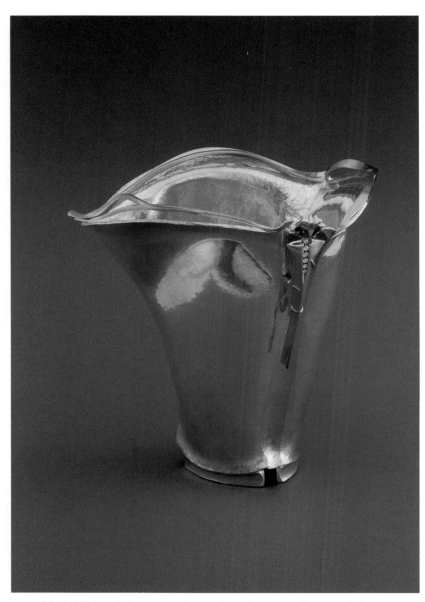

Linda Weiss. "Hemerocallis Hybrid." Vase with Brooch. 18k green gold, and platinum. Her reason for having a vase with a detachable brooch was two-fold. The vase is a display device. Instead of storing the brooch in a drawer it invites the owner to interact with and enjoy it when it's on display. *Photo, Hap Sakwa*

Linda Weiss's vase was created by seamless angle raising from a 9-inch disk of 18 gauge, 18k gold. The base, made in wax, was then cast, to assure a perfect fit, and soldered to the vase body. A wide variety of hammer facing and chasing were used for texture. The rim elements, forged from 18k gold and platinum, were soldered in position to suggest the outer edge of flower petals.

When the brooch is positioned onto the vase, it appears to be part of its design and, of course, it was planned that way. Remove it from the vase, and it is a subtle, elegant piece of gold jewelry.

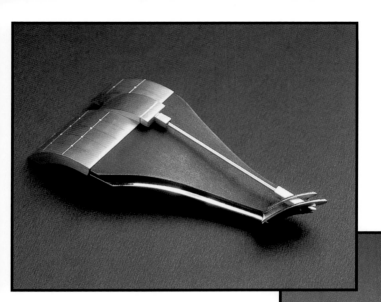

Patrick Marchal. "The Beautiful Pretension." Brooch. 18k gold, iron, stainless steel. Marchal uses a personal set of graphics to translate life as he sees it into images. 4" high, 2.75" wide, 0.75" deep. *Photo, S. Anton*

Patrick Marchal. "H2 Moon." Pendant. 18k gold and silver. 4" high, 3.5" wide, 1.75" deep. *Photo, S. Anton*

Jayne Redman. "Chrysanthemum Bead" neck wire. An 18k gold kum boo overlay gives this hand fabricated, oxidized fine silver bead its gold color. 18" long, 0.78" diameter. *Photo, Robert Diamante*

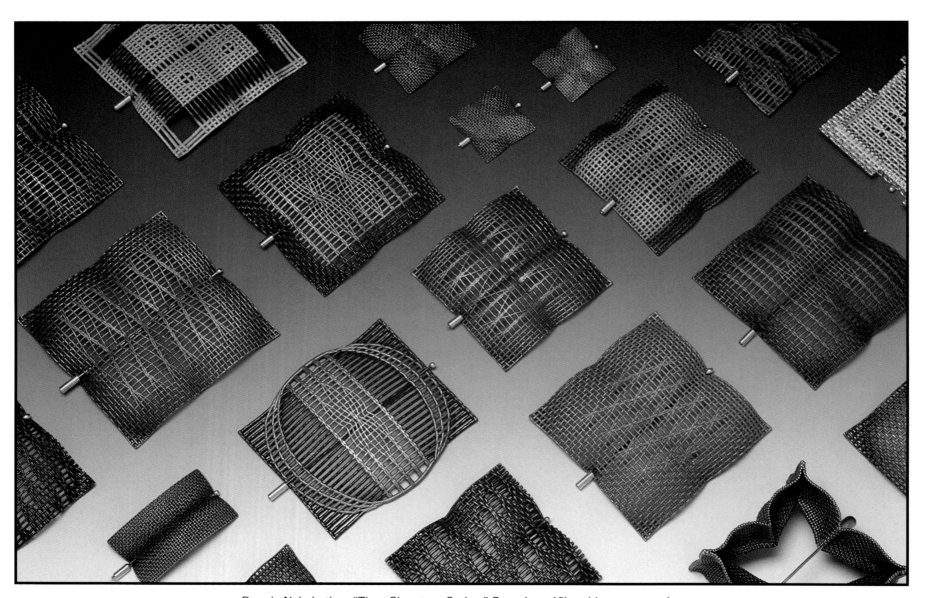

Dennis Nahabetian. "Time Signature Series." Brooches. 18k gold, copper, patina, and steel. All use a variety of weaving and other fiber techniques. *Photo, artist*

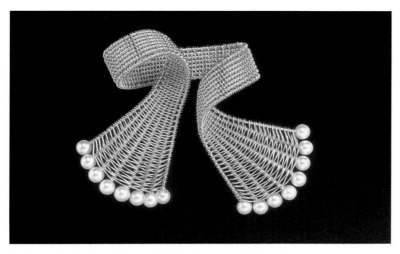

Barbara Berk. "Bow Brooch." Hand woven 22k and 18k gold wire using the soumak stitch. Akoya pearls. 2" high, 2.35" wide 0.75" deep. *Photo, Dana Davis*

▶ Eileen Gerstein. Necklace. The central piece is 24k gold kum boo overlay on fine silver with a sterling silver frame. 2" high, 1.48" wide, 0.48" deep. The 17" long fine silver neckband was hand woven. The central piece is 5.25" wide, 2" high, 0.25" deep. *Photo, Hap Sakwa*

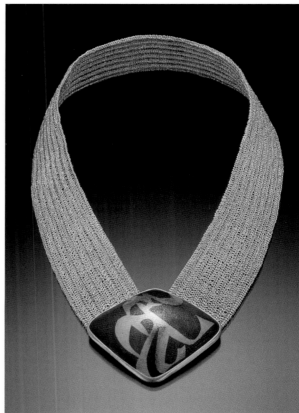

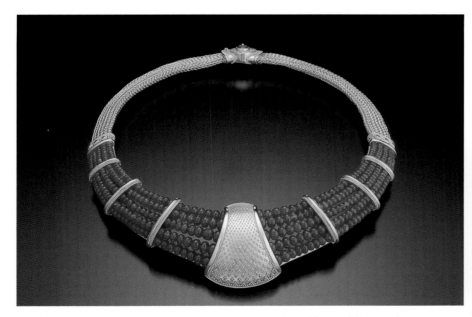

Kent Raible. Hand woven gold chain and beaded necklace with an 18k gold granulated ornament and matching clasp. *Photo, Hap Sakwa*

▶ Sandra Manin Frias. "Water From the Amazon." 22k and 18k gold, blue topaz and diamond. The gold pendant is woven. *Courtesy, artist*

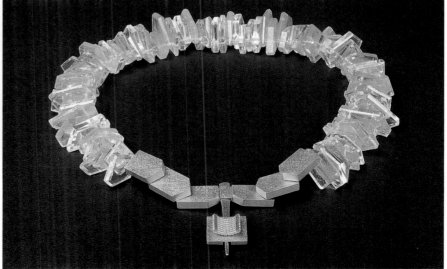

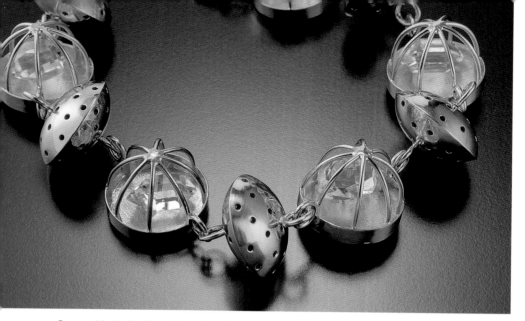

BRACELETS

Bracelets provide a different format and pose special problems to be addressed than those required for a brooch or neckwear. The examples shown illustrate cuff bracelets, slip over the hand styles, and clasps. Some are a solid ring, others have flexible parts cleverly joined.

Susan Gallagher's bracelet elements are held together with hand made loops. Patricia Madeja, Roy, and Aaron Macsai fashion individual hinges to make their bracelets flexible. Todd Reed's piece has a unique loop arrangement. Clasps for solid metal bracelets are often hand made, and may be camouflaged in the bracelet as in William Scott's *Container* bracelet. Kent Raible's chain bracelet is flexible but still requires a clasp that is hidden in a design element.

Susan M. Gallagher. Bracelet. Fabricated 14k gold with quartz crystals. Hollow shell construction, pierced and fabricated. 7" long. *Photo, Allen Bryan*

Jan Mandel. "Poignet Too." Cuff. 14k and 24k gold, sterling silver, seed pearls, fused clusters. Constructed. The cuff is a separate piece but it is also part of a transformation; the ornate separate fretwork is removable so it can be worn separately. It also connects to a larger cuff that can be worn higher on the arm. *Photo, Doug Yaple*

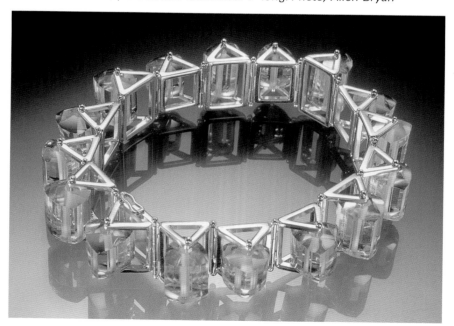

Patricia Madeja. Citrine bracelet. Fabricated gold hinged links with citrine beads that spin in each link. It has an 18k gold box clasp and a safety catch. *Photo, Ralph Gabriner*

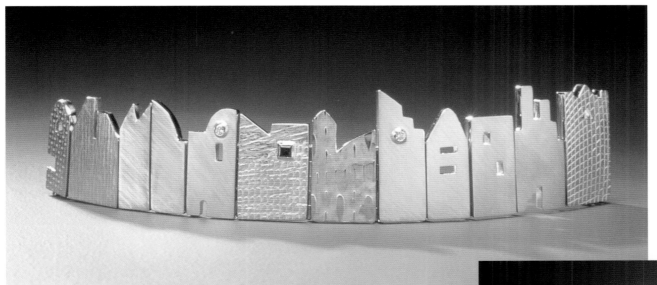

◄
Roy. "Byzantium." Bracelet. 18k white and yellow gold, diamonds, and a square sapphire. 1.3" high, 7.5" long, 0.2" deep. Architectural inspiration, use of smooth and rough textures, hinging, and piercing. *Photo, Dean Powell*

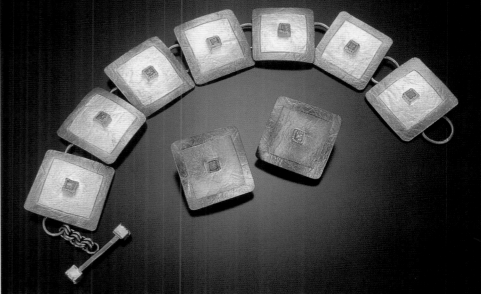

Aaron Macsai. "Panels of Movement." 18k gold. Silver and copper patterns created by the artist. 7" long, 0.07" high. *Photo, artist*

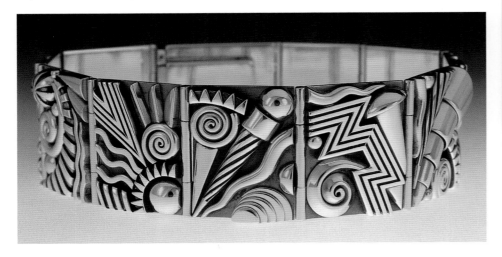

Todd Reed. Bracelet and earrings. Forged and fabricated. Fused gold on silver with uncut diamond cubes. *Photo, Azad*

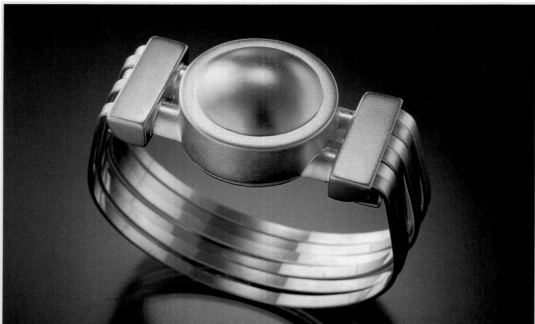

William Scholl. Container bracelet, 14k gold and silver bands. The container opens by lifting one of the rectangular bars so something can be placed inside. *Photo, Ralph Gabriner*

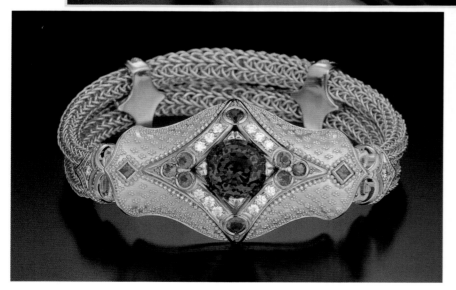

Kent Raible. Bracelet with 18k gold tapered hand woven double strand chains. Tanzanite, tourmaline, pink sapphire, diamonds, and platinum. Gold granulation on the large gold plate. Pressure on the pink sapphire stone opens the hidden clasp. *Photo, Hap Sakwa*

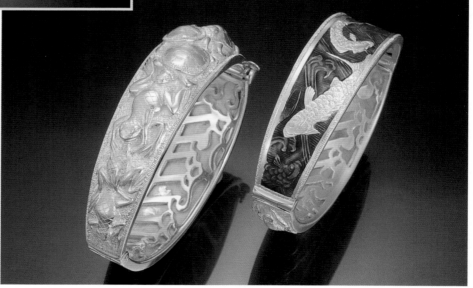

Jaclyn Davidson. "Pond Bracelet." Lost wax cast in 18k gold. Each of the bracelets is intricately carved to tell a story. The figures are symbolic of Japanese family life. The pond in ancient Asian sculptures embodies family relations. *Photo, Ralph Gabriner*

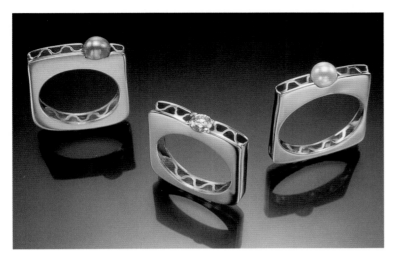

Christopher A. Hentz. "Cardboard" rings, so called because they resemble the corrugations in cardboard. The 14k gold is corrugated, fabricated with pink pearls, and diamonds are added. *Photo, Ralph Gabriner*

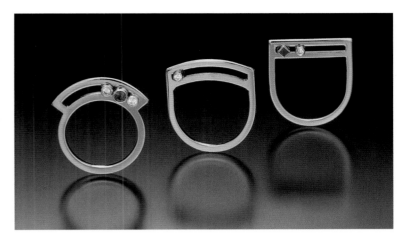

Jennifer A. Dawes. Kinetic rings. The gold rings have gold ball bearings and stones set on round balls that move back and forth as they are worn. *Photo, Hap Sakwa*

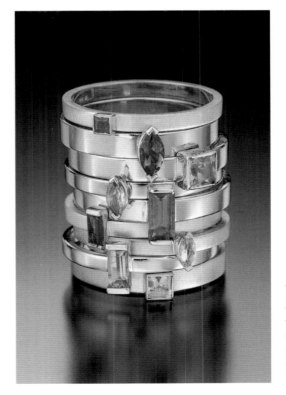

Jennifer A. Dawes. Assorted rings in yellow and white gold with stones in shapes designed to lock into one another and in different widths for variety. They are squares, marquisette, and baguette shaped in varied bandwidths. *Photo, Hap Sakwa*

RINGS

Probably no other piece of jewelry is as universal as the gold wedding band. Men and women wear bands; some people never remove them. Over the years, one can see the edge of the gold worn away if it is a soft gold. The plain wedding band, or one with minimal engraving, remains popular. Fortunately, other rings for hand adornment are as fanciful and varied as the artist can create, and the wearer can envision as a statement.

The rings shown are only a minuscule representation of those submitted for these pages. An entire book could be prepared on rings alone. The examples graduate from very simple to ornate, and represent exciting ideas. Christopher Hentz's square rings get their sandwiched texture concept from corrugated cardboard. Jennifer Dawes shows rings that are kinetic; some element is designed to move as the wearer's hand moves. Hubert Bliard shows variations on a theme. Each ring is similar but with varying surface textures created by using different hammers and other tools.

Hubert Bliard. Three yellow 18k gold rings, each is similar but has a different top casting and hammer finish. It shows the versatility of the metal in the hands of a master craftsman. The texture of the one on the right resembles reticulation but it's all done with a hammer. *Photos Stéphane Bocqué*

Hubert Bliard. Ring. 18k yellow gold. Gold sheet is layered, wrapped with gold details, and textured, for a simple, and elegant statement. *Photo, Stéphane Bocqué*

Jacob Snow. Hand forged ring. Pierced and carved 18k gold band with pavé diamonds. *Photo, Ralph Gabriner*

◄

Andy Cooperman. "Spiral Krater Ring." The wide circle is oxidized 14k white gold. The spiral and ring band are 18k yellow gold. A yellow diamond completes the ring inspired by a type of Greek vase. *Photo, artist*

George "Shukata" Willis. "Fancy Dancer." Ring in 18k yellow gold. An animated fancy dancer moves around a pipestone campfire portrayed by a red Mexican opal in the center. Cast and constructed. *Courtesy, artist*

Zaffiro. Jack and Elizabeth Gualtieri. "Classic Ring." Spessartite garnet in granulated 22k yellow gold with an 18k yellow gold band. *Photo, Daniel Van Rossen*

William Scholl. Ring. 18k gold fabricated with 4 rubies surrounding the triangular opal. Another ruby is set in the round shape on the bottom so it shows when the hand is opened. The Works Gallery. *Photo, Ralph Gabriner.*

Christopher A. Hentz. Ring with triangular garnet and micro-chasing on a pure palladium band. 14k gold and a garnet. *Photo, Ralph Gabriner*

William Scholl. Green Brazilian arch cut tourmaline. Triangular diamond on bottom. 18k gold. Fabricated. The Works Gallery. *Photo, Ralph Gabriner*

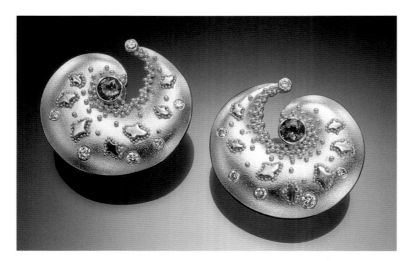

Corneila Goldsmith. "Large Wave." Earrings. 18k white and yellow gold with 22k yellow granulation, and diamonds. Fabricated and die formed. 0.9" high, 0.99 " wide. *Photo, Ralph Gabriner*

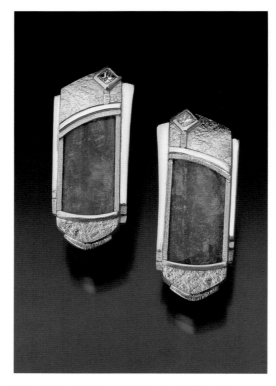

Patty Bolz. Earrings. Fabricated 22k gold with Boulder opals and diamonds. Each is 1" high, 0.5" wide. *Photo, Robert Diamonte*

EARRINGS and OTHER THINGS

Jewelry from the neck up usually means earrings, but there are tiaras, hair catches, and other hair adornments. Shown here are earrings, a crown, and Jan Mandel's hair catch that converts to an evening bag, thanks to clever designing and hinging.

Until recently, people wore earrings that matched, or that mirrored the design from one earring in the other. Then ethnic jewelry appeared, original and flamboyant. Artists realized that earrings do not have to be exact replicas of each other.

Variations led to more interesting pieces to make and to wear. Observe these subtle differences in the earrings by Dellana, Tami Dean, and Janis Kerman. It's not unusual for someone to wear only one stunning long earring and to wear only a stud or nothing in the other ear. It's a perfect style when one loses an earring or wants to share a pair. No apologies necessary.

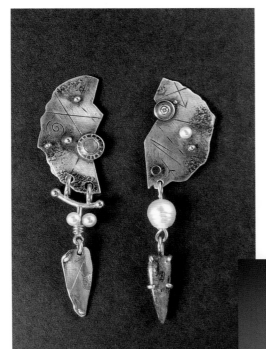

◄ Dellana. "Fragments #2." 14k gold, sterling silver, pearls, diamond, opal, and a Boulder opal. Fabricated, engraved and fused. Observe that while the shapes of each earring are the same, they are also dissimilar in their design and placement of stones. *Courtesy, artist*

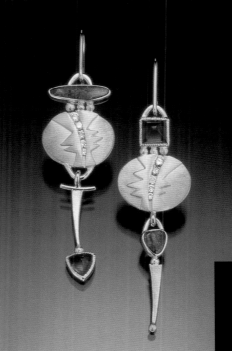

◄ Tami Dean. Fabricated earrings of 14k Palladium White gold, 18k yellow gold, diamonds, Boulder opal, and amethyst. Similar exterior shapes with design variations on the interiors. *Photo, Hap Sakwa*

► Janice Kerman. Asymmetrical earrings in 18k gold, opal on ironstone, rose cut diamonds and natural pearls. *Photo, Larry Turner*

► Christopher A. Hentz. "Arrow and Cones." Earrings, 14k gold, with pearls. Fabricated. *Photo, Ralph Gabriner*

Reiko Ishiyama. Earrings. 18k gold, with sterling silver and Bi-Metal that is pierced, oxidized, hammer textured, and riveted. She manipulates thin sheets of metal, both silver and gold, until they become springy. This opens up unexpected layers of space around the wearer and the earrings. *Photo, Ralph Gabriner*

Reiko Ishiyama. *Photo, Ralph Gabriner*

◄ Michael Good. Single loop earrings using the anticlastic bending technique. 18k gold with matte finish. *Courtesy, artist*

► Reiko Ishiyama. Earrings. *Photo, Ralph Gabriner*

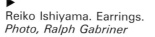

Patrick Marchal. "The Golden Boy $ King." Crown. Fine gold bullion from credit Suisse with sterling silver, and brass. *Photo, J.P. Pfister*

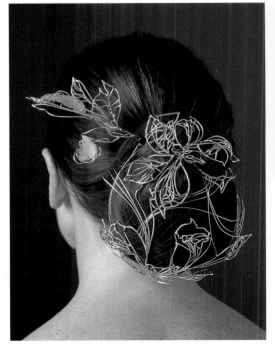

Jan Mandel. "Autumnessence Transformation." Hair catch and evening bag. 18k yellow and red gold, and druse. Art to Wear Gallery. *Photo, FXP London*

Jan Mandel. Hair adornment converted to an evening bag. The artist believes that adornment should complement the body and allow for interaction through transformation. By providing possibilities for different variations the wearer can transform each object, creating new designs to suit her need or mood of the moment. Art to Wear Gallery. *Photo, FXP, London*

Susan Brooks. Brooch. Sterling silver, engraved, chased, and patinated. Brooks is interested in texture, pattern, and the repetition of patterns and images. 3.5" high, 3.25" wide. *Photo, Kate Cameron*

Chapter 4
MOSTLY SILVER

If gold is the king of metals, silver is considered the queen, and second in the nobility scale. It has been so since ancient times when people of all cultures wore jewelry and created many objects of silver. It was evident in European countries, throughout Asia and Africa, and among ethnic societies.

Jewelry was worn for personal adornment, as badges of official or social status, and as emblems of religious, social, or political affiliations. Not much has changed. Even the techniques remain essentially the same, though modern technology has developed more efficient tools than the ancient jewelers had. Artifacts found in burial sites show that the Egyptian artisans skillfully produced chased, engraved, soldered, repoussé, and inlaid jewelry. In cultures where burial sites have not revealed well-preserved objects to study, information comes from portraits in surviving paintings and sculpture.

Jewelry has been worn on the head in the form of crowns, diadems, tiaras, aigrettes, hairpins, hat ornaments, earrings, nose rings, earplugs, and lip rings. The neck sports collars, necklaces, and pendants. Pectorals, brooches, clasps, and buttons adorn the chest. The limbs too, are sites for rings, bracelets, armlets, and anklets. At the waist, there are belts and girdles, with pendants such as chatelaines, scent cases, and rosaries.

What makes silver such an attractive material for jewelry? Silver reflects 95 percent of the light that strikes it, making it the most lustrous of the metals. It takes a high shine or it can be buffed to a soft matte finish. It can be colored by a variety of materials and patinas. It is second only to gold in ductility so it can be drawn out into fine wires. It is highly malleable and easy to hammer into various shapes. It is less costly than gold.

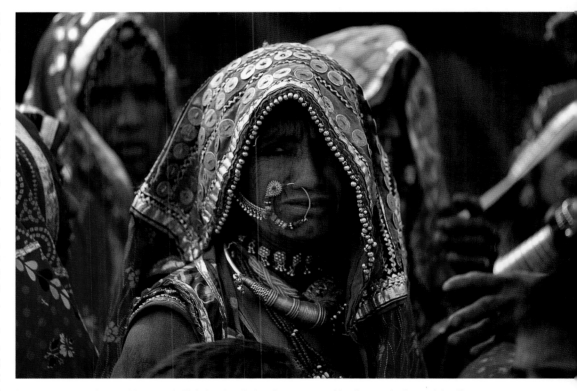

Women attending a Livestock Fair in the Rajasthan area of India are laden with silver jewelry. Silver beads edge their headwear. Because silver is a sign of wealth in India, one assumes the more silver worn, the wealthier the person. *Photo, Bushnell-Soifer*

◄ Susan Brooks. Brooch. Sterling silver, engraved, chased, and patinated. 4" high, 3" wide. *Photo, Kate Cameron*

◄ Susan Brooks. Brooch. Sterling silver, engraved, chased, and patinated. 4.5" high, 1.5" wide. *Photo, Kate Cameron*

Silver, like gold, does not react chemically with most substances. However, the presence of sulfur compounds causes silver to develop a black or gray coating of silver sulfide, called tarnish. Because polluted air contains these compounds, silver tarnishing is a greater problem today than in the past.

The jeweler can buy sterling silver in sheet, wire, foil, and hollow tubing in round, square, rectangular, or triangular shapes. It is sold by the troy ounce, as is gold. Fine bezel wire can be purchased in different sizes so the jeweler doesn't have to cut and prepare the material. The findings, which are beads, pins, clasps, chains, and items needed to finalize a piece of jewelry, can be purchased ready to use from many suppliers to the industry.

Silver is a soft, white metal. In its pure form, it is called metallic, free, or native. Like gold, it is too soft to be used for most purposes. It is normally alloyed (mixed) with other metals, usually copper, to increase its hardness and strength. Sterling silver, for example, is an alloy of 92.5 percent silver and 7.5 percent copper. Silver plate is an object made of a base metal, such as steel, that is coated with a thin layer of silver or silver alloy.

Silver occurs in deposits of native metal and as silver ores. Native silver mines provide only a small amount of the world's silver. The most common silver ores contain the mineral argentite or the compound silver

sulfide. Silver often occurs along with such metals as copper, gold, lead, and zinc. Miners obtain about 80 percent of the world's silver as a by-product of mining and processing these metals. During the refining process, silver is separated from the copper or other metals to form a mixture called sludge. The sludge is removed and treated with nitric acid to dissolve the silver. The silver is then recovered by electroplating.

In the examples that follow, note the shapes into which the silver elements are manipulated, and how its malleability gives it high versatility. Techniques shown in Chapter 2 can be identified.

The techniques Susan Brooks uses in her stunning brooches are the same as those used by generations before her. But the chasing tools, in each person's hands, produce different effects. The ideas that produce the shapes and their interaction, the highs and lows, and the coloring, validate the uniqueness of each individual artist.

Says Brooks, "I am interested in texture and pattern, and in the repetitions of patterns and images. I have always been intrigued by the body and face, and in seeing other ways of using these images."

To Brooks, the figure and face are a language of structure. Faces within faces, thoughts within thoughts, pattern upon pattern, building texture to form shadows and light, and finally a story is generated. Sometimes an extra eye represents a different way to focus on a situation.

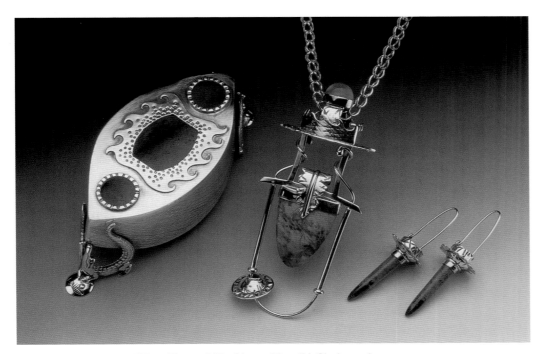

Caryn L. Hetherston. "Blue Planet." Necklace. (Detail.) Chain and earrings. Sterling silver, 22k and 14k gold, parrot wing stones, moonstone, and handmade fine silver chain. *Peter Groesbeck*

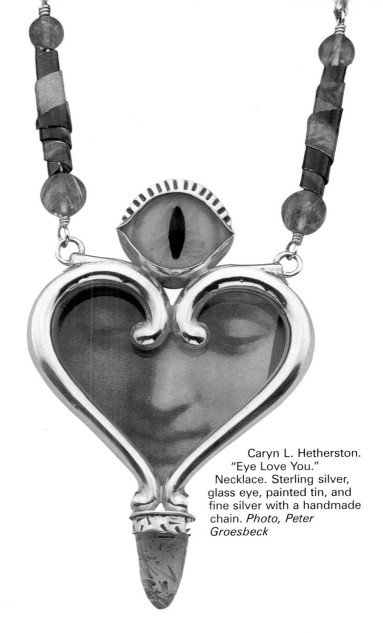

Caryn L. Hetherston. "Eye Love You." Necklace. Sterling silver, glass eye, painted tin, and fine silver with a handmade chain. *Photo, Peter Groesbeck*

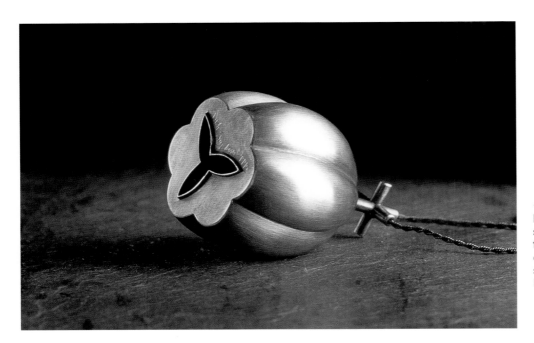

◄
Didi Suydam. "Seed." Pendant. Sterling silver oxidized. Influences are organic forms of nature and architecture. Pieces often have cutout areas to create a sense of space. 2.25" high, 1.25" diameter. Suydam & Diepenbrock Gallery. *Photo, Roger Brin*

99

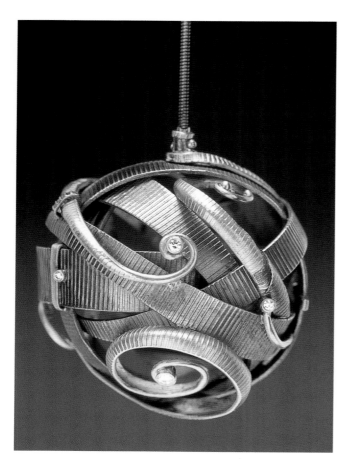

Geoffrey Giles. "Connective Perpendicularity."
Necklace. Sterling silver and 14k yellow gold.
His objective is to explore the use of rivets and
movement in relation to the rhythm of the
human form. 20" long. *Photo, Taylor Dabney*

▶

Linda Kaye-Moses. "One Ounce of Silver."
Neckpiece. Sterling and fine silver, jasper,
beetle elytra, shell, 19th Century Siamese
token, and bone. Among the fabrication
processes are roll printing, soldering, stone
setting, cold connections, and Precious Metal
Clay. 6.5" high, 6.5" wide, 2" deep. *Photo, Evan
J. Soldinger*

Andy Cooperman. "Medusa Ball." Neckpiece. (Detail.)
Sterling silver, 18k and 14k gold, guitar string, and
diamonds. 2.25" diameter. *Photo, Doug Yaple*

Many artists explore the ability to create different surface textures. Says
Geoffrey Giles, "Surface plays a significant role in my work. I believe that
developing several different surfaces within one piece of jewelry produces
tension through texture, creating an intimacy between the piece of jewelry
and those who view it." His pieces shown here also explore the riveted
form and the sense of volume created.

Andy Cooperman's pieces also rely heavily on texture, and on contrasts
between smooth gold and, in this case, corrugated silver. Cooperman likes
to layer materials, then peel them back or cut down through them with a
torch to see the potential of texture and design beneath.

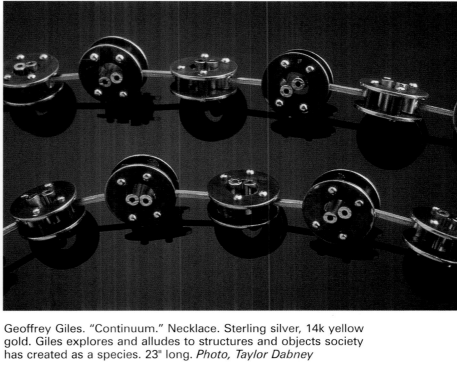

Geoffrey Giles. "Continuum." Necklace. Sterling silver, 14k yellow gold. Giles explores and alludes to structures and objects society has created as a species. 23" long. *Photo, Taylor Dabney*

Linda Kaye-Moses. "Once was Lost." Pendant and neckpiece. Sterling and fine silver, 14k gold, found object, beetle elytra, and quartz. There is a nesting case for this piece (See chapter 4-page???). *Photo, Evan J. Soldinger*

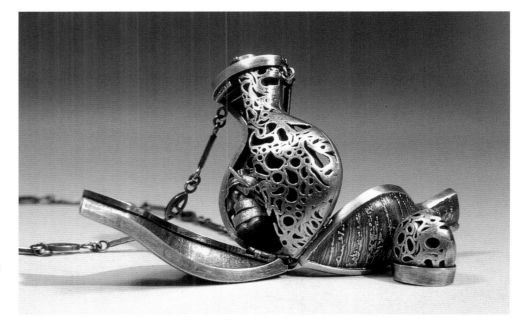

▶
Sun Hong. "Sacred to the Memory of *Ran.* "Pendant. Sterling silver, and 14k gold. A container form that requires the viewer to open it and establish an intimate relationship with the piece. 2.25" high, 1.75" wide, 0.75" deep. *Photo, artist*

Talya Baharal. "Onionskin." Neckpiece. Pendant of fabricated sterling silver and copper on stainless steel cables. *Photo, Gene Gnida*

Talya Baharal. Neckpiece constructed and fabricated in sterling silver with copper details. Stainless steel cable. *Photo, Gene Gnida*

Kimberly Navratil-Pope. Neckpiece. Hollow form sterling silver, titanium, plated crystal, and moonstone. 5" high. *Courtesy, artist*

Annie Hallam. "What If...?" (Detail.) Sterling silver and 18k gold. The neckpiece is about the act of worrying. It has an underlying skeleton to which the wearer can add worry "tags." Each tag has one worry written on it, some are more serious than others. As more tags are added, the neckpiece gets heavier, possibly choking the wearer, as would the worries. In this piece, there are 58 worry tags. *Courtesy, artist*

Jana Brevick. "Robot Girl." Neckpiece. Sterling silver cast and fabricated with articulated joints. 8" high, 2" wide, 0.75" deep. *Photo, Doug Yaple*

Keith A. Lewis. "Key." Pendant and chain. Sterling silver, patinated. Self-portrait. The piece is riddled with locks to comment on what is hidden. Studded with keyholes, the figure brandishes his own sexualized key to use on himself or to reciprocate with another. Susan Cummins Gallery *Photo, artist*

Arline M. Fisch. "Silver Anemone." Necklace. Fine silver wire using spool knitting
and spiral braiding. 19" diameter, 5" wide. Fabric techniques in metal have a basis
in historical jewelry among many cultures. Fisch has projected and developed the
techniques into new statements for contemporary jewelry. *Photo, William Gullette*

NECKWEAR

A brooch is a center of interest, a small item pinned on a blouse, dress, or jacket. A pendant hanging at the end of a chain is usually at the neck or chest position where the eye takes in the entire piece at once. That pendant's chain surrounds the neck and must be compatible with the pendant, or be decorative on its own. Think of neckwear as a single piece that might be considered a sculpture in the round. No one part of it is less important than the other because it is viewed coming and going. Variations in the pieces shown, (some may be considered body wear as well as neckwear), capture this sculptural concept in an astounding diversity of brilliant concepts and executions. They must perform on their own as sculpture. They must be integrated as an adornment for the body that, in turn, becomes the whole sculptural entity.

In several of the following examples, nature dominates the subject matter. For some, nature alone is the inspirational reason for a piece's existence. For others, the nature element might have a personal and specific meaning as well. Nancy Mēgan Corwin's neckwear is an ambitious replica of floral elements that become the chain as well as the frontal decoration. Dallae Kang's *Cycle of Life*, also has elements all around the neck and is both decorative and philosophical.

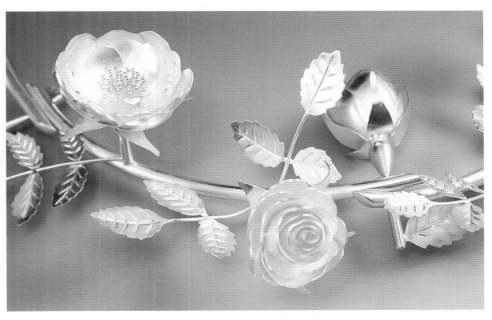

Dallae Kang. "The Cycle of Life." Necklace. (Detail.) Silver and gold. 1.5" high, 11" long, 11" deep. *Photo, Helen Shirk*

Nancy Mēgan Corwin. "The Garden." Neckpiece. Sterling silver, 22k gold on silver, stones, and pearl. Facérè Jewelry Art Gallery. *Photo, Doug Yaple*

▶ Dallae Kang. "The Cycle of Life." Necklace. Silver and gold. 1.5" high, 11" long, 11" deep. *Photo, Helen Shirk*

Anya Kristen Beeler. "Secret Garden." Necklace. Fine silver and steel. Leaves
surround the neck and lay flat like a collar. 18" long. 3" high. *Photo, Balfor Walker*

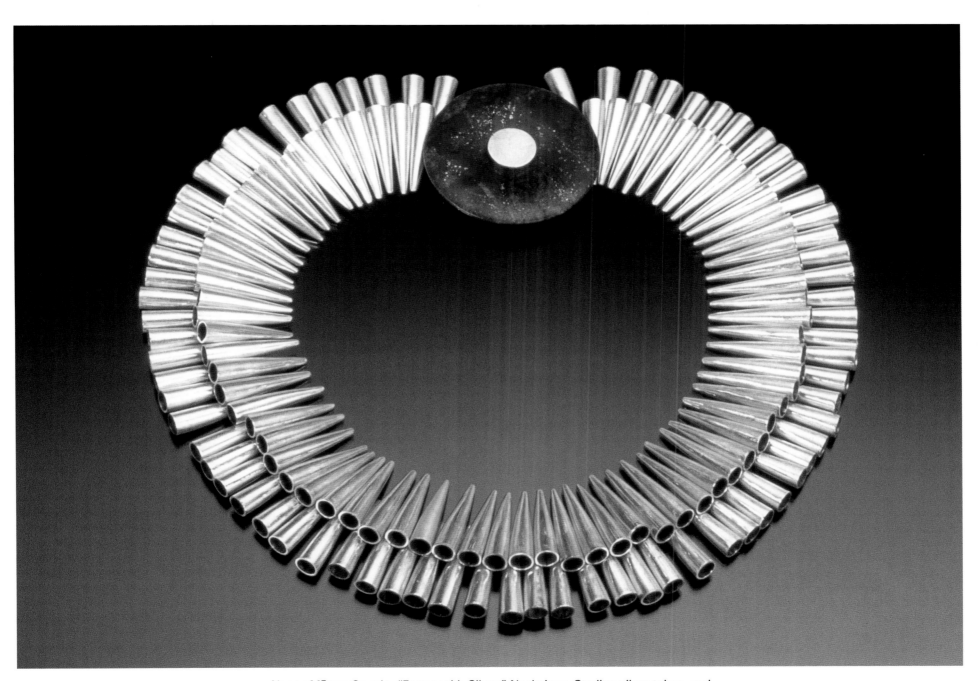

Nancy Mēgan Corwin. "Forms with Silver." Neckpiece. Sterling silver tubes, and a lapis lazuli disk. 10" diameter. Facérè Jewelry Art Gallery. *Photo Doug Yaple*

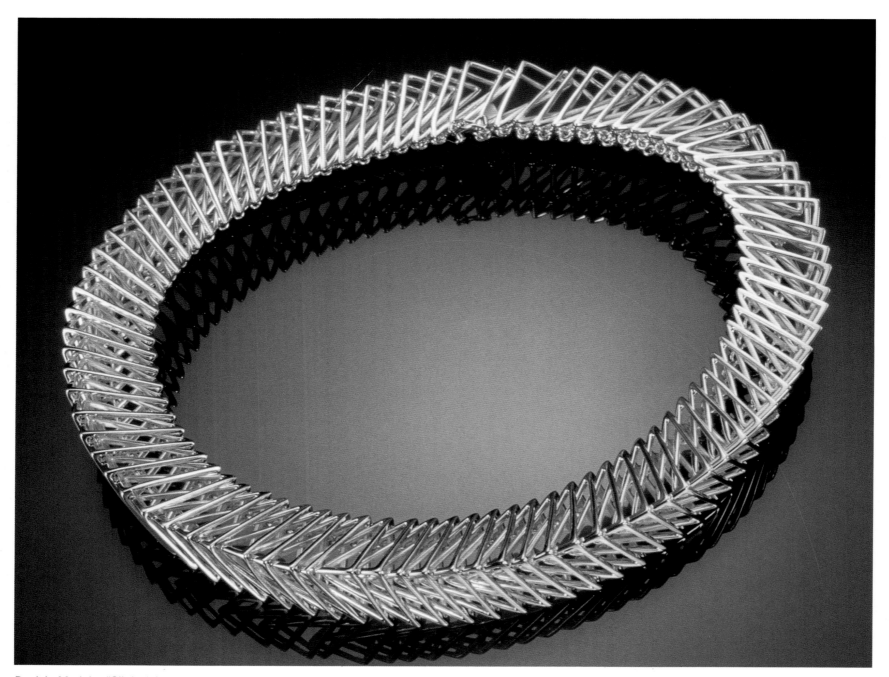

Patricia Madeja. "Slinky." Necklace. Cast sterling silver links have an intricate linking system on the back that creates a slinky toy-like flexibility. The catch has a 14k white gold additional safety clasp. *Photo, Ralph Gabriner*

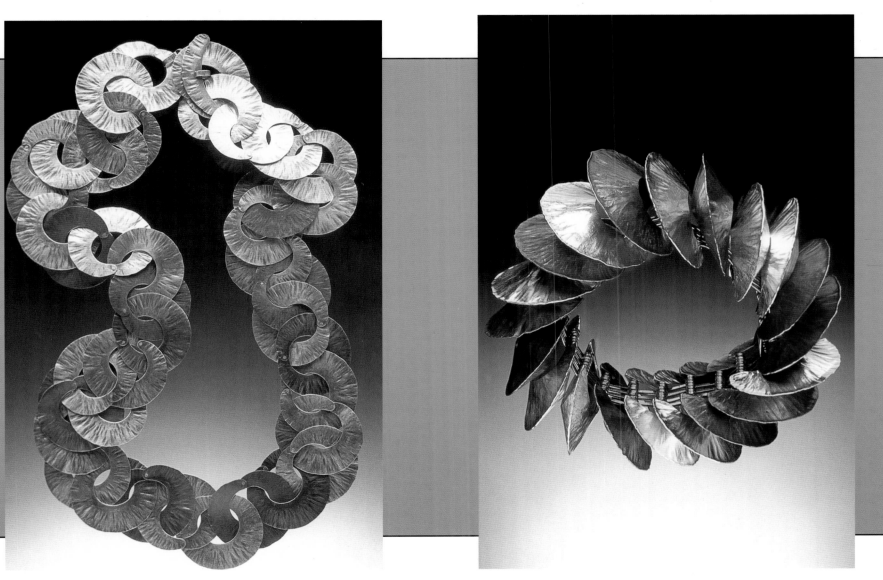

Kristine J. Bolhuis. "Numisma. Numismatica Series " Necklace. Sterling silver, copper, and brass. (Forged). 23" long, 2" wide. 0.5" deep. The artist calls these site-specific sculptures because they are sculptural forms made to be worn on the body. *Photo, Mark Johnston*

Kristine J. Bolhuis. "Cyclopedia Numismatic. Numismatica Series." Bracelet. Fold formed sterling silver, bronze, and brass. 7" long, 1.5" diameter.

► Jenn Parnell.
"Ostentation
Simplicity."
Neckpiece. (Detail.)
Sterling silver and
blue topaz. 12"
long. *Photo, Mark
Johnston*

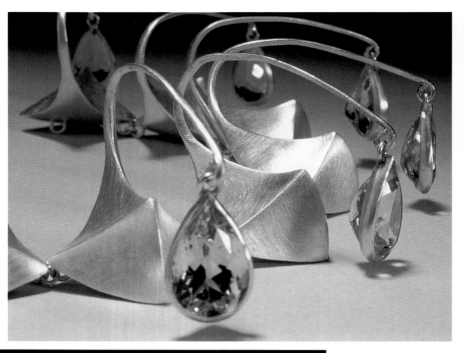

Dina Varano. "Cascade." Neckpiece. (Detail.) Oxidized handmade chain mail with sterling silver sheet hammered and formed into leaves. The leaves shimmer, drape, and move with the wearer. Martina & Co. *Photo, Ralph Gabriner*

Jenn Parnell. Ostentation Simplicity." Choker neckpiece. Sterling silver and blue topaz. The pieces were cast in sheet wax so the silver form would be hollow and lightweight. The topazes hang straight out from the body in the style of a jester's collar that inspired it. They are connected by jump rings so are free to swing around like the jester's bells. It's the repetitions and scale that make it "ostentatious." 12" long. *Photo, Mark Johnston*

Jenn Parnell's, *Ostentation Simplicity*, is worn as a choker but it projects straight out from the body in the style of a jester's collar, her inspiration for the piece. The topazes are connected by jump rings so they are fee to swing around like the bells on the jester's garment. Parts were created using hollow core lost wax casting so they would not be heavy. The bezels are very narrow rims around the stones to allow maximum light through the stones. Parnell's piece required a great deal of thought, sketching, and technical work before it came to fruition as part or her senior degree project for a B.F.A. in jewelry design.

Micki Lippi creates tree branches in silver, and Yugo Yagisawa's silver *Flower Sweetness* fits exactly the way real leaves might wrap around the neck wire.

◄
Micki Lippe. "The Seasons go Round and Round." Choker. Sterling silver "tree branches" with gold, and recycled glass wheels. The "wheels" move for both a kinetic effect and to fulfill the idea in the title. In addition, because the glass used in the beads is recycled, it contributes another "round and round" concept. 12" outer diameter. *Photo, Richard Nicol*

▶
Yugo Yagisawa. "Flower Sweetness." Neckpiece. Sterling silver and stone. 10" long, 8" wide, 1" deep. *Photo, artist*

▲
Christopher A. Hentz. "Feathers." Collar. A feather-like texture has been achieved using micro chasing on sterling silver. Fresh water pearls and an amethyst. Hollow construction. 8" diameter. *Photo, Ralph Gabriner*

▶
Veleta Vancza. Necklace/neckbrace. Sterling silver and pearls. Back view. The piece is hinged and intended to constrain movement. It forces the wearer to keep her head up and look straight ahead. The artist explains, "This piece was created to challenge society's ideals of 'femininity', which I feel are constraining." 4.5" high, 7" diameter. *Photo, Bob Barrett*

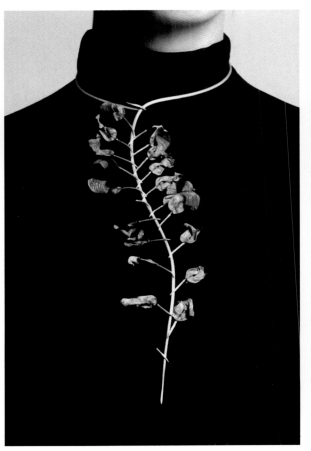

Lonna Keller. "Silver Massage."
Neckpiece. Sterling silver tubes
and black onyx. Front. 36" long,
16" wide. *Photo, Michael Kreiser*

Lonna Keller. "Silver Massage."
Neckpiece. Sterling silver tubes
and black onyx. Back. *Photo,
Michael Kreiser* ▼

Nancy Lee Worden. "Generations." Necklace.
Silver, 14k gold, and glass. 32" long, 1.5" wide.
Helen Drutt Gallery. *Photo, Rex Rystedt*

▶
Caroline A. Adams. "Flow." Neckpiece.
Sterling silver, 14k gold, and seedlings.
10" long, 6" wide. *Photo, Jeff Powers*

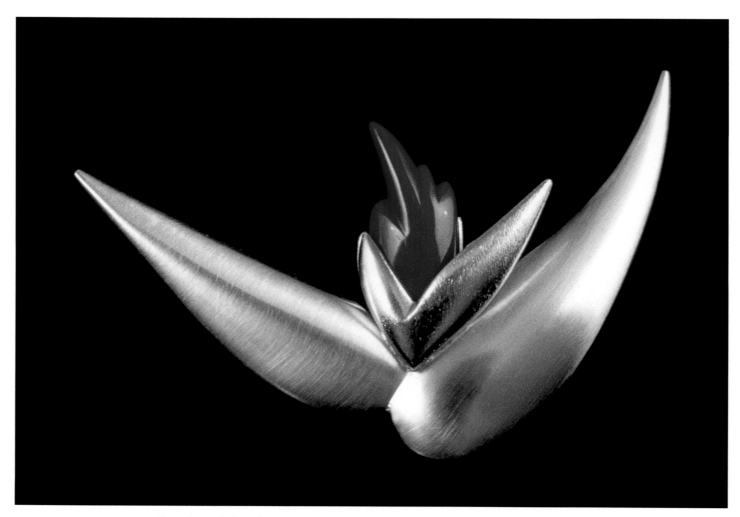

Sue Amendolara. "Protected Blossom II." Brooch. Sterling silver, coral, and 18k gold, cast and carved. The way leaves often protect flowers and buds was the visual inspiration. 1.75" high, 3.25" wide, 2.5" deep. *Photo, artist*

Sue Amendolara. "Heliconia." Brooch. Sterling silver and 18k gold. Cast and fabricated. The form of the heliconia flower is bold, yet elegant and gestural. It is an exotic Hawaiian flower that resembles a bird of paradise. 4" high, 2" wide, 0.25" deep. *Photo, artist*

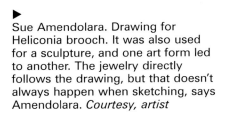

► Sue Amendolara. Drawing for Heliconia brooch. It was also used for a sculpture, and one art form led to another. The jewelry directly follows the drawing, but that doesn't always happen when sketching, says Amendolara. *Courtesy, artist*

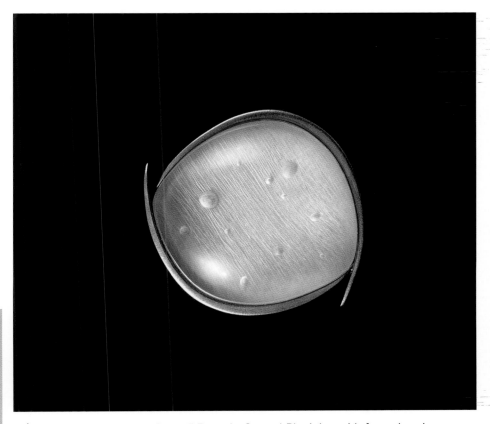

Sue Amendolara. "Black Snow." Brooch. Carved Plexiglas with forged and fabricated sterling silver, colored with liver of sulfur. The Plexiglas represents water surrounding lily pads. 2.5" high, 2" wide, 0.5" deep. *Photo, artist*

Sue Amendolara is inspired by nature and the idea of abstracting it for jewelry. She focuses on the visual combinations of various plants, their strength, and the support structure they provide each other. Amendolara's background of working silver into hollowware and functional objects, is carried into the smooth, curving, graceful, and clean pointed sheet metal forms that she enhances with touches of color.

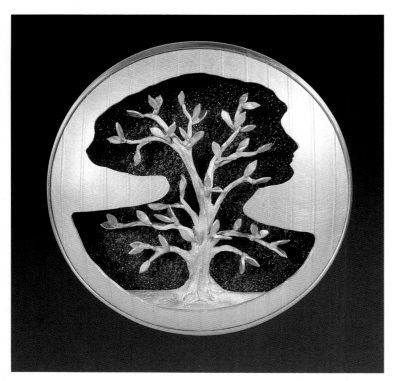

◄ Heather White. "Protean Cameo #9." Brooch. 22k and 18k gold, and sterling silver. The tree is made using lost wax casting. The leaves are soldered on, the circle is die formed, and the sheet metal behind the tree is embossed to create the texture. 2.2" diameter, 0.5" deep. Mobilia Gallery. *Photo, Kyle Dick*

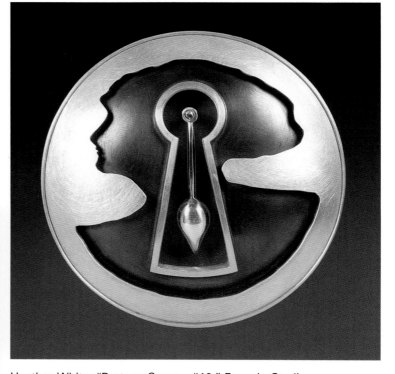

▶ Joanna Kao. "Culturally Challenged II." Brooch. Sterling silver, 22k and 14k gold. Fabricated. Her jewelry reflects emotional responses to events in her life. 2" diameter, 0.78 deep. *Photo, James Chan*

Heather White. "Protean Cameo #10." Brooch. Sterling silver, nickel silver, and velvet. The pendulum is from a lost wax casting, the circle is die formed. The pendulum swings from a rivet; other parts are soldered. A miniature skeleton key is soldered to the back. 2.2" diameter, 0.5" deep. Collection, Fred and Laura Bidwell. *Photo, Kyle Dick*

Jan Peters. Pin. Sterling silver, aluminum, and a pearl.
1" high, 4.5" wide, 0.75" deep. *Photo, Ralph Gabriner*

Roberta and David Williamson. "Nantucket." Sterling silver raised canoe with an
oar, and other boat details including a spilled can of liquid. *Photo, James Beards*

Aline Gittleman. "Stars and Stripes Forever."
Brooch. Sterling silver. Folding techniques. 1.5"
diameter. 0.38" deep. *Photo, Mark Johnston*

Sun Hong. "My Sister's Poem." Bracelet. Sterling silver, 23k and 14k yellow gold, ruby, and sapphire. Both sides are finished and shown here. The piece represents metaphors and objects that helped her deal with her sister's death. *Courtesy, artist*

Sun Hong. "Behind the Door." Bracelet. Sterling silver with 14k yellow gold. Intricately fabricated objects are based on imagery, dreams, and personal iconography. 8" long, 1.18" wide, 0.5" deep. *Courtesy, artist*

BRACELETS, RINGS, and OTHER FORMS

Bracelets and rings are obvious objects of adornment. The assortment of styles and ideas is infinite throughout history. Silver is prevalent because of its many favorable characteristics. It is shiny, durable, and is workable with many techniques. It costs less than gold, and usually doesn't cause allergic reactions. Sue Hong and Jim Kelso create silver bracelets with incredible intricacies using casting, raising, repoussé, chasing, hinging, fabrication, and whatever is required to bring out the image they want to express. Hong's bracelet is filled with complex metaphors. Kelso's piece focuses on a dolphin for its interest. Anika Smulovitz's bracelet is also a metaphor stated in its title.

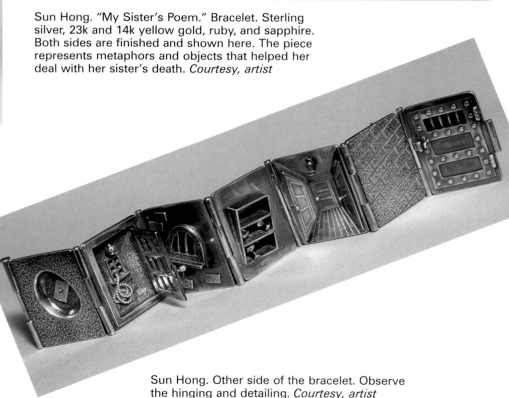

Sun Hong. Other side of the bracelet. Observe the hinging and detailing. *Courtesy, artist*

Jim Kelso. "Dolphin." Bracelet. Sterling silver, shibuichi, and 18k gold. *Photo, artist*

Anika Smulovitz. "On Loss and Longing III." Bracelet. Sterling silver. The artist examines keys, metaphorically and historically, and as objects. She observes them and considers the general use of keys to lock away something precious. 5.25" high, 2.75" wide, 0.25" deep. *Photo, Jim Wilderman*

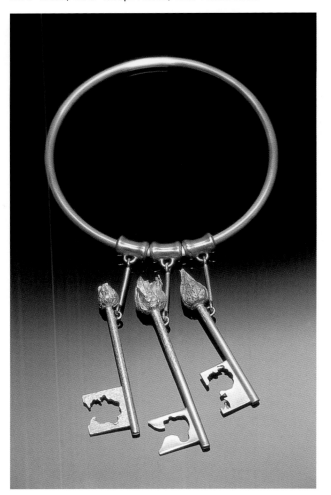

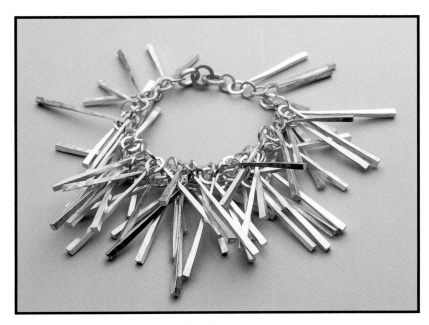

Tamar Kern. "Fringe Bracelet." Sterling silver. 9" long. *Photo, Mark Johnston*

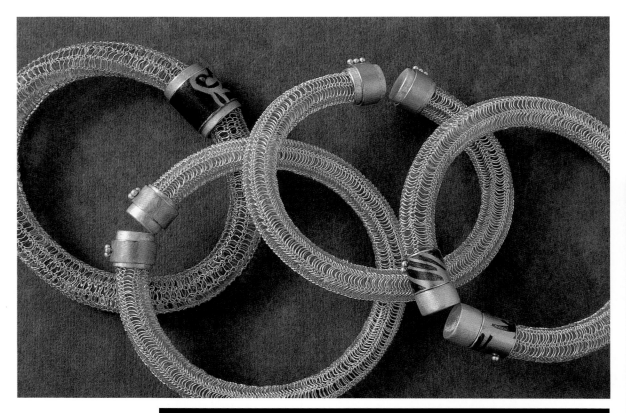

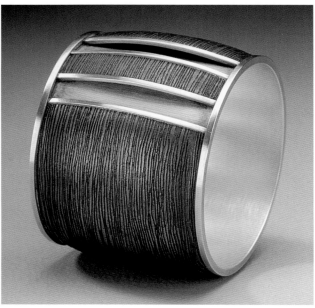

Eileen Gerstein. Bracelets. Fine silver and sterling silver. Fiber techniques over Plexiglas. Clasps are sterling silver and 24k kum boo overlay, and 22k Bi-Metal. *Photo, Hap Sakwa*

Kristine J. Bolhuis. "Kapa." Bracelet. Sterling silver and copper. Etching and fabrication. 3" high, 2.5" diameter. *Photo, Dean Powell*

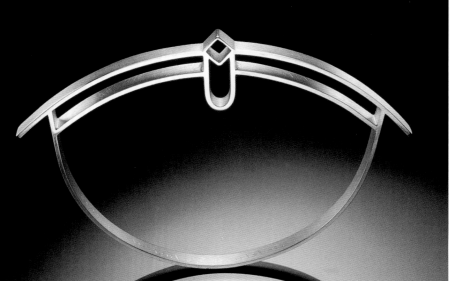

Jan Peters. Bracelet. Sterling silver. Constructed. 2.5" high, 3.5" wide, 0.25" deep. *Photo, Ralph Gabriner*

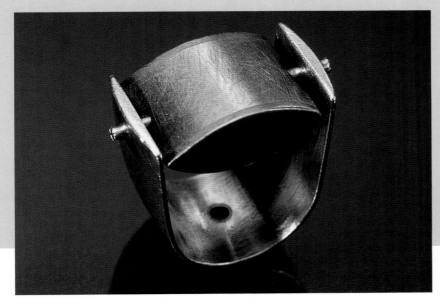

Talya Baharal. "Swivel Ring." Sterling silver with copper details. Constructed and fabricated. It is a contemporary version of a signet ring, *Photo, Gene Knida*

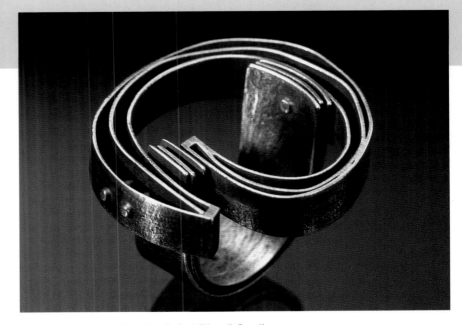

Talya Baharal. "Onionskin Spiral Ring." Sterling silver with copper details, fabricated. *Gene Knida*

Talya Baharal's aesthetic approach is simplicity. She tries to find beauty and aesthetic meaning in the unlikely, the unfamiliar, and that which is absent. Always present is the need for a bond with the wearer. She loves the sculptural scale of jewelry and the intimacy it engages.

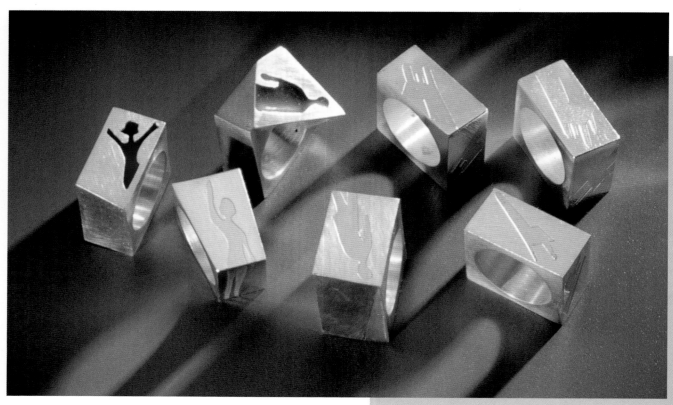

Saskia Bostelmann. "Shadow and Silhouettes." Rings. Sterling silver, constructed. *Photo, Enrique Bostelmann*

Susan Myer's rings are metaphors, too, but of happy occasions as opposed to the darker symbolism in Hong's and Smulovitz's pieces.

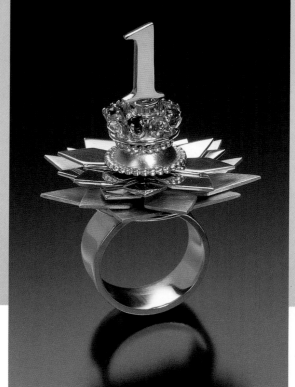

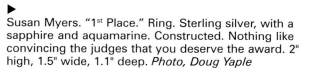

▶
Susan Myers. "1st Place." Ring. Sterling silver, with a sapphire and aquamarine. Constructed. Nothing like convincing the judges that you deserve the award. 2" high, 1.5" wide, 1.1" deep. *Photo, Doug Yaple*

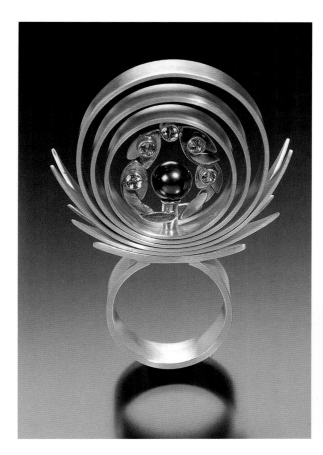

◀
Susan Myers. "Triumph." Ring. Sterling silver, 24k gold plate, tanzanite, and black pearl. Constructed. *Photo, Doug Yaple*

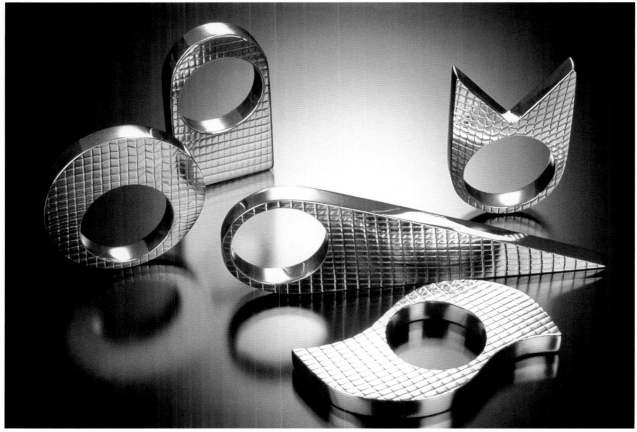

▶
Jennifer (Jeff) Bowie. Ring series. Sterling silver, fabricated. An architectural approach to making geometrically designed rings. *Courtesy, artist*

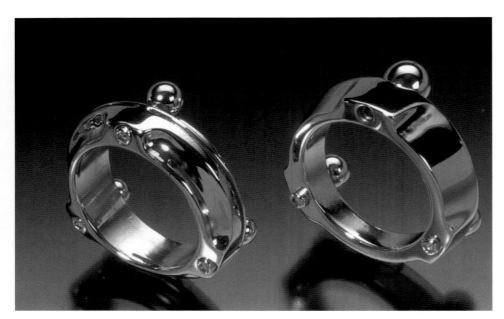

Speaking of happy, Phillip Carrizzi's milled rings (one was given to his bride), are dynamic in their geometric simplicity. Harley McDaniels' *Puzzle Rings* and glasses, and Heidi Nahser's watch fob with a spider, may bring smiles to one's face as they are studied.

Phillip Carrizzi. Rings. Stainless steel, turned and milled. Collection: Stacie Carr. *Photo, Doug Yaple*

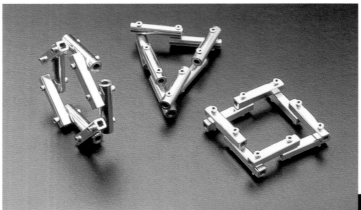

◄ Harley J. McDaniel. "Puzzle Rings." Sterling silver. *Photo, Keith Meiser*

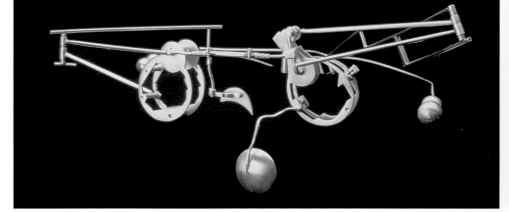

► Harley J. McDaniel. Glasses. Sterling silver. 2" high, 12" long. *Photo, Keith Meiser*

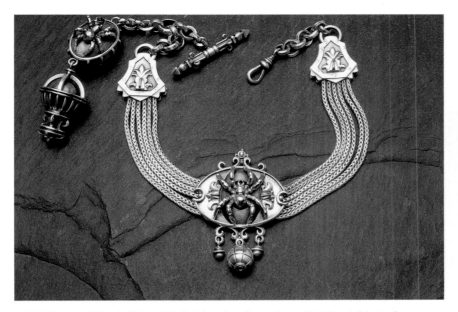

Heidi Nahser. Watch Fob with Spider. Sterling silver. Oxidized. Made for the main character in the movie, "Wild, Wild, West." The character's theme was a spider. The center piece is 2" high, 1.5" wide. *Photo, artist*

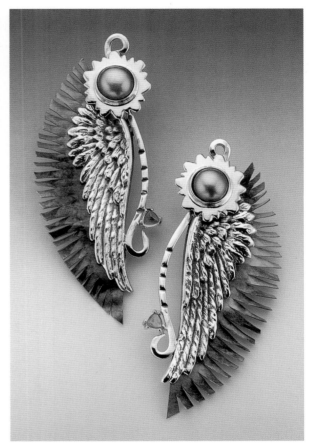

Caryn L. Hetherston. "Icarus." Earrings. Sterling silver, 14k gold, fresh water pearls, painted tin, and citrines. *Photo, Peter Groesbeck*

Jan Peters. Hair barrette. Sterling silver with a cultured pearl. 0.58" high, 4.5" wide, 0.58" deep. *Photo, Eric Long*

◄
Heide Kindelmann. "Ushebti" Talisman series. Porcelain-like casting finished with gold foil, hand painted, and glazed. *Photo, George Meister*

MIXED METALS AND OTHER MEDIA

With gold and silver the reigning king and queen of metals, because of their stable, non-corrosive, non-toxic, long lasting qualities, what chance do other metals have for use in jewelry? Plenty.

Many jewelers bypass these so-called noble metals altogether in favor of aluminum, brass, bronze, copper, nickel, platinum, and stainless steel. They may also combine other metals with gold and silver. Additionally, they may include plastic and Polymer Metal Clay (PMC). Given such a broad vocabulary of metals, the resulting language is a mélange of magnificent, expressive works of art stated in brooches, pendants, necklaces, collars, chokers, bracelets, earrings, rings, and bracelets.

Even jewelry that bypasses the precious metals can be precious by virtue of design, the work involved, and its perceived value to the wearer. It's not the preciousness of the gems or the metals, rather it's the ideas behind the pieces, how they are executed, and what they represent.

Heidi Kindelmann works with various metals to create her moveable sculptural figures, worn as jewelry. She may cast metals of porcelain, add gold and silver, and other metals, hand paint, glaze, and finish them with a special protective layer of resin.

▶
Groom's Headdress. Silver, gold, pearls, and plastic are the components for this heavily jeweled and colorful turban decoration worn by a groom at his wedding in Jaisalmer, India. *Photo, Bushnell-Soifer*

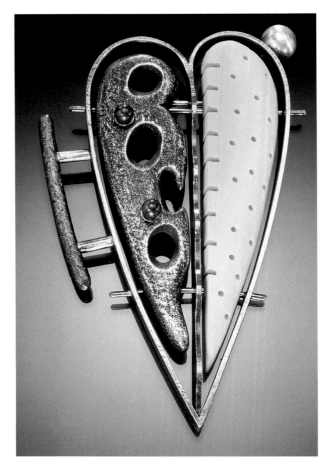

Thomas Robert Mann. Float Series. Pin. Silver, brass, bronze, aluminum, Micarta, and paint. 3" high 1.5" wide. *Photo, George Post*

Mann's jewelry pieces then were composed of materials acquired from surplus stores and supply houses, from electronic instruments, musical instruments, model trains, old costume jewelry parts, and other previously used metals. He was recycling before recycling became a household word. Eventually, he began combining metals, often using silver along with nontraditional and synthetic materials such as Micarta, and plastics.

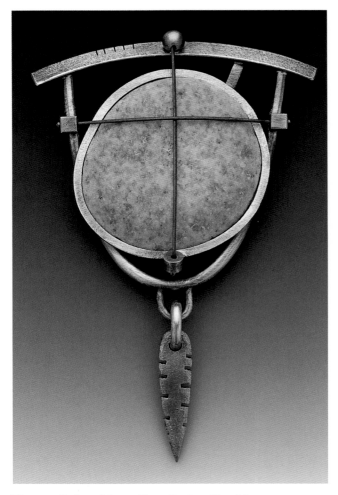

Thomas Robert Mann. Float Series. Pin. Silver, brass, bronze, aluminum, Micarta, and paint. Elements of New Guinea mask forms are evident in this piece. 3" high. 2.5" wide. *Photo, George Post*

Any and all metals are fair game for Thomas Robert Mann who has dubbed his approach to jewelry, "Techno-Romantic," a term he has copyrighted. Mann has been making jewelry since the early 1970s, when the concept that jewelry is art, sculpture, and a vehicle for self-expression began seeping into the culture. Inspired by the popular artists who were then creating collages, Joseph Cornell, Max Ernst, Man Ray, Marcel Duchamp, Pablo Picasso, and Georges Braque, Mann's jewelry became collaged pieces of wearable art. At the same time, metal sculpture was evolving as a modern medium, thanks to welding, forging, and the use of diverse metals for sculpture. These artists and events combined to focus Mann on the type of jewelry he wanted to design.

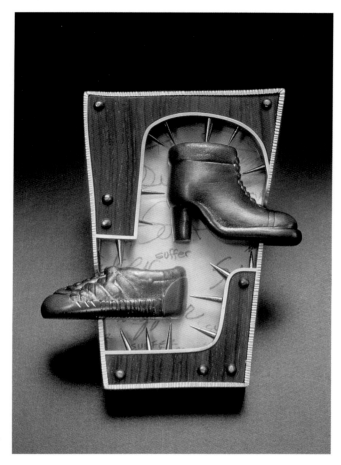

If Kristin Mitsu Shiga's pendant, *Unbearable*, were blown up six to ten times its size, it could be an attention-riveting, three-dimensional wall piece that combines sterling silver, copper, acrylic, and wood.

Christina Lemon's brooch, part of a series of seven such pieces, is inspired by her interest in African masks that she has researched and collected over the years. She uses a selenium toner patina that produces a blue-gray coloration on the surface of the sterling silver.

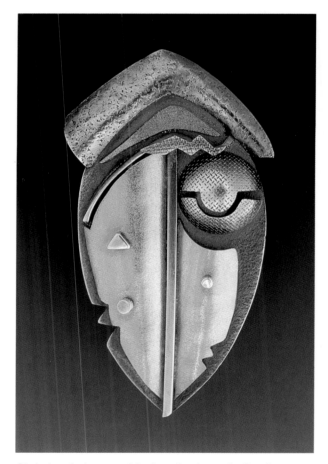

Kristin Mitsu Shiga. "Unbearable." Sterling silver, copper, acrylic, wood. 2.75" high, 2.25" wide, 0.5" deep. *Photo, Courtney Frisse*

Today, using, and reusing objects developed for other purposes is as usual for many jewelers as tying one's shoes. The test is how well such pieces are used and integrated into a new statement.

These mostly metal pieces may include other media and techniques. Purism is not a factor. The other criterion is what works? What makes the statements valid and results in a pleasing work of art?

Christina A. Lemon. Mask series brooch. Sterling silver and 18k Bi-Metal are riveted onto a fabricated sterling silver backing. A blue-gray patina was achieved with a selenium toner. The brooch is a composite of many influential masks she has collected and researched. 2.5" high, 1.5" wide. *Photo, Michael Cunningham*

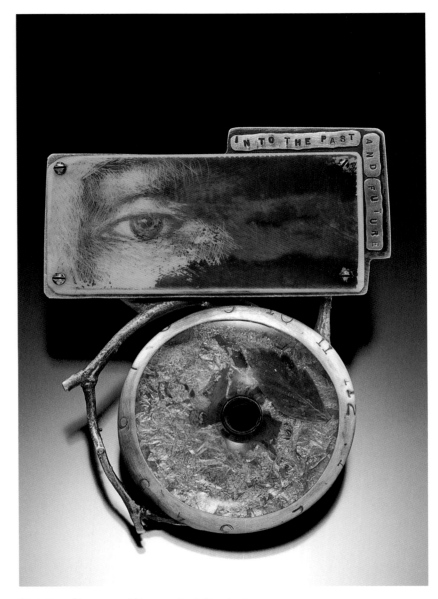

Christine Simpson. "Shemanite." Pendant and pin. Piano key with drawing, oil paint, ammonite fossil, 14k gold, and sterling silver. 3" high, 0.75" wide, 0.5" deep. *Courtesy, artist*

Christine Simpson uses photo images, gold, silver, ivory, ammonite shell, organic materials, and other objects in her pieces. She says, "I like to create a sense of mystery, something original and rare lingering within."

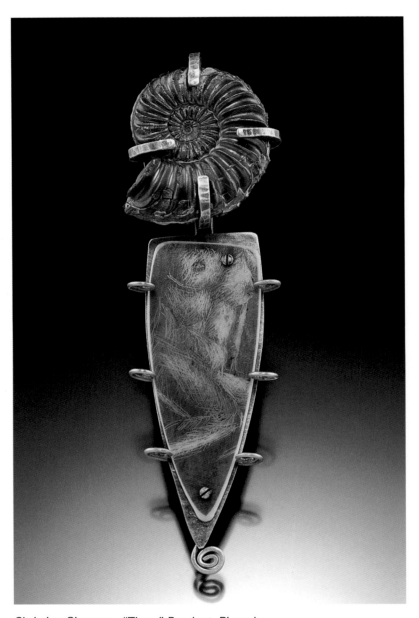

Christine Simpson. "Time." Pendant. Piano key with drawing, oil paint, quartz crystal, fern leaf, 23k gold leaf, and sterling silver. *Courtesy, artist*

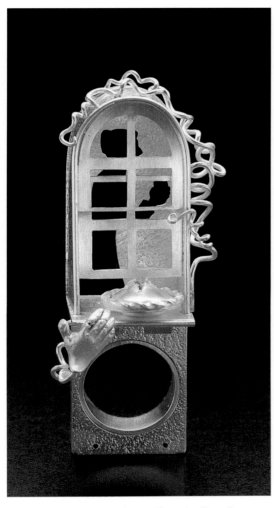

Pamela Morris Thomford. "Sneaky Pete."
Sterling silver and Precious Metal Clay. 3.25"
high, 1.25 " wide, 1" deep. *Photo, Tim Thayer*

Pamela Morris Thomford. "Connubial Bliss."
Sculpture in pendant form with moveable ele-
ments. Sterling silver and red fiber optic material,
roller printed, and fabricated. *Photo, Tim Thayer*

Pamela Morris Thomford. "The Play-
ground." Brooch as sculpture. Sterling
silver, copper, concrete, and resin,
fabricated and patinated. 2.75" high, 0.75"
wide, 0.75" deep. *Photo, Tim Thayer*

Assorted metals and other materials also figure in Pamela Morris
Thomford's pieces. Along with roller textured sterling silver, she may incor-
porate copper, fiber optic materials, concrete, and resin. She makes her
own dies from non-traditional materials such as Plexiglas, and uses pieces
of rubber tubing to "push" the metal down into the cut out areas.

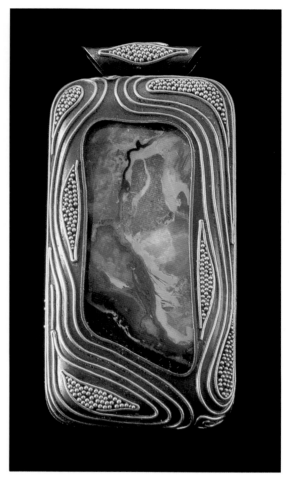

Judith Kinghorn. Brooch and pendant with detachable stand. Sterling silver, 22k gold, and a Boulder opal. Fabricated, fused, die formed, granulated, and oxidized. 1.75" high, 1" wide. 0.27" deep. *Photo, Michael Knott*

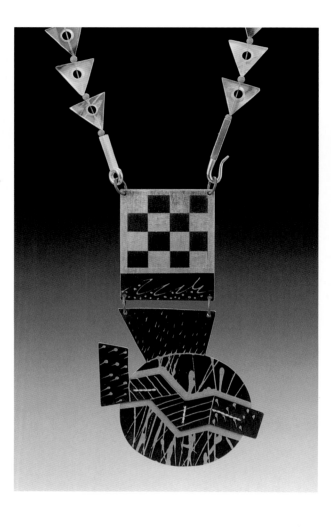

◄

Garry Knox Bennett. Necklace. Fabricated steel, oxidized, resist, and treated 23k gold plate, 14k gold wire, and beads. Julie Artisan's Gallery. *Photo, Hap Sakwa*

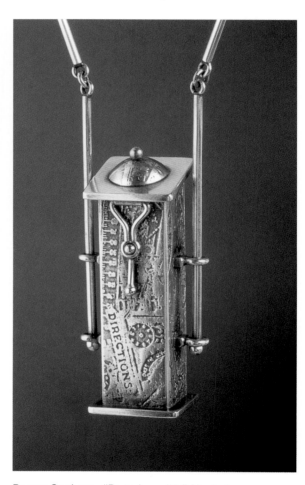

Peggy Cochran. "Parts box #2." Neckpiece. Fabricated from flat sheet metal that is acid etched from a collage made from mechanical/ industrial line drawings. The top, latch, and hinge, are also fabricated. Pendant: 2.38" high, 1.01" wide, 0.75" deep. *Photo, Courtney Frisse*

Judith Kinghorn's brooch that doubles as a pendant combines gold and sterling silver with a stunning opal. Both metals can be shaped, roller printed, oxidized, patinated, fused, die formed, and combined with unusual minerals. Note how Kinghorn sets the stone into the piece. She doesn't use a bezel, prongs, or rivets. Rather, she makes a model of the stone with dental molding material, and then uses a hydraulic press to form the setting around the stone's shape. Essentially, she creates a frame for the gem adding the textures and colors she wants.

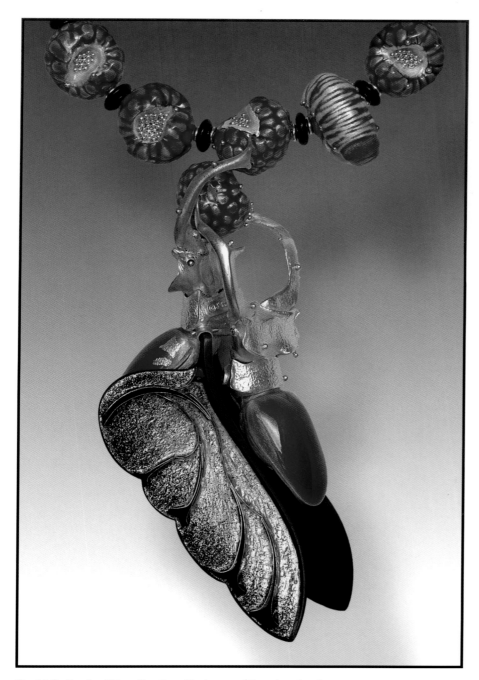

David C. Freda. "Stag Beetles, Grubs, and Raspberries." (Detail) Fine silver, sterling silver, 24k, 18k yellow gold, and glass enamels. 4.5" long, 2" wide. *Photo, artist*

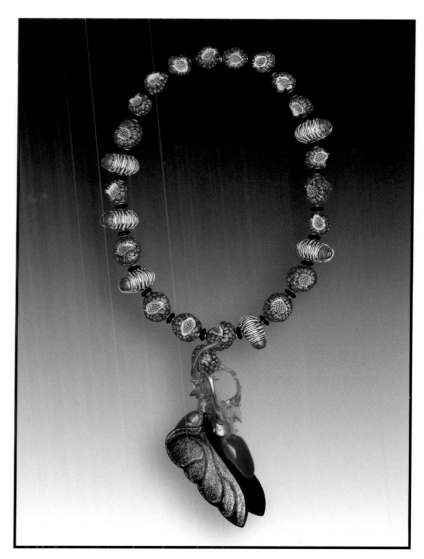

David C. Freda. "Stag Beetles, Grubs, and Raspberries." Fine silver, sterling silver, 24k, 18k yellow gold, and glass enamels. Hollow core cast, hammer textured beetle, granulation, and enameling. Photo, Barry Blau

When mixing materials and techniques are involved, David C. Freda's methods are unique. He may cast different metals, solder, or screw them together, then add enamels to the surface for color. His models for the small creatures are the creatures themselves that have been preserved, and from which a wax mold is made. Then he casts the shapes in silver and finishes them with enamels.

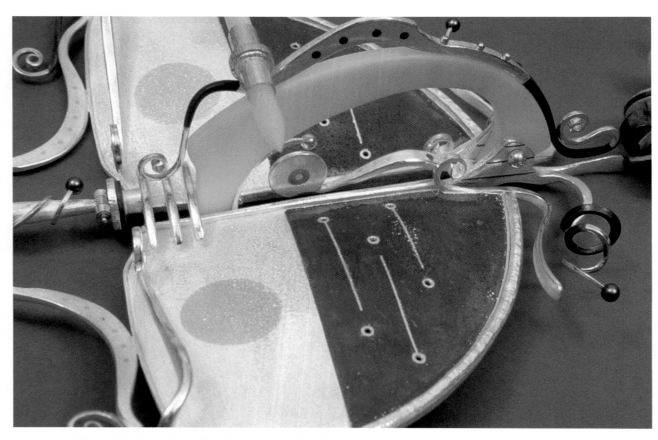

Juan Carlo Caballero-Perez. Necklace series. (Detail.) Forged and fabricated speculum (an alloy of gold and copper), 18k gold, 18k palladium white gold, Delrin, (an industrial material), rutilated quartz, black pearls, and glass. 14.5" high, 7.5" wide, 2.75" deep. *Photo, Dan Neuberger*

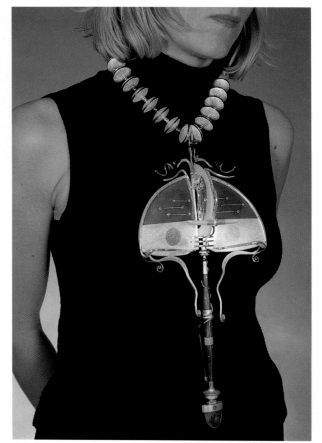

▶
Juan Carlo Caballero-Perez. Full necklace. Same as above. *Photo, Dan Neuberger*

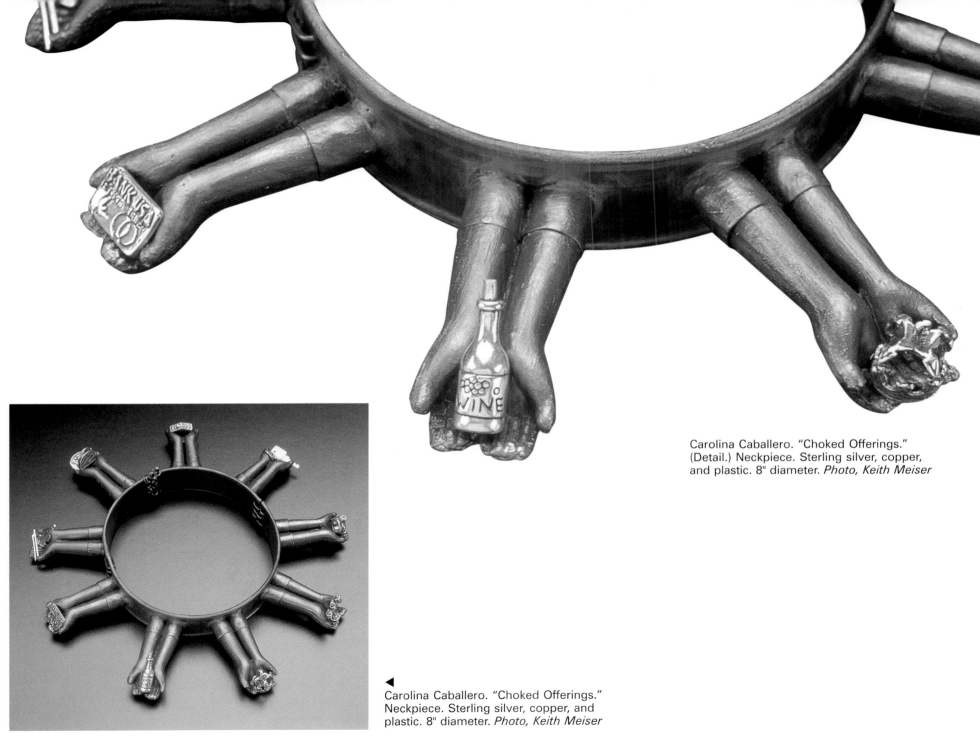

Carolina Caballero. "Choked Offerings."
(Detail.) Neckpiece. Sterling silver, copper,
and plastic. 8" diameter. *Photo, Keith Meiser*

◄
Carolina Caballero. "Choked Offerings."
Neckpiece. Sterling silver, copper, and
plastic. 8" diameter. *Photo, Keith Meiser*

135

Gretchen Klunder Raber. "Morphosis-Grille" (Closed.) Pin.
Stainless steel and onyx. Gallery Flux. *Photo, Robert Diamante*

Gretchen Klunder Raber. "Morphosis-Red Slash." (Closed.) Pin. Anodized
aluminum, stainless steel, and onyx. Gallery Flux. *Photo, Robert Diamante*

Gretchen Klunder Raber. "Morphosis-Grille." (Extended.) Pin.
Stainless steel and onyx. Gallery Flux. *Photo, Robert Diamante*

Gretchen Klunder Raber. "Morphosis – Red Slash" (Extended.) Anodized alumi-
num, stainless steel, and onyx. Gallery Flux. *Photo, Robert Diamante*

► Debra Dembowski. "Girl on a Swing." Pin. Hand fabricated from sterling silver and a mixture of diverse materials. Faces may be carved from marble or tagua nut, or cast from resins and pigments. Stylized hair may be added by sewing on branch-fringed beadwork. In this piece, the legs are movable. 4.25" high, 3" wide. *Photo, Larry Sanders*

Jennifer Monroe. "Free Milk." Silver and copper, fabricated. The theme behind this piece is based on her parents' admonition when she was growing up: "Why buy the cow when you can get the milk for free?" 3" high, 3" wide. *Photo, artist*

People in various activities and poses play a major part in the jewelry of many artists. Often, each tells a story, or is symbolic of some aspect of the artist's life, or psyche. They encompass metaphors, humor, irony, and meaning that go beyond what the eye takes in.

Non-precious metals, or a combination of precious and non-precious metals, with other materials, are used advantageously in these pieces. The artists take advantage of the inherent working characteristics, function, and appearance of the metal in the finished pieces.

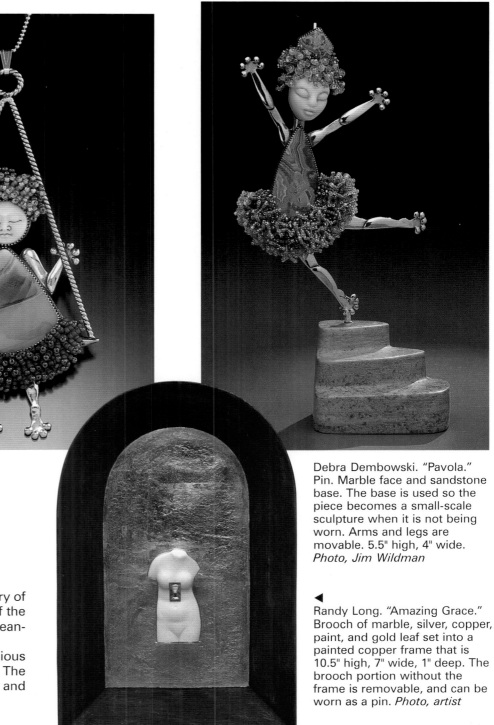

Debra Dembowski. "Pavola." Pin. Marble face and sandstone base. The base is used so the piece becomes a small-scale sculpture when it is not being worn. Arms and legs are movable. 5.5" high, 4" wide. *Photo, Jim Wildman*

◄ Randy Long. "Amazing Grace." Brooch of marble, silver, copper, paint, and gold leaf set into a painted copper frame that is 10.5" high, 7" wide, 1" deep. The brooch portion without the frame is removable, and can be worn as a pin. *Photo, artist*

Mariko Kusumoto. "Kisekae Dolls." Pins with changeable clothes have hooks on the back that connect to a necklace. When not worn, the wardrobe resides in an old Japanese sewing box. The box is 8.5" high, 7" wide, 11" deep. Susan Cummins Gallery. *Photo, Hap Sakwa*

Mariko Kusumoto. "Kisekae Dolls." (Detail.) Pins. Brass, sterling silver, bronze found objects, copper, and coral. Susan Cummins Gallery. *Photo, Hap Sakwa*

Mariko Kusumoto's pieces are meant to be viewed as well as useful. They invite the viewer's participation. Hence, her *Kisekae Doll* pins. (*Kisekae* means "doll with changeable clothes.") She often makes metal boxes for them. The dolls are about 4" high and each has a hook on its body that connects it to a necklace. She says, "Just as we change our appearance by changing our hairstyle, clothes, accessories, etc., I thought it would be interesting to do the same things to jewelry pieces."

Her kit includes a traditional Japanese wig with ornaments, a western-style Barbie doll blonde wig, toys, bags, and Japanese and western style clothes. Small pieces that fit inside the dolls can be seen through a small window in the doll's body.

► Mariko Kusumoto. "Kisekae Dolls." (Detail.) Susan Cummins Gallery. *Photo, Hap Sakwa*

▶

Lisa and Scott Cylinder. "Ogling Fish." Brooch. Sterling silver, nickel silver, brass, found object, epoxy resin, pearl, 23k yellow gold leaf, mica powder, and paint. 2.25" high, 3.5" wide, 0.75" deep. *Photo, Jeffrey K. Brady*

The husband wife team of Lisa and Scott Cylinder create superb images that "...occupy an odd space somewhere between logic and intuition." The couple share a love of materials. They have allowed themselves the freedom to explore any materials they feel are appropriate for a particular piece, whether it is found, manufactured, or made by them. Their work is sculptural, but they are always acutely concerned with the importance of the pieces functioning as jewelry. Wearable and intimate objects that address artisanship, weight, and scale are as important as concept and design.

Their pieces are inspired by the place they live and work. They convey allegories about their environment through the creatures that are its players. The pieces are stories about their habits and habitats and how they coexist in the natural and man-made world.

Lisa and Scott Cylinder. "Speckle Faced Elgin." Brooch. Sterling silver, copper, epoxy resin, patina, gold leaf paint, and acrylics. 3.25" high, 5" wide. *Photo, Jeffrey K. Brady*

Keith A. Lewis. "Building Self." Brooch. Sterling silver, 24k gold vermeil, wood, Lucite chased, cast and fabricated. 2.25" high, 2.25" wide, 1.5" deep. Susan Cummins Gallery. *Photo, artist*

Keith A. Lewis. "Building Self." Reverse side. *Photo, artist*

Keith A. Lewis says his jewelry tries to avoid the clichés and easy meaning of most jewelry we see: "...the concept of jewelry associated with wealth, weddedness, and perhaps frivolity." For him making jewelry is a serious art form that embodies physical objects and broad collections of thought, feelings, experiences, and fears. The artist and what is created can reflect the self. Through that reflection, it can cast light on more general aspects of the human condition, or on the individual circumstances of another.

Lewis explains, "Being a jeweler, I think about the body as a site and about how intimate jewelry can be by virtue of that site. Jewelry exists on a comforting human scale, not as some ponderous self-regarding sculpture. It soothes, questions, or provokes without bombast or affectation."

Yeonmī Kang. "Where Am I?" Brooch. Sterling silver, 24k kum boo, and wood. 2.25" high, 2" wide, 1" deep. *Courtesy, artist*

Yeonmī Kang. "Sealed Wisdom." Brooch. Sterling silver, 24k kum boo, and ivory dice. 2.25" high, 2.5" wide, 1" deep. *Courtesy, artistb*

The following brooches, neckwear, rings, and other items use assorted materials to make their statement while simultaneously encompassing the essential design components of balance, composition, color, texture, contrasts, and scale.

Some metals, such as titanium, niobium and aluminum are inexpensive but used ingeniously the jewelry becomes valuable. Chemical treatments of the metals can produce striking colors, tones, and color combinations. Monoprinting, direct painting on anodized aluminum, dyes, for example, can add unique surface decoration. Many artists use Computer Aided Design (CAD) programs and computer color printing to produce striking results.

Yeonmī Kang. "Spring." Brooch. Sterling silver, 24k kum boo, and wood. 2.75" high, 2.5" wide, 1" deep. *Courtesy, artist*

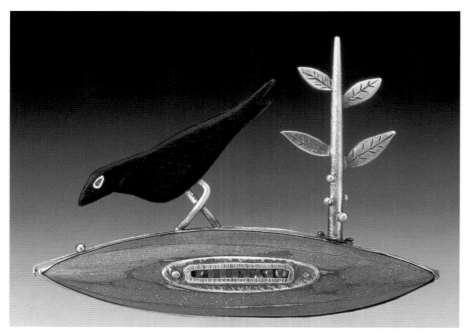

Marcia Macdonald. "Always Searching." Bird brooch with branch and seed. Wood, milk paint, sterling silver, and gold. *Photo, Hap Sakwa*

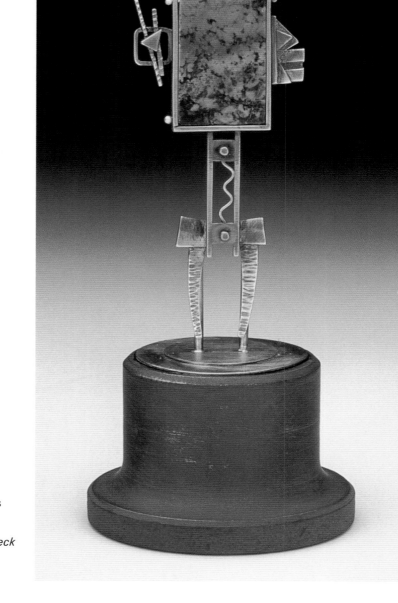

Maggi DeBaecke. "Picasso." Brooch. Bronze, copper, brass and silver, with an agate "shield." She created a series of African inspired pieces after taking a class in African mask making. 6" high with stand, 1.75" wide. *Photo, Peter Grosbeck*

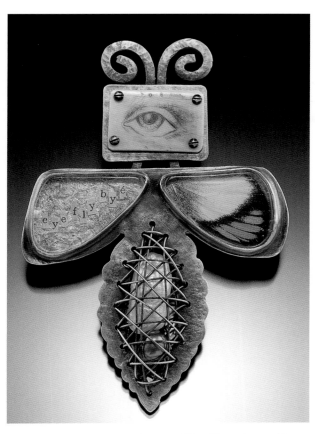

Christine Simpson. "Eyeflybye." Pin. Piano key with scrimshaw, butterfly wing, and 23k gold leaf. Type from a 1920s French almanac, Plexiglas, pearls, and sterling silver. 3" high, 2.6" wide. *Courtesy, artist*

▶
Lawrence Woodford. "Padlock." Pendant. Sterling silver, 18k gold, and Peruvian walnut. Galerie Noël Guyomarc'h. *Photo, Paul Fournier*

▶
Josée Desjardins. Pendant. Sterling silver, ammonite, chrysoprase, and felt. Galerie Noël Guyomarc'h. *Photo, Paul Simon*

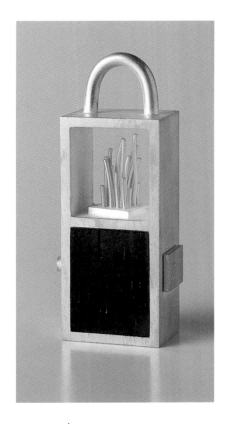

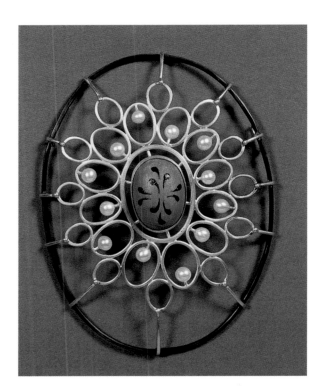

▶
Heather White. "Cassanian Oval #5." Steel frame, 18k gold, wood, and oil paint. *Photo, artist*

143

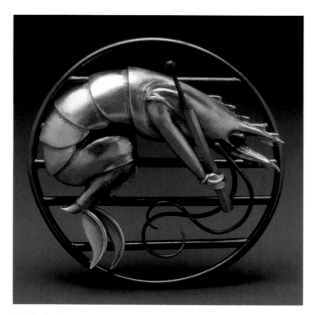

Keith A. Lewis. "Prawn" (self portrait). Pin. Stainless steel, bronze, bronze powder, and patinas. 3" diameter. Collection: Lee Ashley. *Photo, artist*

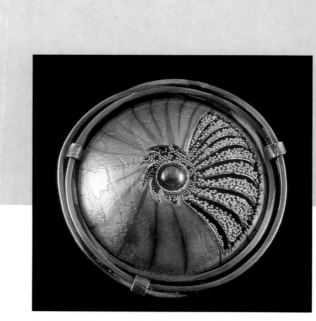

Judith Kinghorn. "Sea Creature." Brooch and pendant. Sterling silver, 24k and 22k gold. Fabricated, fused, die formed, embossed, engraved, granulated, and oxidized. 2" diameter. 0.5" deep. *Photo, Michael Knott*

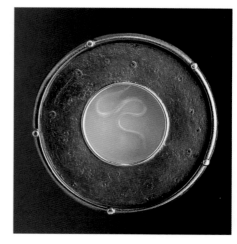

Andy Cooperman. "Flagella." Brooch. Bronze, sterling silver, gold, fine silver and glass. 2" diameter. *Photo, Doug Yaple*

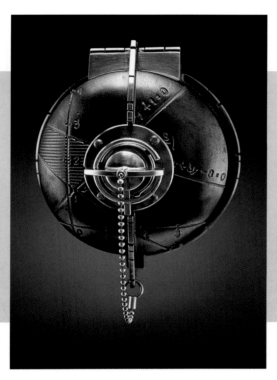

Kristin Mitsu Shiga. "Tears Won't
Help." Brooch. Sterling silver, copper,
brass, glass, charting paper, and
tears. *Photo, Courtney Frissee*

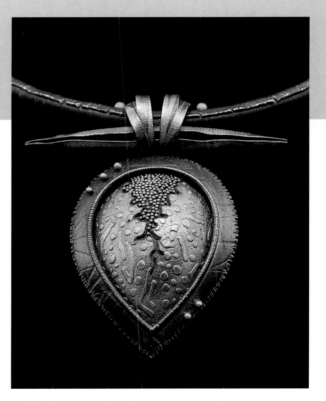

Judith Kinghorn. Necklace worn on a hand
wrapped cable. Sterling silver, 24k and 22k gold.
Fabricated, fused, die formed, embossed,
engraved, granulated, and oxidized. 2.25" high
2.5" wide, 0.25" deep. *Photo, Michael Knott*

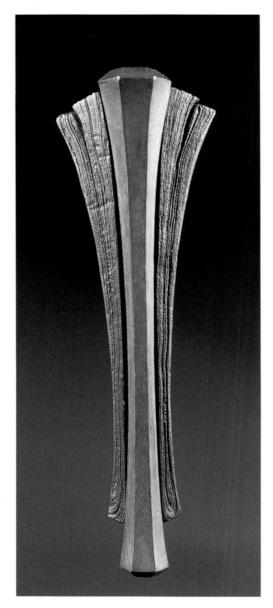

Marc Maiorana. "Rift Pin." Bronze, iron, and sterling silver. Forged and constructed. 4" long, 1.2" wide. 0.5" deep. *Photo, artist*

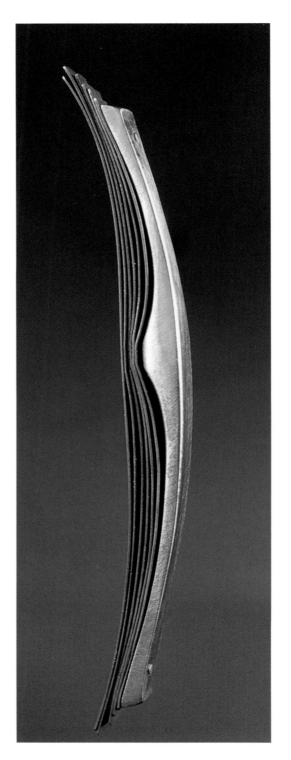

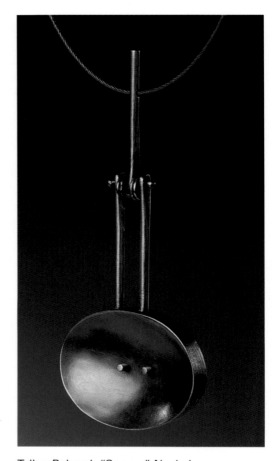

Tallya Baharal. "Spoon." Neckpiece. Bronze and sterling silver. Fabricated. An example of her idea that jewelry should stand on its own "sculptural feet." She tries to find beauty in the unlikely, the unfamiliar. Wearability and simplicity are essential elements. 4" high, 1.5" wide. 0.25" deep. *Photo, Gene Gnida*

◀
Marc Maiorana. "Contact Pin." Mild steel, titanium. Forged. 5" high, 0.35" wide, 0.25" deep. *Photo, artist*

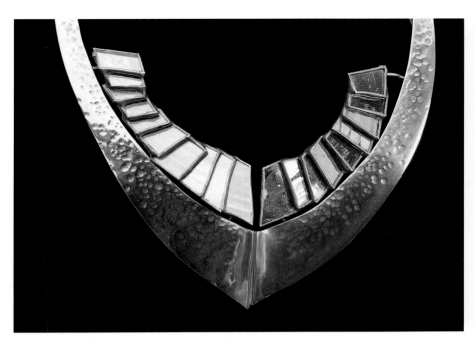

James Hubbell. Neckpiece. Forged and hammer-textured bronze with mirrored glass. *Photo, artist*

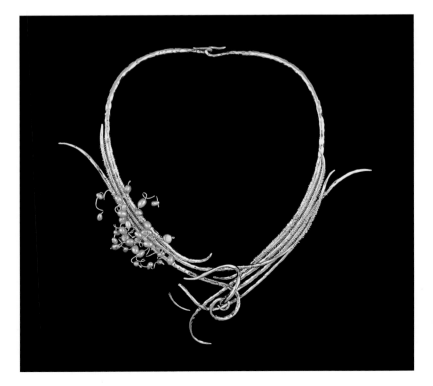

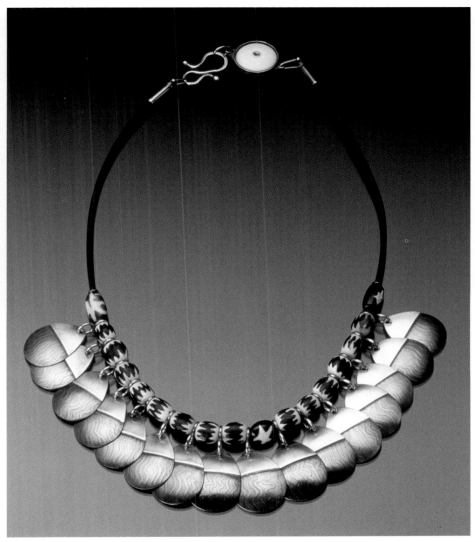

Ronald J. Pascho. Neckpiece. Elements fabricated from sterling silver, etched and domed copper spinning blades from fishing lures, nitrile cord, and bone beads. *Photo, Doug Yaple*

◄
Valerie Ostenak. "Transformation #3." Necklace. Forged and woven sterling silver, with golden pearls. The opening hinge mechanism is a loop at the front center. When unhooked at the back of the neck, the front hinge allows the two sides to open. *Photo, Batista Moon Studio*

Nancy Lee Worden. "Gilding the Past." Necklace. Silver, copper, coral, turquoise, and gold plate. Inspired by the World Trade Organization riot in Seattle and the resurrection of imagery from the 1960s and 1970s. 43" long, 4.5" wide 0.75" deep. Helen Drutt Gallery. Collection, Lois Boardman. *Photo, Rex Rystedt*

Nancy Lee Worden. "Look at Me." Necklace. Silver, brass, copper, nickel, glass, and gold foil. Inspired by the installation Louise Bourgeois designed for the opening of the new Tate in London. Her three towers encouraged self-inspection and self-reflection. 20.5" long, 2.25" wide, 1.5" deep. Helen Drutt Gallery. *Photo, Rex Rystedt*

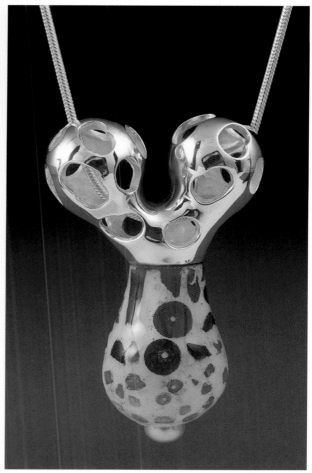

Bernard Francois. "C.Q.F.D." Neckpiece with pendant. Sterling silver anodized aluminum, aluminum, Plexiglas, and a compact disc. 12" high with neckpiece, 5.5" wide, 1.2" deep. *Photo, Jacques Vandenberg*

Josée Desjardins. "Pacifier #2." Pendant. Sterling silver, mosaic of semi-precious stones, and a pearl. Galerie Noël Guyomarc'h. *Photo, Paul Simon*

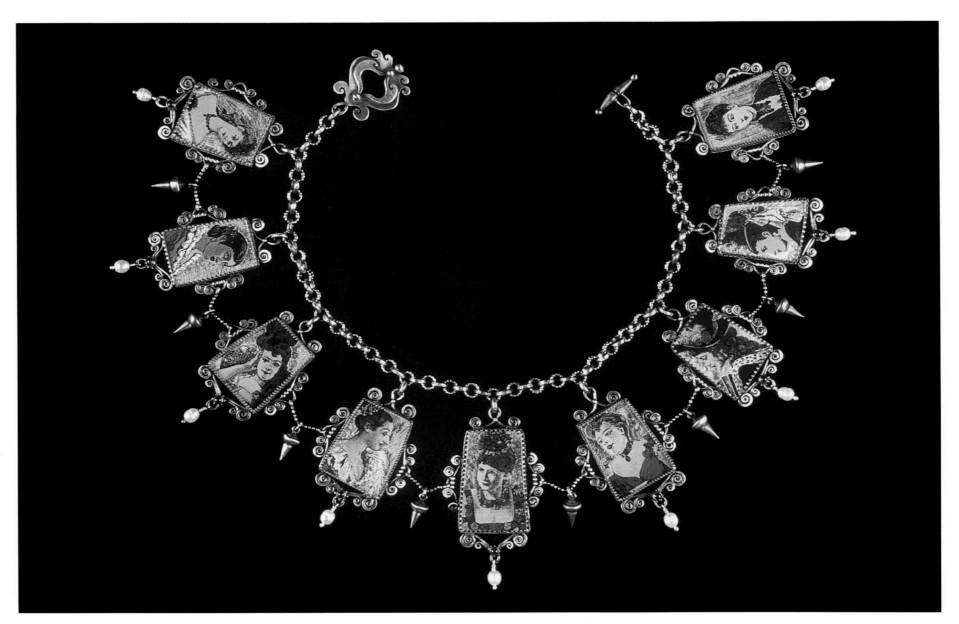

Marcia Macdonald. "Be A Dahling and Pass The Opera Glasses Please." Made especially for a show called, "Jewelry for the Opera." Necklace. Images adhered to Plexiglas and painted on the front. Each piece is set into a bezel. Sterling silver, Plexiglas, 24k gold leaf, pearls, carnelian, and 14k gold. *Photo, Hap Sakwa*

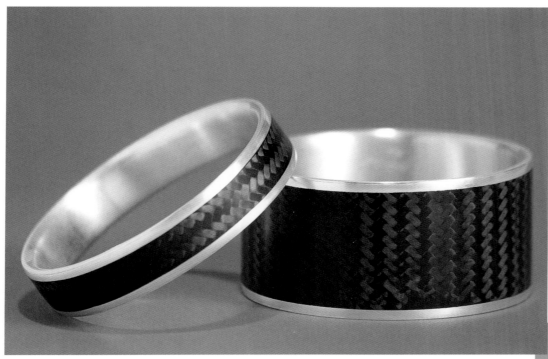

Diana Hall. Two bangles. Sterling silver and woven carbon fiber.
2.5" diameter. Martina & Company. *Photo, Jennifer Uhrhane*

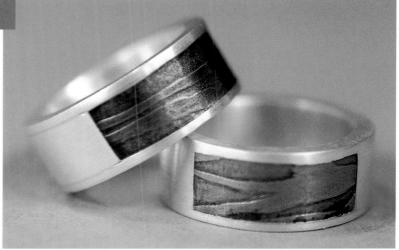

Kelly Jacobson. Ring set of sterling silver with a
pattern-welded iron inset. 1" diameter. *Courtesy, artist*

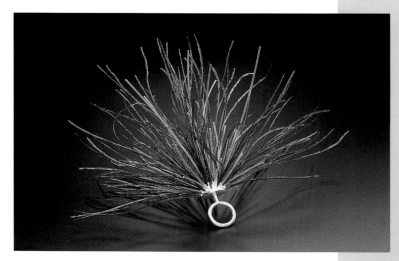

Kimerlen Moore. "Peacock Ring." Sterling silver,
peacock feathers, and fiber optics. *Photo, Keith Meiser*

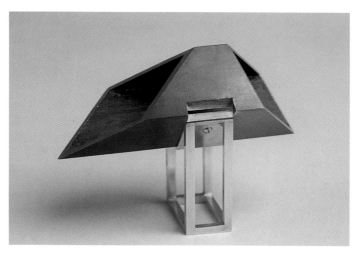

Liaung-Chung Yen. "Geometric Space 1." Ring.
Anodized aluminum and sterling silver. 2.25" high,
1" wide, 1.75" deep. *Photo, Kristin M. Despathy*

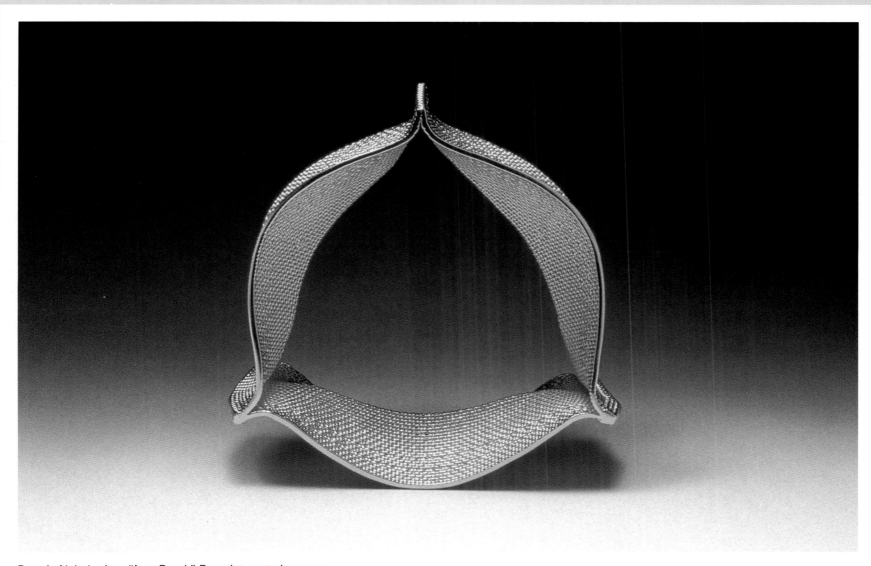

Dennis Nahabatian. "Arm Band." Bracelet, or to be worn on the upper arm. Copper, gold plated. *Photo, artist*

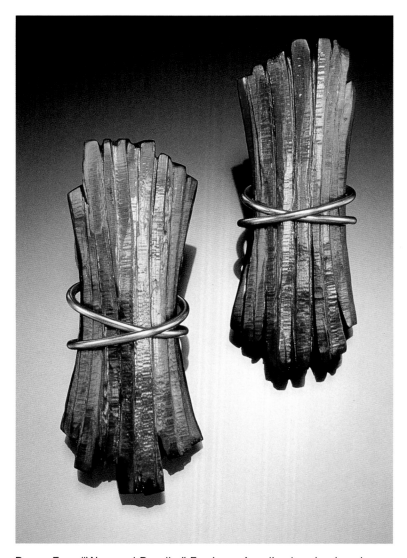

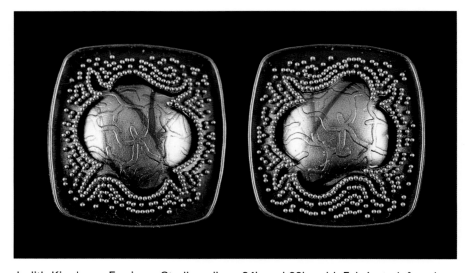

Judith Kinghorn. Earrings. Sterling silver, 24k and 22k gold. Fabricated, fused, die formed, embossed and granulated. 1" square. *Photo, Michael Knott*

Peggy Eng. "Wrapped Bundle." Earrings. Anodized and colored aluminum, carved. 14k gold wire. *Photo, Ralph Gabriner*

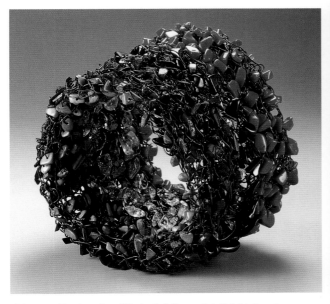

Zuzana Rudavska. "Golden Citrine Pendant." 14k gold, sterling silver, citrine, white and green crystal. Knotting techniques. *Photo, George Emrl*

Zuzana Rudavska. "Colorful Bracelet II." Natural crystals and stones, copper wire using various interweaving techniques developed by the artist. 3" diameter, 3" high. *Photo, George Erml*

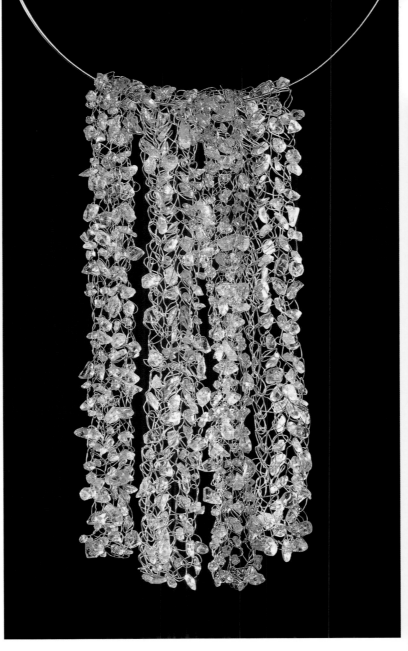

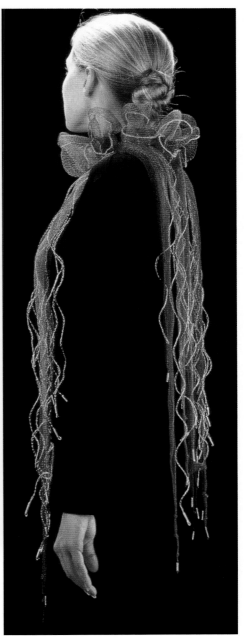

Arline M. Fisch. "Lion's Mane Jellyfish." Collar. Coated copper and fine silver wire. Machine knitting and crochet. 9" diam, 36" long. *Photo, William Guillette*

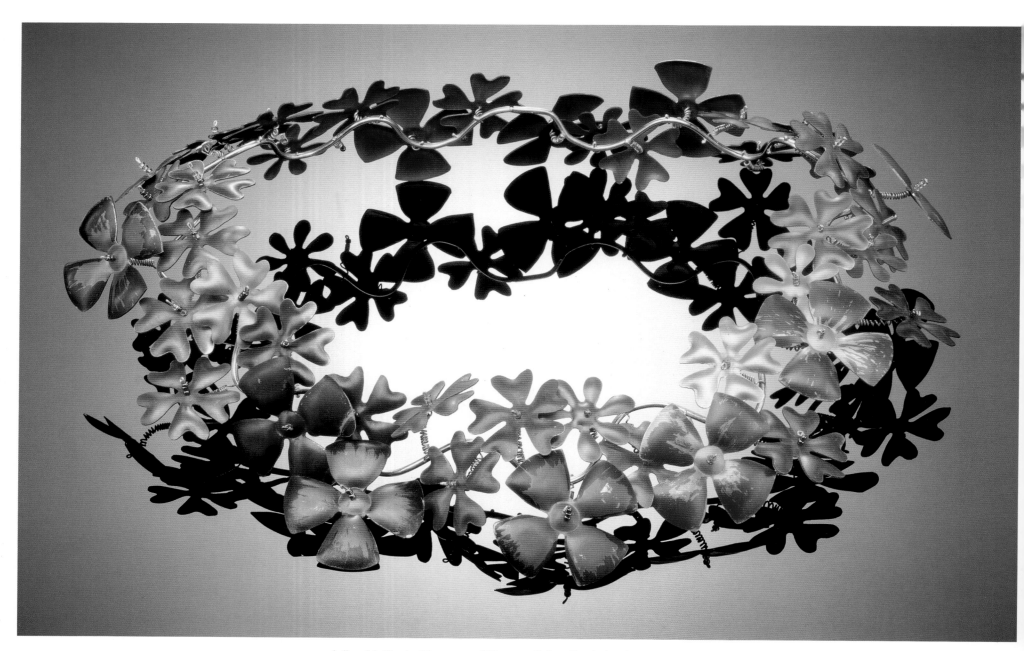

Arline M. Fisch. "Bouquet of Flowers." Anodized aluminum, and
sterling silver, press formed. 10" diameter. *Photo, William Guillette*

Annie Publow. "Fall." Necklace. Sterling silver and anodized aluminum. The aluminum is shaped, and then dipped into dye baths. Overlay colors are added with a paintbrush. 9" diameter. *Photo, Helen Shirk*

Marcia Macdonald. "She's Taught me so Much."
Brooch. Carved nut, carved maple, gold leaf,
eggshells, sterling silver, rusted steel cheese
grater, garnets, 14k gold, steel rivets. 4" high, 4.5"
wide, 0.5" deep. *Photo, Richard Gehrke*

Chapter 6
FOUND AND RECYCLED OBJECTS

Creating jewelry from found materials is nothing new to Native American artisans who work feathers, shells, seeds, and whatever else they deem usable for fabulous headpieces, neckwear, earrings, ankle, wrist adornments, and more. The contemporary artist has picked up on this practice and carried it to new dimensions.

Using found objects for body adornment may have gotten its start during the Hippie days of the 1970s, when antiestablishment was the byword for many activities. Whoever and wherever it began is not as important as where it has led and how the concept has grown. The practice is being fanned and nurtured today.

Some found objects appear in the jewelry in Chapter 4, as an adjunct to the metals. In this chapter, the found or recycled objects become the center of interest, or comprise a major portion of the piece. Some are so cleverly incorporated into the jewelry that you don't suspect their origin. Traditional materials may be used, too. It's not a question of purism or using only found materials. The idea is to incorporate materials in an "anything goes" concept so long as the result meets the artist's standards for wearable jewelry, and someone likes it enough to buy and wear it.

Marcia Macdonald's brooch, *She's Taught Me So Much* fulfills those requirements. Often, the found objects aren't obvious and they may have hidden meanings. Says Macdonald: "The cheese grater is behind the tagua nut carving of the hand holding a plate with half an eggshell on it. If you look very closely, you can see little bumps. I cut up part of the cheese grater that one would use if they were grating lemon rind…the teeniest part of a multi grater. The eggshells sit under the quartz cabochon that hangs from the larger piece. I usually put gold leaf down first and then the eggshells, so you can see gold leaf behind them. The shells were left in the kitchen of an elderly aunt when she moved to a nursing home, so I put one on the plate. The piece is named for the aunt."

Papua New Guinea tribes people create adornments for their annual Sing Sing celebration using materials at hand. Study the photo carefully to observe how different types of shells, feathers, leaves, nuts, and vines become jewelry. Note the modern wristwatch. Conversely, primitive adornments have inspired jewelry made with traditional materials. Almost every jewelry counter will display silver feather shaped pins, shell shaped gold beads, and braided metal bracelets that simulate the vine windings on a native's wrist. The department store counters, fashion features, and advertisements, establish the "look," and beckon you to wear layers of varied beaded necklaces. The stimuli are infinite.

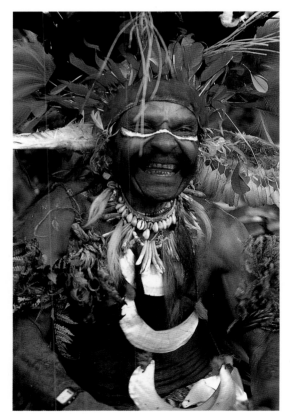

Dancers, Papua, New Guinea. During the annual Sing Sing Celebration, participants wear jewelry made of peacock feathers, beads, and shells. *Photo, Bushnell-Soifer*

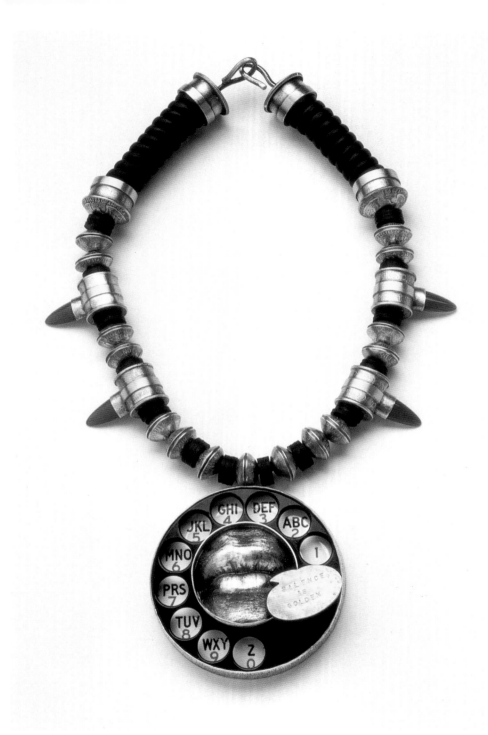

Found object jewelry doesn't appear full blown like Sandro Botticelli's painting of *The Birth of Venus*. Each piece requires vision, courage, know-how, construction, and fabrication. It's not just stringing ready-made beads into a necklace. Seeing potential and beauty in found objects, and placing them in new relationships requires imagination, vision, an artistic eye, and follow through. The time, thought processes, additional materials, and marketing all take time and effort. The components may have little intrinsic value but the artists' talents and expertise make these jewels as precious as any made with fine gold, silver, and gems.

In the following examples, there are clever, innovative, and ingenious uses for coins, bottle caps, book covers, decorative tin boxes, old credit cards, old paper money, sticks, bones, even type cartridges from an old IBM typewriter. All are fair game to the ever-watchful eye of the artist seeking something that can become grist for the jeweler's bench.

Nancy Worden's necklace, *Silence is Golden*,, uses the center from an old dial phone as a story telling pendant. She combines it with fabricated silver and carnelian beads. Her *Diamond and Lust* neckpiece has small, electroformed and gold-plated arms holding money circling the neck, a design that resembles Native American squash blossom necklaces. Worden's jewelry always has some deeper meaning based on what is going on in her life at the time. A piece with turkey bones refers to her opinion of World Trade Organization demonstrators and their desire to emulate the anti-war culture of the 1960s and 1970s.

◄

Nancy Lee Worden. "Diamond and Lust." Neckpiece. Found objects with sterling silver, 18k gold, copper, and pearls. This is a commentary on the ridiculous salaries of baseball players. Helen Drutt Gallery. *Photo, Rex Rystedt*

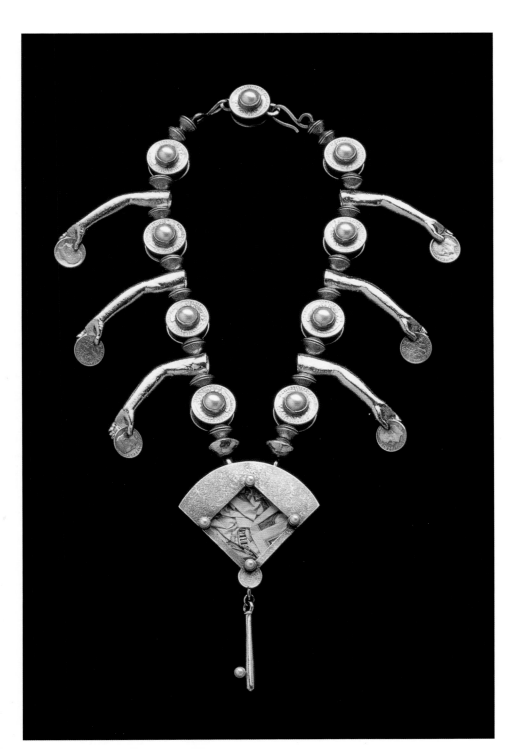

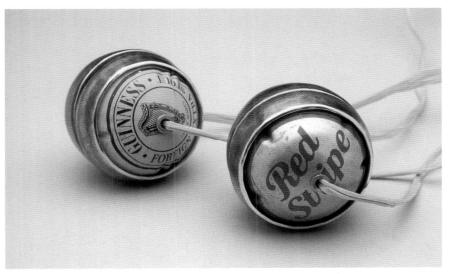

Roy. "Bottle Stoppa." Neckpiece. Jamaican bottle caps, oxidized brass, copper, and raffia. *Photo, David L. Smith*

◄
Nancy Lee Worden. "Silence is Golden." Neckpiece. Found objects with sterling silver, 18k gold, and carnelian. A response to phone solicitors. Helen Drutt Gallery. *Photo, Rex Rystedt*

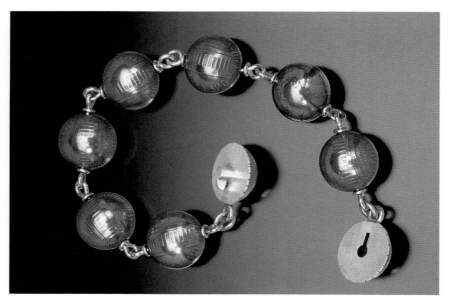

Ronald J. Pascho. "16-Cent Bracelet." Fabricated from sterling silver and U.S. pennies (copper pre-1980), domed and soldered. The ball clasp is fabricated of pennies and sterling silver. *Photo, Doug Yaple.*

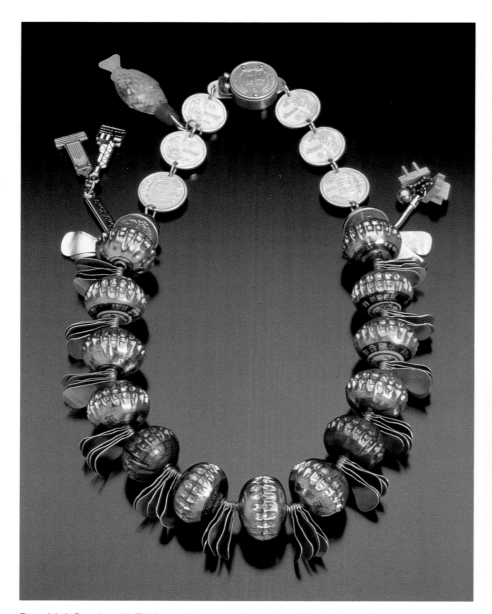

Ronald J. Pascho. "2 Tables, 4 Beers, and no Cola." Neckpiece. Found objects. Beads made from beer bottle caps, flanked by pop can pull-tabs, Chinese coins, jade, airport trinkets, and a fabricated sterling silver box clasp. The fish is a soy sauce container filled with pieces of Chinese Yuan paper money. All materials were obtained during a trip through southern China to visit minority tribes. This neckpiece was inspired by sounds of jewelry worn by village dancers. To replicate sounds, each bead contains several copper BB shot. *Photo, Doug Yaple*

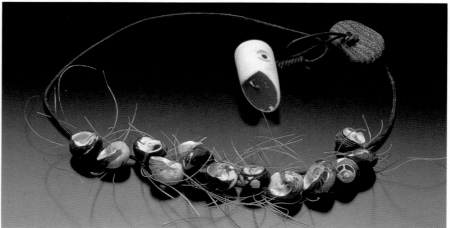

Ronald J. Pascho. "Yellow Banks #1." Neckpiece. Leather, shells, fishing line, fish lure body, and drift wood. *Photo, Doug Yaple*

Alexia Markarian. "Fortunate Diner." Cuff. Found metal and paper on cedar fence board with brass and copper brads, and lacquer. Years of accumulated and saved fortunes from Chinese fortune cookies are used for the interior. The exteriors are made from rescued soy sauce tins. 3.75" diameter, 2" wide. Facèré Jewelry Art Gallery. *Photo, artist*

Alexia Markarian. "Pulp Fiction Bangle Bracelet." Altered vintage paperback book jackets. Each is one-of-a-kind because the book jackets vary. All are erotically charged and lots of fun. The actual covers are over wood. 4.25" high, 5.5" wide, 0.36" deep. *Photo, artist*

◄
Nancy Lee Worden. Hologram bracelets. Silver, 14k gold, onyx, and credit cards. 8" long, 2.5" high. 0.5" deep. An interpretation of modern day slave bracelets. Facèré Jewelry Art Gallery. *Photo, Rex Rystedt*

Roberta and David Williamson. Assorted brooches with found objects cleverly assembled. Some use the objects almost as found, others have added silversmithing, perhaps a frame around a bottle top or wrist watch face, silvered pencils, and a cabochon around an object. Each pin tells a story or has a theme built around the dominant object. *Photo, Jerry Anthony*

Marcia Macdonald. "Look But Don't Touch." Neckpiece. Carved wood, 24k gold leaf, coral branches, sterling silver, brass balls, cameo, antique buckle, and antique furniture hardware. The pendant is 7.5" high, 2.75" wide, 0.5" deep. Necklace is 32" long with chain. *Photo, Richard Gehrke*

Harriete Estel Berman. Beads. Details from 3
necklaces. Multicolored recycled tin, Plexiglas,
brass, electic wire, polymer clay, and sterling
silver. Sybaris Gallery. *Photo, Philip Cohen*

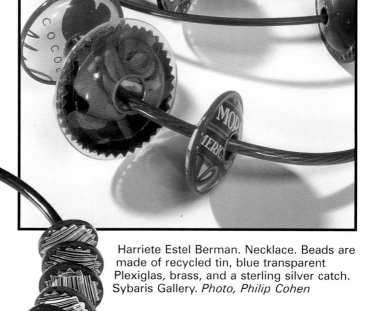

Harriete Estel Berman. Necklace. Beads are
made of recycled tin, blue transparent
Plexiglas, brass, and a sterling silver catch.
Sybaris Gallery. *Photo, Philip Cohen*

◄
Harriete Estel Berman. Neckpiece. Beads
are made of recycled tin with UPC codes,
yellow and orange transparent Plexiglas, brass,
electrical wire, polymer clay, and sterling silver.
Sybaris Gallery. *Photo, Philip Cohen*

Kathy Buszkiewicz. "Tender Revival." Pair of anklets. (Detail at right.) Composed of U.S. currency and wood. They are reminiscent of an African status symbol, but use our culture's primary symbol of status, U.S. currency. Historicall, large anklets falsely identified enslavement in the mid-20th Century. Many African governments forbade women to wear large anklets, which are now valued and used only as currency. One anklet has the words, "This Note is Legal Tender;" the other is covered with the phrase, "For all Debts Public and Private." The piece questions whether we have become enslaved by money. Each anklet measures 3.5" high, 8.5" diameter. *Photo, artist*

Kathy Buszkiewicz. "Tender Revival." Anklets. (Detail.) *Photo, artist*

▶

Kathy Buszkiewicz. "$4900.00 and $5300.00." Bracelets. Old U.S. currency and wood. Respectively, there are 245 and 265 $20 bills in these pieces giving the bracelets their titles. Value is placed upon the power of crafting worthless materials into beautiful objects. The color and designs of U.S. currency symbolically link it with fertility cycles. Green money, with its decorative motifs, represents vegetation and our ability to be fruitful in the world. 0.5" high, 8" diameter. *Photo, artist*

Lisa and Scott Cylinder. "Grand Hotel." Game bird brooch. Sterling silver, epoxy resin, 23k yellow gold leaf, found objects, and paint. 4" high, 3.75" wide, 1" deep. Snyderman/The Works Gallery. *Photo, Jeffrey K. Brady*

Lisa and Scott Cylinder. "Darwinian Combine Brooch." 14k gold, sterling silver, brass, Bakelite, Catalin, dice, 23k yellow gold, patina, and paint. 2.75" high 3.75" wide, 0.5" deep. Snyderman/The Works Gallery. *Photo, Jeffrey K. Brady*

◄
Lisa and Scott Cylinder. "Evolution Pencil." Brooch. Silver, brass, found objects, and patina. 2.25" high, 4" wide, 0.5" deep. Snyderman/The Works Gallery. *Photo, Jeffrey K. Brady*

Sue Kaye. Memorabilia pins. Composed of personal mementos such as graduation, sorority and scout pins, buttons, gemstones, etc. glued together and placed on a backing. 3" to 4.5" diameter. *Photo, Dona Meilach*

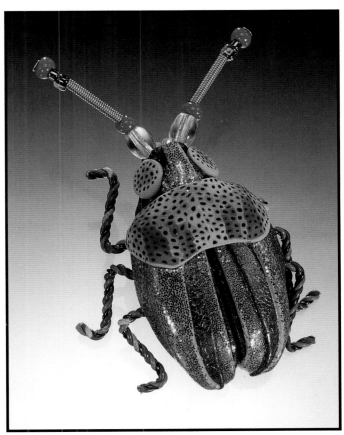

Joyce Fritz. "Beetle." Pin. Polymer clay, glitter, metallic leaf, glass beads, telephone wire, and brass wire. 2.25" long, 1" wide. *Photo, Ralph Gabriner*

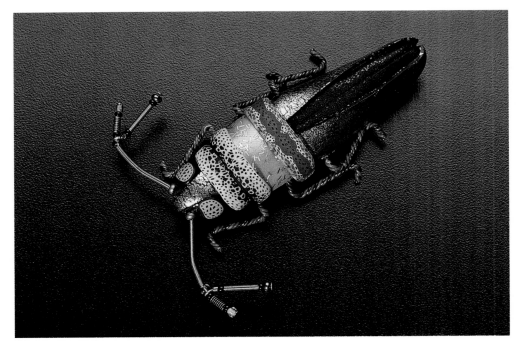

◀
Joyce Fritz. "Beetle." Pin. Polymer clay, glitter, metallic leaf, telephone wire, and glass beads. *Photo, Ralph Gabriner*

Kara Tennis. "Five Smooth Stones, " Fabric, stones, nylon stitching, and beads. All elements are hand-stitched on a fabric covered backing. The idea was to create a dense stitch of a few contrasting elements to create a satisfying pattern and texture. 2-1/2" high, 5" wide. *Photo, Ralph Gabriner*

▶
Kara Tennis. "Large Spiral." Fabric, wood, zipper, terra cotta, nylon stitching, polymer clay, ceramics, beads, and found objects. All elements are hand stitched on a fabric covered background. The inspiration was the ordering of disparate elements, each with different textures, into harmony. 6.5" high, 4.5" wide. *Photo, Ralph Gabriner*

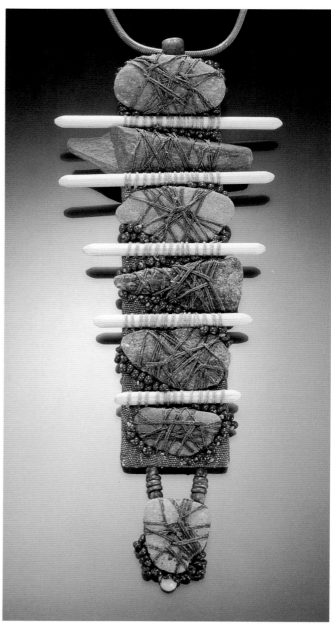

Kara Tennis. "Ladder." Fabric, wood, stone, polymer clay, terracotta, nylon stitching, linen thread, beads, and found objects. All elements are hand-stitched on a fabric covered background. There is a subtle harmony of colors and textures. 4.5" high, 2" wide. *Photo, Ralph Gabriner*

170

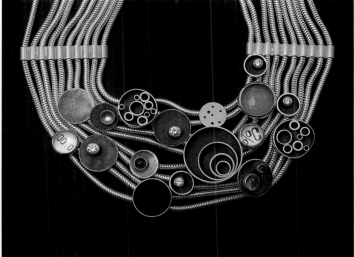

Kristin Mitsu Shiga. "Zip." Necklace. Sterling silver, assorted stones, and found objects. *Photo, Phil Harris*

▶
Roy. "Greek Rhythm Tambourine." Bracelet. Oxidized sterling silver and re-used Greek island bottle caps. 5" diameter, 1.36" deep. *Photo, David L. Smith*

Gerda Rasmussen. Found object metal decoration assembled onto a hand made fiber padded backing, with a twisted and wrapped chain. Pendant: 4" high, 7.5" wide. *Photo, Dona Meilach* ▼

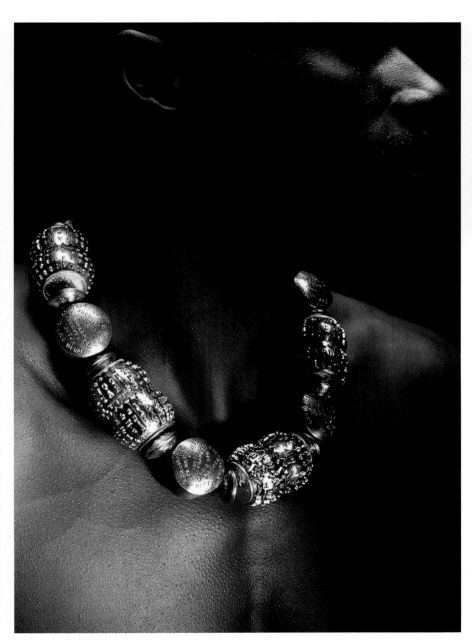

Nancy Lee Worden. "Terminology." IBM print balls, sterling silver, and brass. 23" long, 1.5" wide. An exploration of politically correct and incorrect terminology. Collection, Daphne Farago. *Photo, Rex Rystedt*

171

Mariko Kusumoto. Interior of a "matchbox" from a series with wearable pins inside. Susan Cummins Gallery. *Photo, Hap Sakwa*

Mariko Kusumoto. "Scientific Specimens of Insects." Pins fashioned from found objects reside in a specially designed box. They can be worn individually, or in groupings. Susan Cummins Gallery. *Photo, M. Lee Fatherree*

Mariko Kusumoto. Another small container box has rings within. Susan Cummins Gallery. *Photo, Hap Sakwa*

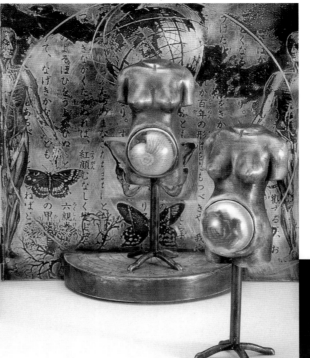

Mariko Kusumoto. "Mother Nature." (Detail.) The jewelry fits into holders within each box: different items on each side. This side shows rings made with embedded found objects. Susan Cummins Gallery. *Photo, Hap Sakwa*

Mariko Kusumoto. "Mother Nature." Exterior (closed view) of a jewelry container composed of bronze, nickel silver, sterling silver, brass, found objects, and resin. 6.25" high, 6.25" wide, 5" deep. Susan Cummins Gallery. *Photo, Hap Sakwa*

Mariko Kusumoto. "Mother Nature." (Detail.) Brooches may also fit within. A sculptured female torso has a space in the abdomen to show a removable, wearable pin. One side displays the rings and becomes a holder for them. Susan Cummins Gallery. *Photo, Hap Sakwa*

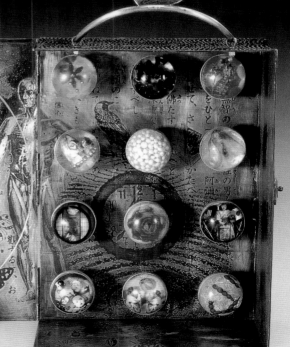

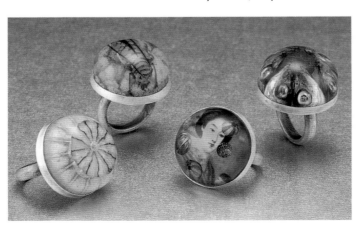

Mariko Kusumoto. "Mother Nature." (Detail). The rings, out of the box, show the detail on each one. Susan Cummins Gallery. *Photo, Hap Sakwa*

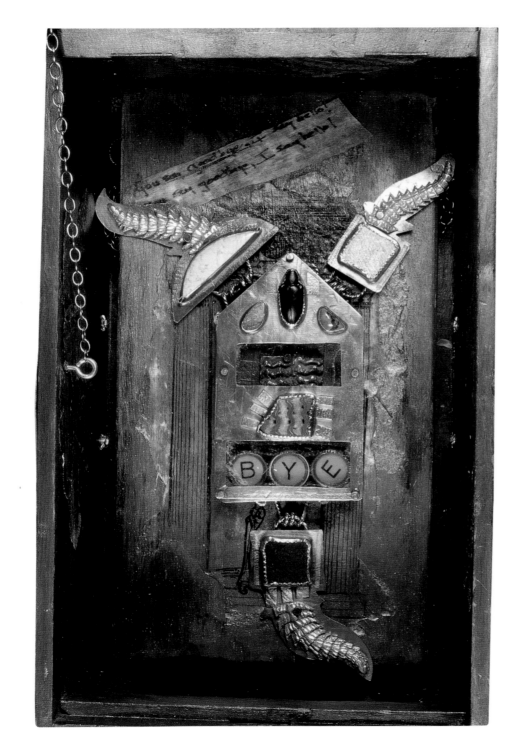

◄
Linda Kaye-Moses. "You Say Goodbye
and I Say Hello." Neckpiece. (Detail.)
Sterling silver, Favrile Glass, citron
magnasite, variscite, Boulder opal,
beetle elytra, pyritized baculite (fossil),
bottle caps, mica schist. The piece
nests in a hand made box (not
shown). 7" high, 5" wide, 0.5" deep.
Photo, Evan J. Soldinger

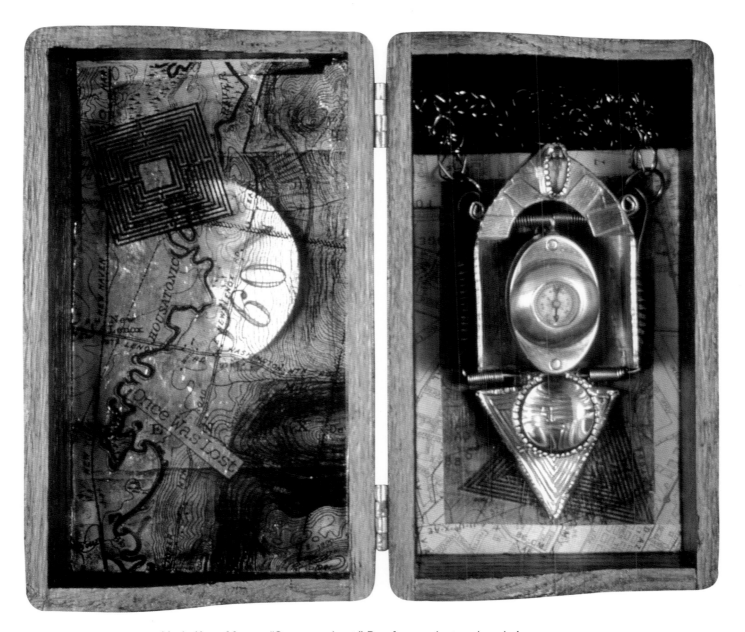

Linda Kaye-Moses. "Once was Lost." Box for pendant and neckpiece. Sterling and fine silver, 14k gold, found object, beetle elytra, and quartz. (See Pendant, Chapter 4, page 100) *Photo, Evan J. Soldinger*

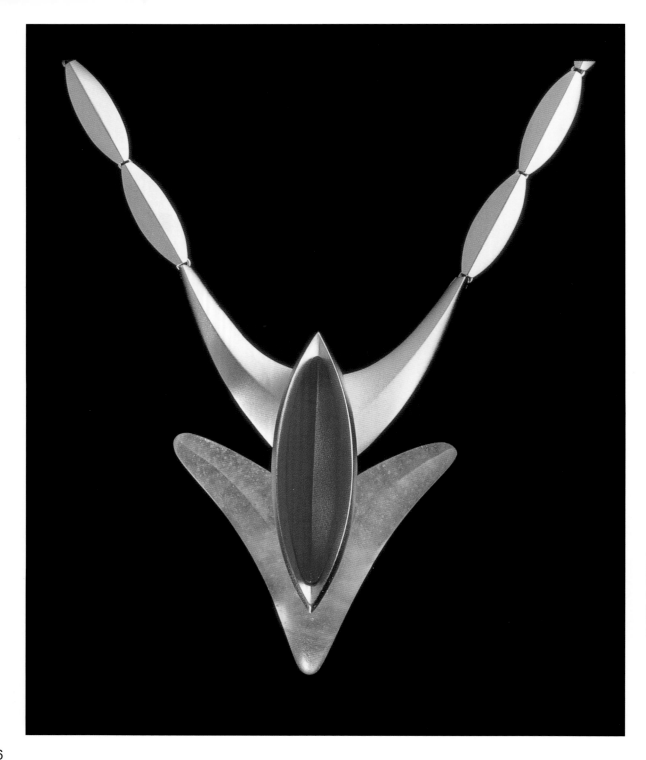

▲
Linda MacNeil. "Tropical Flower."
Floral Series Necklace. Acid polished
aqua and red pâte-de-verre (cast)
glass. 24k gold plated brass pendant.
Pendant, 3" high, 2" wide, 1" deep.
Necklace 6.5" long. *Photo, Bill Truslow*

GLASS

Glass beads and baubles are among the hottest types of jewelry being made by art jewelers today. A renaissance in glass bead making is enticing jewelers to revive centuries old glassmaking techniques, and to experiment with new ones. They are buying small kilns for fusing materials in their studios, a torch for heating, glass rods for making flamework beads, even kits with glassmaking materials. They are taking classes at local colleges, and in studios from experienced glassmakers. The results are eye-popping in their colors, textures, layering, and how the beads are used.

The penchant for glassmaking for the craftsperson today owes its start to Harvey Littleton, the son of a Corning Glass Works Ph.D. physicist. He grew up in the world of glassmaking, exposed to its exploration and artistic development. After excelling in ceramics, he gave up clay and turned to glassmaking. He and Dominick Labino, Director of Research for Johns-Manville Glass Fibers Division, developed a technique that revolutionized the medium that would take it out of factory production and into the studio milieu.

Today, Littleton is recognized as the founding father of the Studio Glass Movement. He established the first hot glass program at the University of Wisconsin. This program produced the first generation of studio glass artists.

Marvin Lipofsky had earned his degree in Industrial Design from the University of Illinois. He became intrigued with glass, and was one of Littleton's first graduate students. Lipofsky introduced glass as an art form into the Design Department of the University of California at Berkeley, and later founded and became head of the California College of Arts and Crafts, in Oakland, California.

Artists know that these pioneers are responsible for furthering studio glass art. Dale Chihuly, also a graduate student of Littleton's, brought it to the public's awareness. As Chihuly's colored glass objects appeared in magazines, galleries, museums, and shops, their unique, exciting, contemporary forms awed people. In 1971, Chihuly's Pilchuck Glass School, fifty miles north of Seattle, Washington, was opened and artists flocked there to take classes. Chihuly was, and still is, pioneering new statements in glass. Anyone unfamiliar with his work should read, *Pichuck, A Glass School*, check various Web sites with his name, and look for Chihuly's remarkable pieces in museums, galleries, and public buildings. Over two hundred museums around the world own Chihuly's

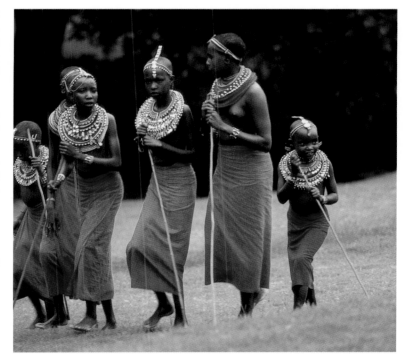

Masai Girls with neck beads. The intricately beaded, colorful, multi strand neckwear worn by the Masai are tubular glass millefiore beads first made in Venice, Italy, from about 1800 to 1950 for the African bead trade. The word millefiore means "1,000 (mille) flowers (fiore)" and refers to the many small slices of canes that are used when making millefiore mosaic beads. Chachasao is the Ashante word for mosaic beads. Collectible beads worn by the Masai may show some wear from everyday use in Africa. *Photo, Bushnell-Soifer*

Linda MacNeil. "Lotus." Necklace. Clear, polished Waterford Crystal, with acid polished green glass and 18k yellow gold. 6.5" diameter. *Photo, Bill Truslow*

here unabashedly hearken back to Lalique designs.

Another influential artist was Louis Comfort Tiffany (1848-1943). He studied painting but became interested in William Morris' Arts and Crafts movement. Thanks to his father's glass factory, Tiffany had experience with glass. He opened his own company from which he made stained glass windows for European cathedrals. In 1879, he switched to decorative arts. Moving into the Art Nouveau period his work displayed the floral elements that were becoming popular.

Tiffany had discovered that a quantity of remaining pot glass in magnificent colors accumulated on the bottoms of the glass furnaces. He decided to use the material to make small objects. The result was his famous Favrile ware with shimmering, surface iridescence, and brilliant colors

Today's art jewelers who are exploring glass for jewelry are bringing experience from other disciplines. Glass shares working characteristics with metal. Both can be stained, painted, fused, etched, carved, cast, slumped, engraved, and sandblasted. Jewelers trained in the use of metals have the advantage of understanding the techniques. They often combine glass and metal, and must contend with the problems of different thermal expansion between the materials.

Bead making and creating jewelry with handmade beads is becoming as popular today as macramé was in the 1970s. In fact, the need for something to suspend beads from is reviving macramé, the art of knotting, along with other fiber techniques. With bead collecting growing in popularity, collectors are seeking glass beads from today's new glass artists around the world.

Fused glass jewelry is popular; much of it can be done in a small kiln about 15 inches in diameter. The principle is similar to making a collage with pieces of flat glass. Layer different pieces on top of each other, melt them in the kiln and that's basically the process. But the variety is infinite. Unusual, and surprise effects are made using special printed glass, decals beneath the glass, luminescent, iridescent, and dichroic glass (a manufactured glass consisting of two colors with interference foils within that reflect and refract colors).

Art jewelers are moving beyond traditional beads-on-a-string concept. Linda MacNeil, originally a metalsmith, has been pioneering glass as a medium for contemporary jewelry, but with historic precedents. She selects glass that may have been meant for optical lenses, blowing, or casting, and grinds and facets it like gemstones, or casts it in refractory molds, then sets the resulting jewel in metal or other glass.

Her pieces are original, sophisticated, and sculptural. While beads are the most ubiquitous form in glass jewelry, MacNeil has progressed to making more complex and unique elements that are mechanically and visually blended in intricate detail. During a session working at Waterford Crystal Ltd., she took advantage of the company's distinctive and sumptuous lead crystal to create elegant pieces emphasizing the material's warmth and luminosity, in contrast to the hard-edged look often found in crystal jewelry.

work. His glass sculptures are installed in major hotels, corporate buildings, airports, and public buildings. In 2002, a museum devoted to his work was opened near Portland, Oregon.

Even before this renaissance of glass in the 1970s, artists were making new statements with the materials. Most were inspired by the work of René Lalique, (1860-1945). His art glass output was as pervasive and exciting during the Art Nouveau period as Chihuly's is to contemporary artists. A show of his work in Paris in 1895 revolutionized modern jewelry design even though jewelry was not his main output. His eminently collectible, and hard to find 250 perfume bottles in clear, and colored "iced" glass in gray, amber, yellow, green, blue, black, and plum, provide infinite ideas for glass artists who make beads today. Lalique's relief designs are fluid and elegant, consisting of foliage, flowers, birds, animals, and fish. They are readily available for inspiration in books and museum displays and some of the pieces shown

Linda MacNeil. Lucent Lines series. Necklace. Optical glass with mirrored details. 14k gold. 7" diameter. *Photo, Bill Truslow*

Linda MacNeil. "Crown Imperial." Floral series. Necklace. Polished black and multicolored *Vitrolite* glass. 24k gold plated brass. Pendant, 3" high. *Photo, Bill Truslow*

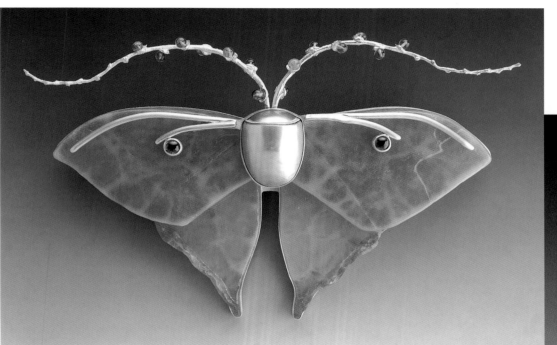

Suzanne B. Stern. "Periodic Table series: Oxygen." Pâte-de-verre (cast) lead glass, lampworked, and cold worked soda-lime glass. Cast and fabricated sterling silver, cultured pearls, garnet, peridot, and tourmaline. The piece is based on a literary reference from the book *The Periodic Table*, by Primo Levi. Stern explains: "Oxygen supports combustion. It's not necessarily important that one understands the relationship I have drawn between the element and my resulting interpretation. What is important is my exploration and the art that it creates." Facérè Jewelry Art Gallery. *Photo, Margo Geist*

► Suzanne B. Stern. Handmade display box for "Oxygen." Facérè Jewelry Art Gallery. *Photo, Margo Geist*

180

Suzanne B. Stern. "Ripe." Brooch/pendant. Metalized Pyrex, lampworked soda-lime glass, cast sterling silver, and a cultured pearl. Facérè Jewelry Art Gallery. *Photo, Margo Geist*

Suzanne Stern's glass and metal pendants and brooches utilize a variety of glass procedures that she combines with metals. She may cast glass using the same lost wax procedure as with metals. She likes the pâte-de-verre result in which the glass piece is translucent rather than transparent. In this technique, finely ground powdered glass is made into a paste by mixing it with water and a binder. The paste is applied to the inside of a mold. A subtle color blend is achieved by arranging alternating sizes of glass. The glass is heated only to the point of melting, so that the carefully placed glass particles do not migrate and disturb the desired color pattern. Various particle sizes produce different levels of transparency. The larger the particle, the clearer the finished pieces. Fine particles will trap air bubbles and produce an opaque glass with the rich quality of alabaster or jade. The mold crumbles away from the finished object after firing.

Stern's pieces are often nature inspired, but she will just as likely capture the nature of the materials. Some of her pieces result from comments people make, or from literary references.

Suzanne B. Stern. "Sleeping Anemones Series." Brooch and pendant. Metalized Pyrex set with zircon. Constructed sterling silver and 18k cast gold, with freshwater pearls set with zircons. Facérè Jewelry Art Gallery. *Photo, Margo Geist*

Matt Bezak. "School Fish." Pendant. Fine cast lead crystal, set in an 18k gold mount, with a cultured pearl drop accent. Hand fabricated. *Photo, Hap Sakwa*

Matt Bezak. "Seahorse Suite." Fine cast lead crystal with 18k gold and drop pearl accents. The cast glass technique, called pâte-de-verre, has been recorded in ancient Egyptian culture and popularized by René Lalique in the early 20th century. *Photo, Hap Sakwa*

Matt Bezak represents one of many jewelers, trained as metalsmiths, who began working in glass recently. He says, "After years of making fine jewelry, I was not satisfied with the traditional palette. Working with standard gemstone shapes grew confining. I needed a colorful medium that could bring a sculptural aspect to my work, offering more flexibility than gemstones. I found the answer in the form and nature of glass.

"Looking beyond traditional materials isn't a revolutionary idea," notes Bezak. "One of my role models, René Lalique, broke tradition by using materials atypical of fine jewelry, including glass, porcelain, horn, and enamel. He is best known for his work in mold-pressed glass and the lost wax method of cast glass. His pieces are expressive and dramatic, classic, and colorful. They are models for what I aspire to achieve with my jewelry."

◀ Patricia Tyser. Necklace and belt. All lampworked beads are made by the artist. Minerals include amethyst, bismuth, rose quartz, coated with titanium and malachite. The cord within the piece becomes the belt and ties to adjustable sizes. *Photo, artist*

▶ Patricia Tyser. Ice Crystal necklace. Consists of 5 strands of clear quartz points, with aquamarine and handmade glass beads. It is strung on soft flex, which is extremely strong. *Photo, artist*

Svatopluk Kasalý is a master practitioner of cold working sculptural glass by lapidary methods. The jeweler from Prague, Czech Republic, works much like the Chinese have done and still do. In addition to the exquisite finishes for his glass and their shapes, they are artfully arranged on neckpieces that have unusual suspending pieces.

◄
Svatopluk Kasalaý. Glass jewelry. Shaded half disk shape with a sterling silver neckpiece. Glasgalerie Hittfeld, Czech Republic. *Photo, artist*

Svatopluk Kasalaý. Glass jewelry. Silver choker neckpiece
with a solid glass amber handmade pendant. Glasgalerie
Hittfeld, Czech Republic. *Photo, Taras Kuščynskys*

►
Svatopluk Kasalaý. Glass jewelry. An off-centered open neckband wraps
around the back of the neck then extends down. Each end has a clear glass
round in a different size. Glasgalerie Hittfeld, Czech Republic. *Photo, artist*

Karen Gilbert works in monochromatic materials and combines uniquely shaped glass pieces with silver for brooches, bracelets, and necklaces. It is interesting to note that glass, in former times, was considered a low cost substitute for jewels. However, in contemporary jewelry, glass is being recognized as a valuable medium for expression and, as such, assumes new value.

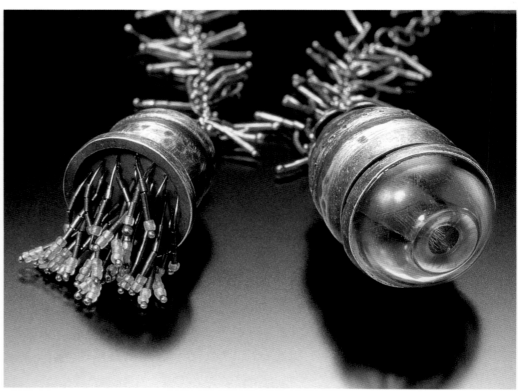

Karen Gilbert. "Produce." (Detail.) Sybaris Gallery. *Photo, Doug Yaple.*

Karen Gilbert. "Produce." Neckpiece. Sterling silver, woven sterling silver wire beads, blown, cut and set glass. The piece was based on the idea of reproduction. Sybaris Gallery. *Photo, Doug Yaple*

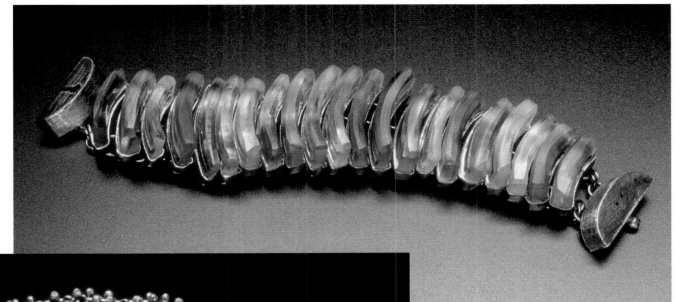

▶
Karen Gilbert. "Crave." Bracelet. Blown and cut glass cut into circles and then into curves. Each piece was beveled and set in sterling silver. 7" long, 1.5" wide. Sybaris Gallery. *Photo, Peter Lee*

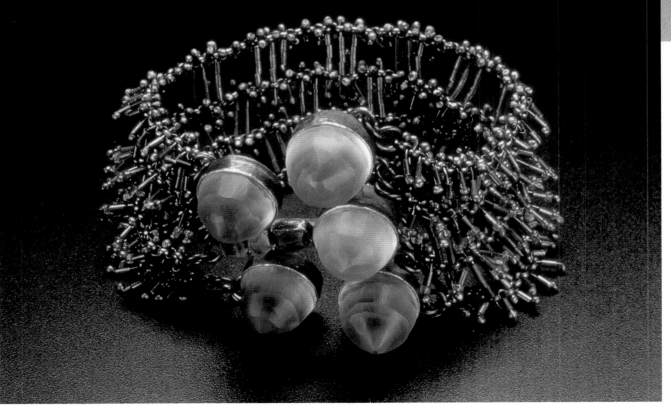

◀
Karen Gilbert. "Shake." Bracelet. Sterling silver with silver tube beads, and cut crystal. Sybaris Gallery. *Photo, Peter Lee*

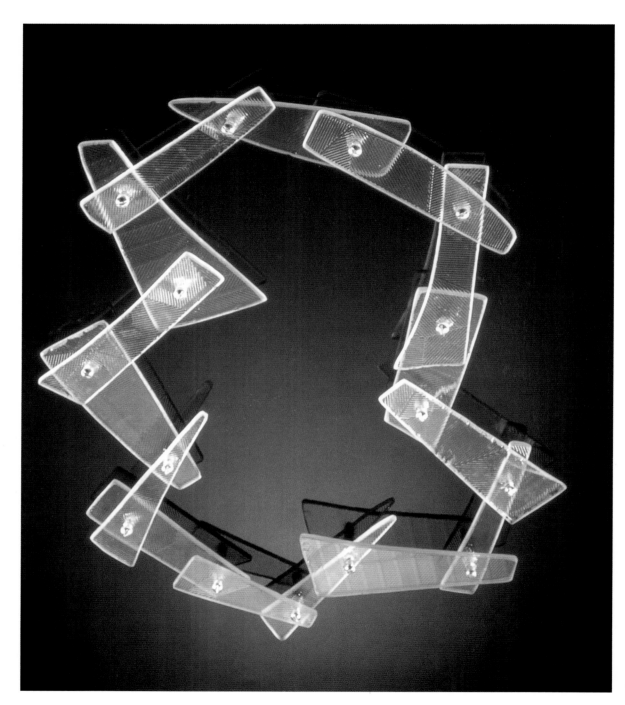

Saskia Bostelmann. "Lego." Necklace. Glass, and small steel nuts and bolts for joinery. Pieces are interchangeable; they may be added, removed, exchanged, and divided into two bracelets if one likes. Because the pieces are relatively small, they are quite strong and do not break easily. The pieces have geometric line textures, all different, that create an interesting subtle texture where they overlap. *Photo, Enrique Bostelmann*

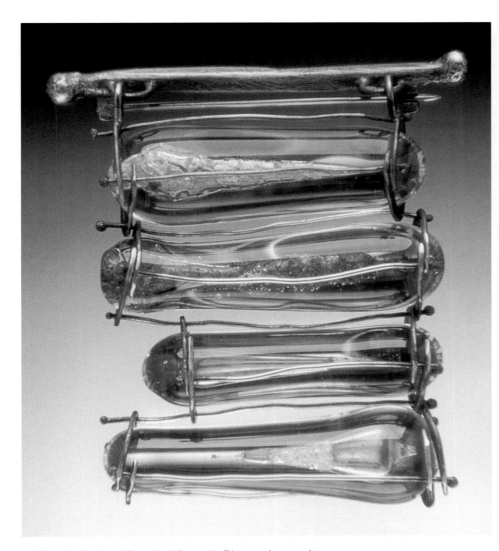

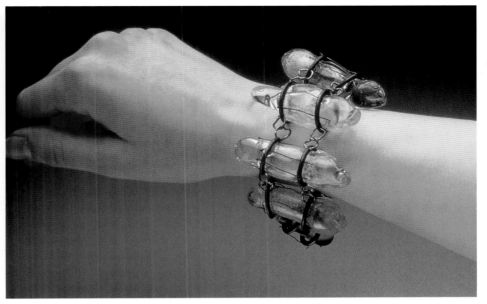

Patty L. Cokus. "Diamond," Rings with Inclusions-#2 Fuse.
(Detail.) Blown glass, salt, paper, sterling and nickel silver, and
14k gold. Facérè Jewelry Art Gallery. *Photo, Doug Yaple*

Patty L. Cokus. "Supple." Brooch. Blown glass, salt, paper,
with sterling and nickel silver. 2" high, 1.75" wide, 0.5" deep.
Facérè Jewelry Art Gallery. *Photo, Dean Powell*

Patty L. Cokus. "Salt to Taste." Bracelet. Blown glass
into copper frames, salt, and silver. 8" long, 2" wide, 1"
deep. Facérè Jewelry Art Gallery. *Photo, Dean Powell*

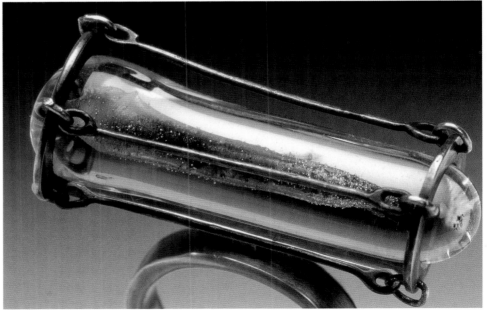

Donald Friedlich. "Translucent Series Brooch." Glass with 18k and 14k gold. The clear glass rods magnify the clothing on which the brooch is worn so the garment's weave becomes the image. 2.25" high, 2" wide 0.38" *Photo, James Beards*

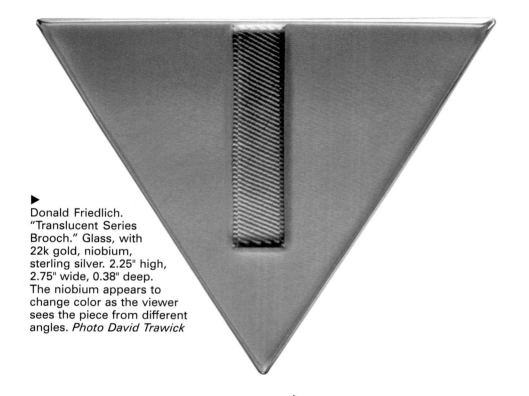

▶
Donald Friedlich. "Translucent Series Brooch." Glass, with 22k gold, niobium, sterling silver. 2.25" high, 2.75" wide, 0.38" deep. The niobium appears to change color as the viewer sees the piece from different angles. *Photo David Trawick*

▶
Donald Friedlich. "Translucent Series Brooch." Glass, with 18k and 14k gold. The sandblasted surface of the rods causes them to change subtly while the central clear portion magnifies the weave of the clothing. 2.25" high, 2" wide, 0.38" deep. *Photo, James Beards*

Donald Friedlich has gained a reputation for working with two non-precious materials, slate, and glass, though he may highlight a brooch by framing it with a piece of precious metal or adding a gemstone. He meticulously works these glass gems (and ultimately that's what each piece is), investigating it for texture, luminosity, reflections, tension, magnification, and optical qualities. They are studies in contrast: rough and smooth, geometric and organic, traditional and experimental. Some are set over niobium, a metal that can be vibrantly colored so that each piece appears to change colors as the wearer moves.

Donald Friedlich. "Translucent Series Brooch." Curved glass, with 18k and 14k gold. The sand-blasted kiln formed glass exploits varying degrees of transparency and translucency so the color of the piece changes with the color of the clothing behind it. The imagery relates to weaving and textiles. 2.25" high, 2" wide 0.38" deep. *Photo, James Beards*

Donald Friedlich. "Translucent Series Brooch." Dichroic glass, with 18k and 14k gold. 2.5" diameter, 0.38" deep. The dichroic glass rods add still another dimension to the colors that reach the eye, depending upon the ambient light and the movement of the wearer. *Photo, James Beards*

▶
Donald Friedlich. "Translucent Series Brooch." Reverse side of above. The pin mechanism is carefully considered to function well and to complement the design of the brooch. It also allows the brooch to stand on its own and be displayed when not being worn. *Photo, James Beards*

Linda MacNeil. "Babylon Fragment." Brooch.
Acid polished and polished amber glass. 14k
yellow gold, with earrings. 2.75" high, 2" wide,
0.25" deep. *Photo, Bill Truslow*

◄
Linda MacNeil. "Blue Nile." Brooch. Polished clear and blue optical glass. Polished 18k gold with earrings. 4" high, 1.25" wide, 0.25" deep. *Photo, Bill Truslow*

Barbara Minor. A selection of graduated egg and spherical-shaped bead pendants. Silver, 18k gold Bi-Metal, transparent and opaque enamel on formed copper and fine silver, 24k gold foil, and over glazes. These are designed to be worn on Chris's cables. Beads vary from 1" to 2" diameter. *Photo, Ralph Gabriner*

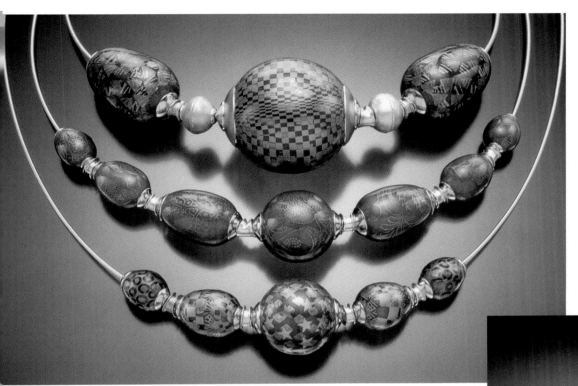

◄
Barbara Minor. Graduated egg and sphere beads on silver Chris's Cables (from Chris Hentz). Beads are silver, transparent enamel, fine silver foil, and 24k gold over glaze. *Photo, Ralph Gabriner*

►
Barbara Minor. Knotted branch coral necklace with enamel beads, and silver. The largest bead is 2" long and 0.75" diameter. *Photo Ralph, Gabriner*

Kristen Frantzen Orr. "Halcyon Summer." Necklace (Detail.) The focal bead, made of soda lime glass, has flowers encased in clear glass as if to preserve their early summer color. She explains, "After carefully masking out portions I wanted to remain shiny, I etched the surface flowers to depict their faded color at summer's end. The smaller glass accent beads have a surface floral design made from detail canes. The berries are crocheted copper and brass wire beads. By combining different shades of wire with tiny seed beads, I was able to portray a wonderful range of colors from plump juicy berries to dried up golden ones." *Photo, Ralph Rippe*

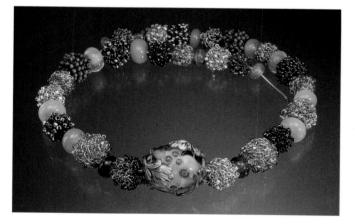

Kristen Frantzen Orr. "Regeneration." Choker neckpiece. Lampwork glass beads, brass, and magnet wire. The lampwork beads are soda lime glass worked over the flame of an oxygen-propane torch. Colors are achieved by layering transparent glass over opaque, and by making detail canes from multiple colors of glass. Crocheted wire beads are made from fine brass wire and copper magnet wire collected from a salvage yard. They float along a snake chain. From the most ancient times, flowers have represented a renewal of life and hope. These flowers represent non-existent realities that signify beauty, the seasons, the renewal of life as old growth is replaced by new. *Photo, Jeffrey A. Scovil*

Kristen Frantzen Orr. "Cosmic Voyage." Necklace. The center bead is crocheted fine silver wire. The frosty white beads are fine silver foil encased in clear soda lime glass and then chemically etched. The beads that look like distant planets are borosilicate glass using crushed glass frit and bits of fine silver under a clear encasement. A crocheted fine silver tube extends around the back of the neck. This piece suggests a trip into outer space, but it is also a journey into the inner space where mysterious images provide a centering and oneness with all living things. *Photo, Jeffrey A. Scoville*

▶
Wendy Ellsworth. "Earth Fire." Necklace. Glass beads, freshwater pearls, large Australian opal, lampworked beads. Free-form gourd stitch and double faced scallop stitches. The opals exhibit the colors of fire and the necklace evokes the elements of fire. 21.5" long, 6" wide, 3.25" deep. Del Mano Gallery. *Photo, David Ellsworth*

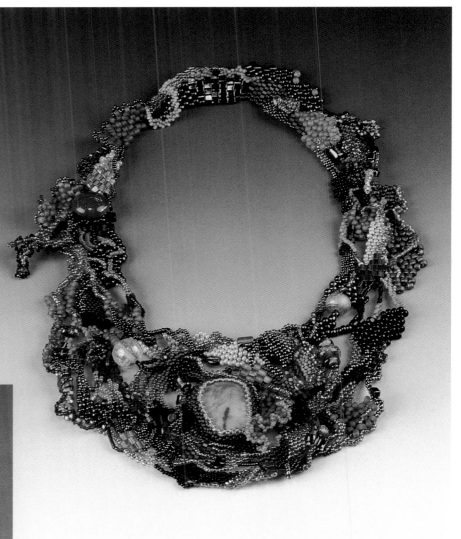

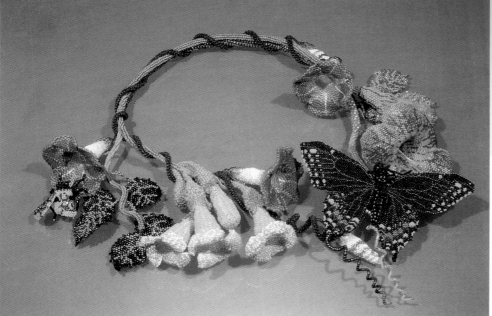

◀
Karen Paust. "Sunset and Sapphire." Glass beads, thread, and wire. *Photo, T. E. Crowley*

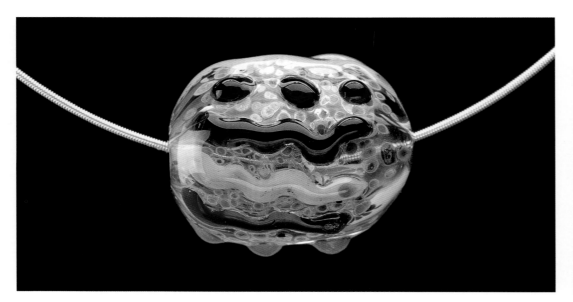

Ellie Burke. Chunky blown flame-worked hollow bead. Frit is on the inside. Dots and lines are drawn on the outside. 1" round. A single dynamically designed and colored bead can be the entire jewelry statement. *Photo, William F. Lemke*

Patricia Tyser. Bracelet with handmade glass beads. *Photo, artist*

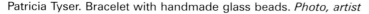

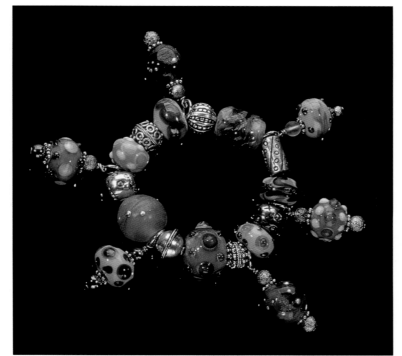

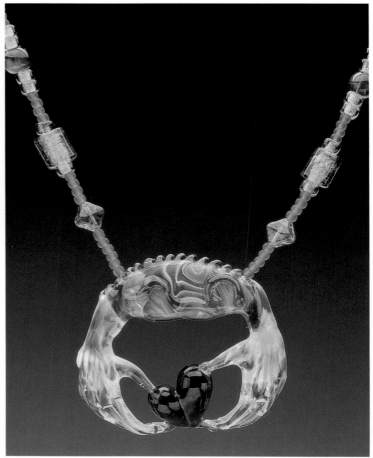

Ellie Burke. Earth tone cladaugh flameworked bead in borosilicate glass. 2.5" high, 2" wide, 0.75" deep. *Photo, William F. Lemke*

Many handmade beads are produced by lampwork or flamework methods. Originally lampwork beads were made by melting the glass, called frit, under the heat of a lamp or lantern (hence lampwork) and working and turning the melted glass around a mandrel as it became soft and malleable, then letting it cool, and it was a bead. Today, the heat source is a small oxy-acetylene or propane torch (hence flamework) instead of the heat of a lamp, and the beads may have layer upon layer of glass in exquisite colors. They may be used alone as a statement with one bead or pendant, or combined with other beads for an entire neckpiece.

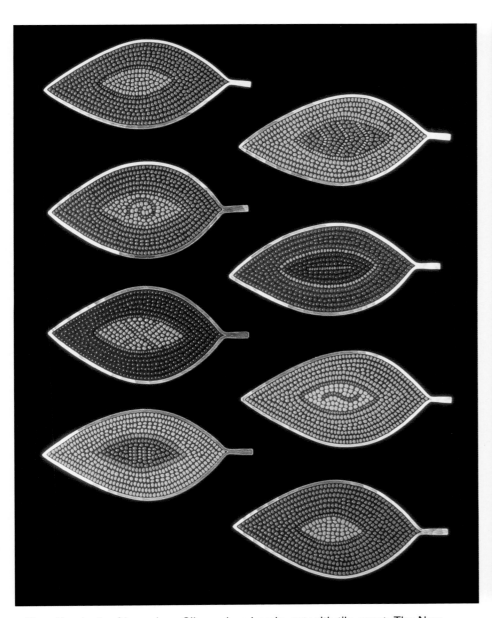

Mary Kanda. Leaf brooches. Silver, glass beads, set with tile grout. The New Mexico artist is strongly influenced by ethnic jewelry. *Photo, Dean Powell*

Gillian Chvat. "Ancient Warrior." Wearable art. A synthesis of carnelians, garnets, and Papanaidupet handmade glass beads. These beads are made in a small village in Andhra, Pradesh, South India, still using pre-Roman glass bead making techniques. The solid beadwork is peyote flat weave with the carnelians and garnets strung on to form the body of the piece. *Photo, Robert Liu*

Marianne Hunter. "Kabuki Kachina of the Blue Lagoon." Pendant and brooch. The pendant has grisaille and foil enamels with a Boulder opal, a split Boulder pearl, and an abalone pearl. The necklace beads are 22k Peruvian opal, tanzanite, 24k and 14k gold, and sterling silver. Each pendant has a title, number, a signature engraved on the back, and an original poem. Collection, artist. *Photo, George Post*

ENAMELS

Enameling is the process of fusing glass to metal under high heat conditions. Almost any metal and any size object can be enameled. Unlike the enamel on our teeth, or paint on the walls, the enamel used in jewelry is vitreous, or glass. Raw materials are in the form of powders, grains, and lumps, which are placed on a metal backing. When heated in a kiln, or with a torch, the raw materials melt and flow into designated areas. They harden as they cool.

Within that simple definition and process description, lie an infinite number of possibilities that enamellers have used for centuries. The basic methods remain much the same as they were in early Egypt. Not surprisingly, innovations have occurred over time. The work of today's enamellists exhibits an exuberance, an openness to technical experimentation, and a creative spirit.

The major processes of *basse-taille*, *champlevé*, *cloisonné*, *grisaille*, *Limoges*, and *plique-à-jour*, described in Chapter 2, have had additional methods associated with them. The renewed interest in the craft has encouraged inventive methods and readily available materials. Recent books devoted entirely to enameling contain specific projects and techniques. Following are a few variations shown in the books listed in the bibliography:

* A design or picture printed on specially prepared paper (essentially a decal) transferred to enamel or glass and to materials that are compatible with the enameling process.

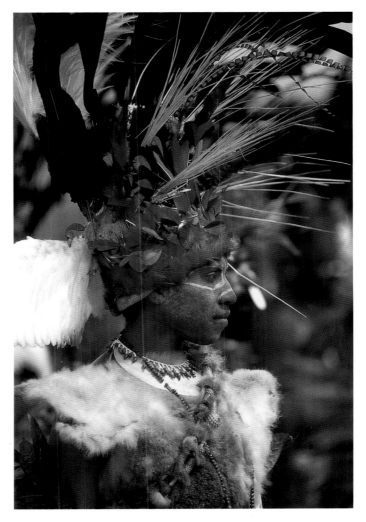

▶
Feathered headdress and face paint colors of New Guinea natives worn during a celebration, can be mimicked in glass to result in dazzling color combinations and overlays of glass threads. *Photo, Bushnell-Soifer*

Marianne Hunter. "Kabuki Kachina. Stepping into the Rainbow Sea." Brooch. Grisaille enamel with foils, Boulder opal, abalone pearl, and cultured pearls. 24k and 14k gold, and sterling silver. Collection, R. Ryan, Switzerland. *Photo, George Post*

Marianne Hunter. Pages from Marianne Hunter's sketchbook show notes, drawings, and pictures for a planned brooch and pendant. *Photo, author*

* Fusion inlay under enamel is an unusual method for patterning the metal before enameling.
* The Japanese use a technique called Ginbari that uses a foil embossing. It looks like cloisonné but doesn't use wire separations for the cloisons.
* Combining stone setting within the enamel composition.
* Silk screen on metal for textures that can be embedded beneath layers of translucent transparent enamels.
* Sgraffito is a technique often used in pottery and ceramics but now being adapted to enameling. It is most often done in black and white and shades of gray. The color is laid down and another color added. The top color is scratched through to reveal the under color.

The history of enameling is rich, varied, long, and spans work from many countries. Artists have used religious symbols, animals, nature, portraits, logos, symbolism, and icons indigenous to their environments.

Enameled jewelry, like other forms of adornment, have followed the same historical trends as other art forms. Since the early 1900s, Art Nouveau has been a dominant historical jumping off point. The curving linear forms found in metal and stained glass of that period were beautifully adaptable to jewelry and other decorative arts. Art Nouveau, and later Art Deco, banisters, chandeliers, and architecture gave jewelers new ideas for line and shape completely different from the reigning Victorian, and earlier, styles.

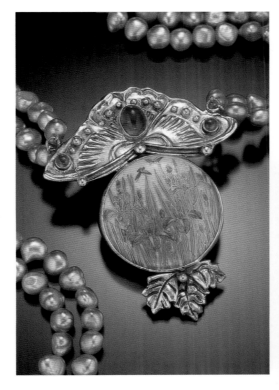

► Sonja Bradley. "Pink Iris." Antique Satsuma porcelain pendant, circa 1880, is set in sterling silver with 22k gold, and gold accents. The pink freshwater pearls of the neck chain pick up the colors in the pendant. Fabricated neck chain. The necklace: 19" long. The pendant: 2.88" high, 2.5" wide. *Photo, Hap Sakwa*

Designs based on the linear forms of Hector Guimard of France and Rennie MacIntosh of Scotland, have been reinvented in jewelry and are being sold in museum stores today.

René Lalique's enamel jewelry of champlevé and cloisonné, and his remarkable ornamental combs set the style for the period. They are pictured in books on Art Nouveau where they are easy to study and use for inspiration. Several of Lalique's contemporaries, such as Alfons Maria Mucha and Eugene Grasset, working in Paris, followed his lead.

Today, anything goes. The more inventive, the better. Any mixture of styles, images, and techniques is being used. The quality depends on the artist's talents. Examples have been selected for the variations in design and methods they bring to the art form. They range from the very ornate Japanese kimono inspired pin or pendant (it can be worn either way), by Marianne Hunter, to the restrained, elegant pins by John Iversen.

Between these ends of the spectrum are the Limoge-style painted brooches by Larissa Podgoretz, and Alex and Mona Szabados. Enameled necklaces, pins, and earrings by Lisa Hawthorne, Barbara Minor, and Christopher A. Hentz, represent contemporary designs.

The unique hollow cast and enameled neckpieces by David C. Freda set their own precedent.

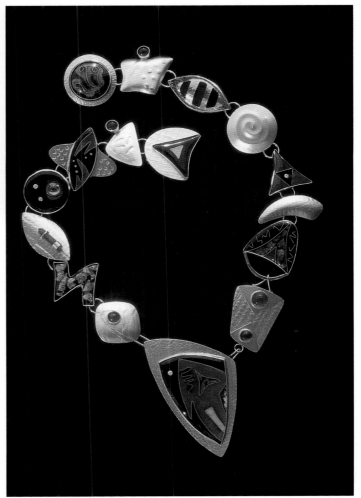

Lisa Hawthorne. "Jammin ta Jazz." Necklace. Cloisonné enamel, hydraulic shaped, die formed. 18k Bi-Metal, 4 diamonds, amber, amethyst, citrine, garnet, and ruby crystal. *Photo, artist*

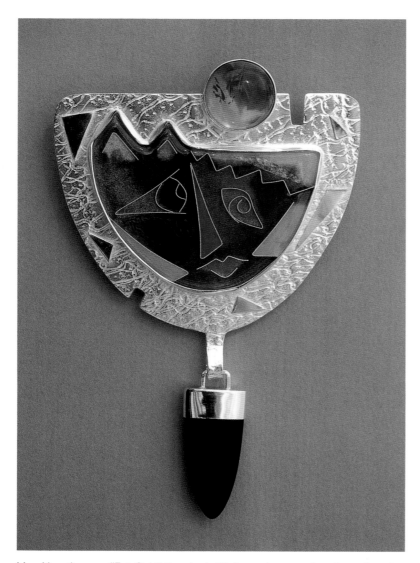

Lisa Hawthorne. "Fat Cat." Pendant. Cloisonné enamel, roller printed fine silver, amber, black onyx, and 18k and 24k gold. *Photo, artist*

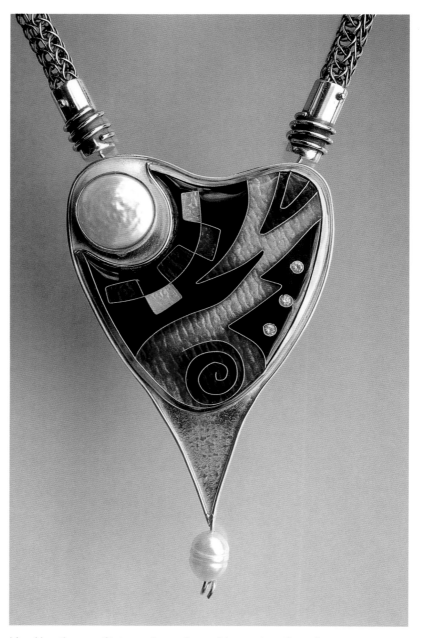

Lisa Hawthorne. Cloisonné pendant with pearl on fine silver. 14k, 22k, and 18k gold, and sterling silver, freshwater pearls, and 3 diamonds. Hand knit sterling silver chain. *Photo, artist*

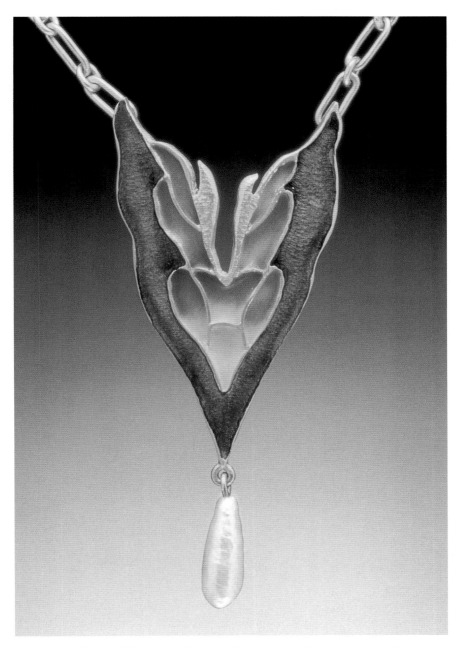

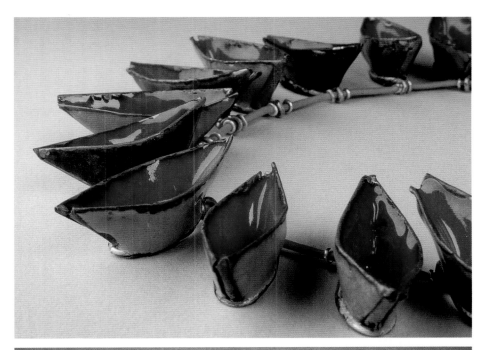

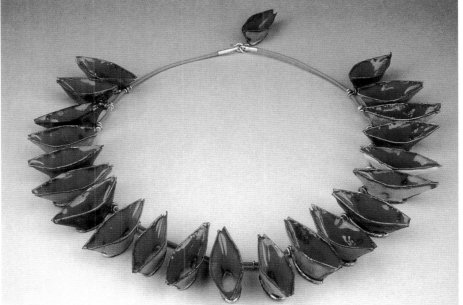

Richard McMullen. "Nature's Window." Art Nouveau inspired pin of 18k yellow gold hand fabricated with shaded basse-taille enamel and multi-color shaded plique–à-jour enamel that resembles a sunset. Fresh water pearl. Hand fabricated 18k gold chain. *Photo, Dean Powell*

Tamar Kern. "Voyage." Necklace (Detail above). Enameled copper on cord with silver jump rings and connectors. *Photo, Mark Johnston*

◀

Marianne Hunter. "Swimming in a Blue Moon." Necklace. Enamels and foil. Boulder opal, sapphire, lapis lazuli, set in 24k and 14k gold, and sterling silver. Collection, Davis/Fike, USA. *Photo, George Post*

▶

Marianne Hunter. "The Desert." Enamels with foils, Montana agate, fossilized dinosaur bone, tourmalinated quartz over golden pheasant feather, all set in 24k and 14k gold, and stainless steel. Fabricated and engraved. Collection, Kassover, USA. *Photo, George Post*

Susan Gifford-Knopp. "Party Cat." Cloisonné on fine silver set in sterling silver, with gems. *Photo, Sue Knopp*

► Jan Smith. "Dots and Lines Green Quilt Series." Brooch emulates textile techniques. Champlevé enamel, copper, sterling silver, and 22k gold Bi-Metal. 2" high, 1.75" wide, 0.38" wide. *Photo, Doug Yaple*

Lisa Hawthorne. "All That Bull." Pin. Cloisonné and sterling silver. *Photo, artist*

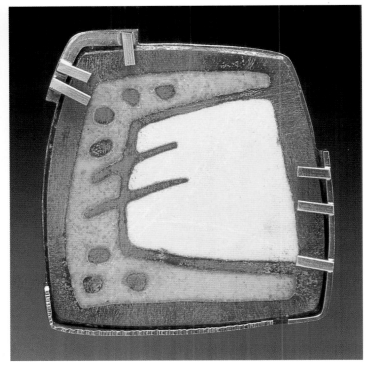

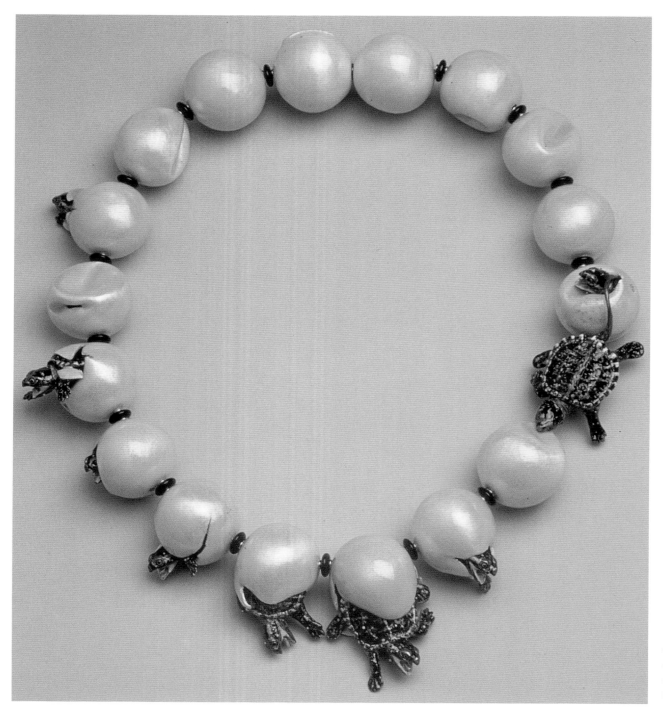

David C. Freda. "Study of Snapping Turtle." Neckpiece. Fine silver, 24k, and 18k yellow gold, glass enamels. Hollow core cast, fabrication, and enameling. (See page 38 for detail) *Photo, Robert Butcher*

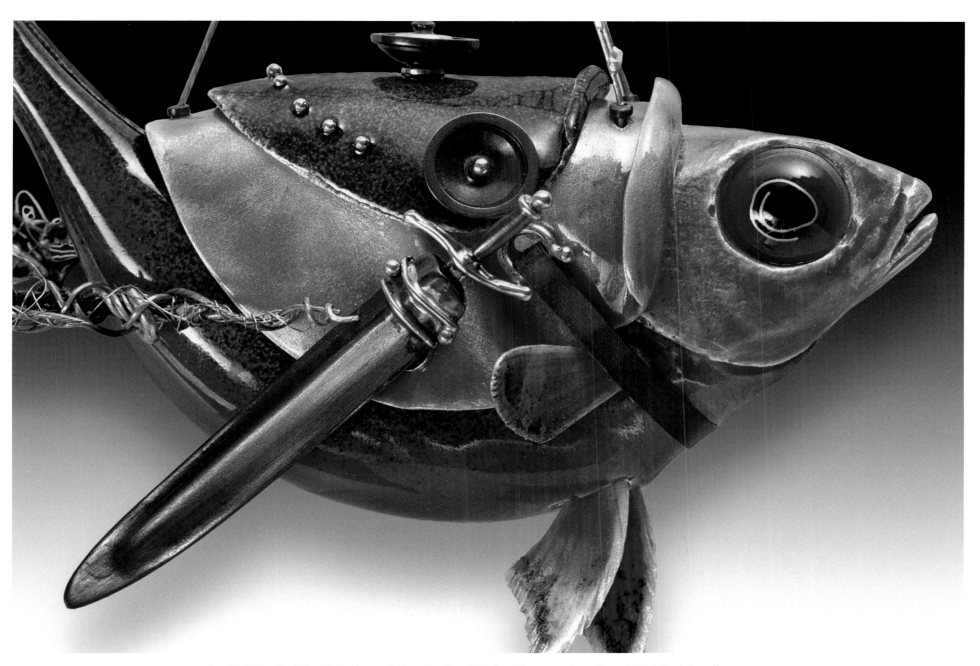

David C. Freda. "The Fish Hunter." Brooch (Detail). Fine silver, sterling silver 24k, 18k, 14k yellow gold, and glass enamels. Hollowcore cast, fabrication, granulation, and enameling. *Photo, Barry Blau*

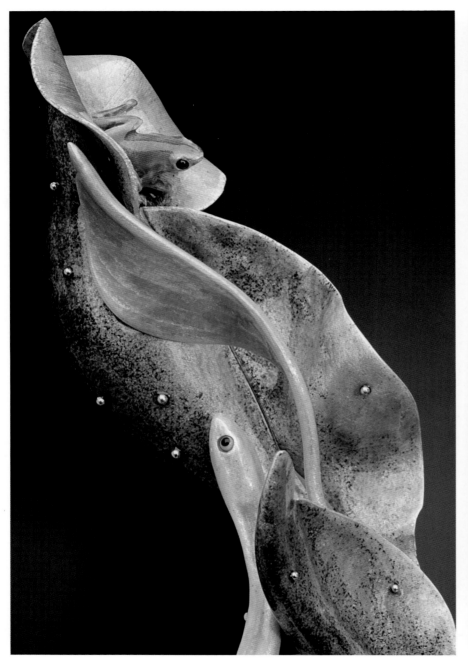

David C. Freda. "The Night Stalker." (Detail.) Brooch. Fine silver, sterling silver, 24k, 18k, 14k yellow gold, pearls, and glass enamels. 8.5" high, 4" wide, 1" deep. *Photo, Robert Sanders*

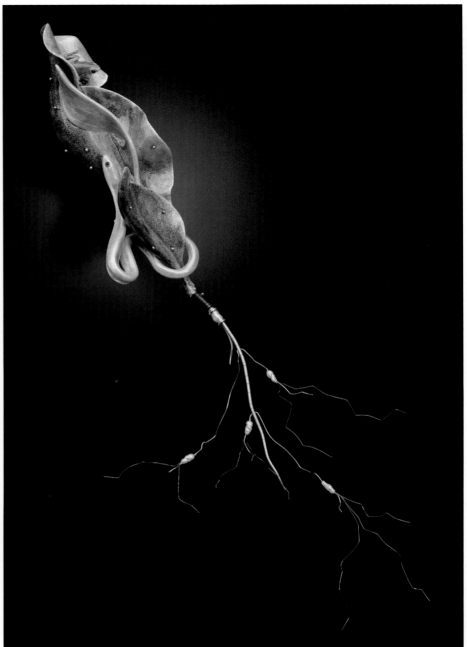

David C. Freda. "The Night Stalker." Brooch. Fine silver, sterling silver, 24k, 18k, 14k yellow gold, pearls, and glass enamels. 8.5" high, 4" wide, 1" deep. *Photo, Robert Sanders*

David C. Freda. "Study of Newborn Snake with Leaves." Brooch. Fine silver, sterling silver, 24k, 22k, 18k, 14k yellow gold, pearl, and glass enamels. 3.25" high, 2" wide, 1.25" deep. *Photo, Robert Sanders*

David C. Freda. "Snap Dragon." Brooch." Fine silver, sterling silver, 24k, 18k, 14k yellow gold, pearl, and glass enamels. 8.5" high, 4" wide, 1" deep. *Photo, Robert Sanders*

Larissa Podgoretz. "Ivy." Brooch. Hand painted enamel with 18k gold. The piece has an alternative brooch that attaches to the ivy leaf neckpiece. The necklace is made in two parts hinged at the back. Del Mano Gallery. *Photo, artist*

▶
Larissa Podgoretz. Alternate brooch that can replace the one shown on the ivy gold neckpiece. *Photo, artist*

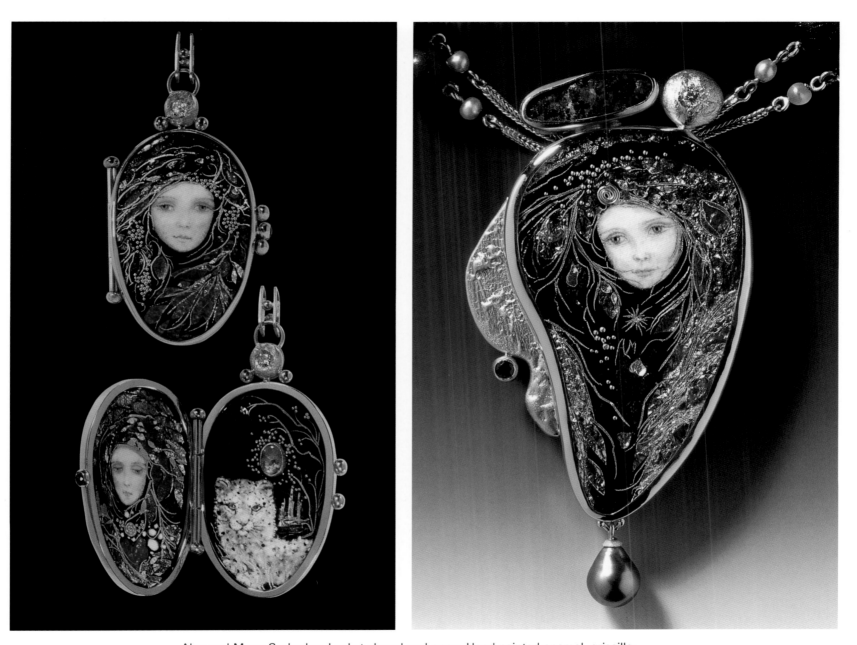

Alex and Mona Szabados. Locket closed and open. Hand painted enamel, grisaille-Limoges technique. 24k gold foil and granules, pure silver and palladium foil. The transparent and opalescent enamels required about 30 firings. 18k and 22k gold, opal, diamond, and sapphire. 2.25" high 1.5" wide, 0.75" deep. *Photo, Marcus Marshal*

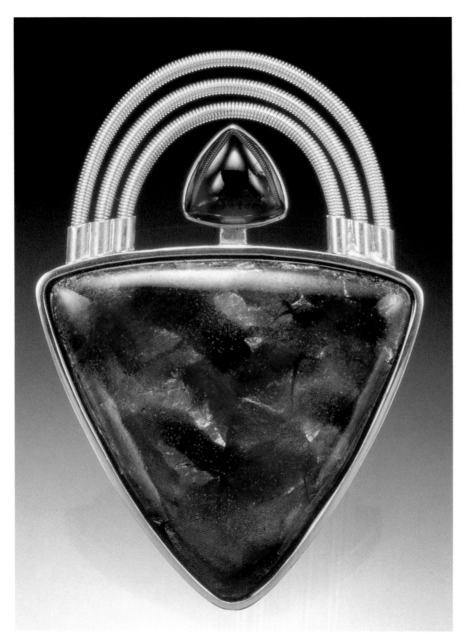

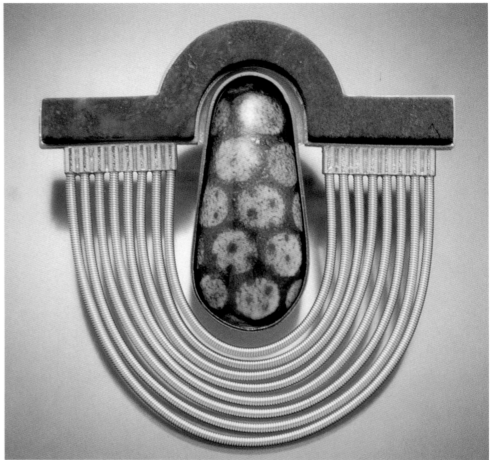

Barbara Minor and Christopher A. Hentz. Architectural pin and pendant with multiple U-shaped parallel Chris's Cables #3. Transparent enamel over 24k gold foil on formed copper. 22k gold. *Photo, Ralph Gabriner.*

Barbara Minor and Christopher A. Hentz. Triangular pin and pendant with Chris's Cables for the arched shapes. Transparent enamel over 24k gold foil on copper, 14k gold, and a garnet. 2.75" high, 1.5" wide, 0.28" deep. *Photo, Ralph Gabriner*

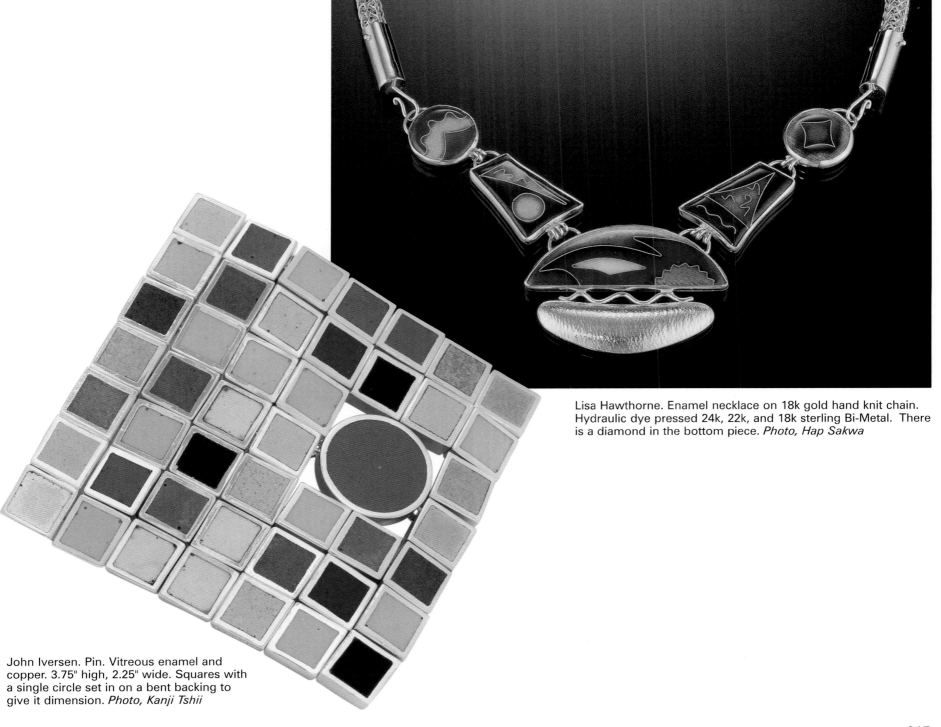

Lisa Hawthorne. Enamel necklace on 18k gold hand knit chain. Hydraulic dye pressed 24k, 22k, and 18k sterling Bi-Metal. There is a diamond in the bottom piece. *Photo, Hap Sakwa*

John Iversen. Pin. Vitreous enamel and copper. 3.75" high, 2.25" wide. Squares with a single circle set in on a bent backing to give it dimension. *Photo, Kanji Tshii*

John Iverson. Blue enamel pin. 18k gold, copper, vitreous enamel. Elegant in its simplicity and enhanced by the glossy finish. 2.25" high, 3.5" wide. *Photo, Kanji Ishii*

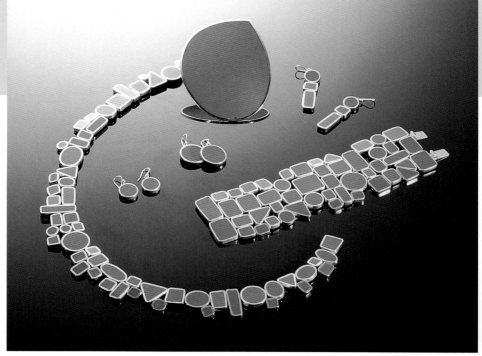

John Iverson. Red enamel necklace with repeat geometric shapes. Coordinated, pin, bracelet and earrings. Each enameled piece is framed in 22k gold. 16" long. *Photo, Kanji Ishii*

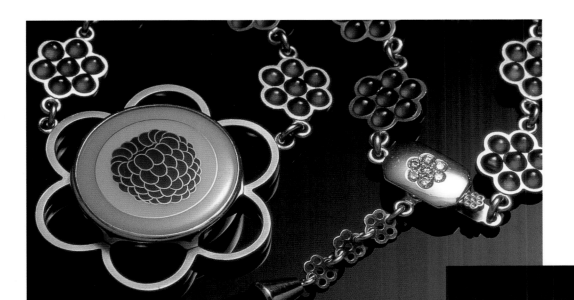

Gallen Benson. "Raspberry." Necklace. Cloisonné enamel with cast and fabricated 24k and 22k yellow gold, 14k pink gold, almandine garnet cabochons, briolettes, and diamonds. Hand fabricated clasp. The pendant is 2" diameter, 0.55" deep. *Photo, Tom Myers*

▶
June E. Jasen. "OOPS. This One's for me Only!" Brooch. 18k white gold leaf fused over red enamel in copper mesh. Copper, brass, and silver. Materials are worked so they alter the visual surface and create unusual effects. 3" high, 2.5" wide, 1.25" deep. *Courtesy, artist*

Barbara Minor and Christopher A. Hentz. Domed pin and pendant with four onyx spheres. Formed copper with transparent enamel over patterned silver foil, with sterling silver, and onyx. All pins and pendants have an adapter so they may be worn on Chris's Cables as a necklace. 1.5" diameter, 0.38" deep. *Photo, Ralph Gabriner*

Jenn Parnell. Mosaic series. Rings in sterling silver with enamel. Versions are also made in gold with enamel. They can be individualized using custom color schemes. *Photo, Mark Johnston*

Daniela Hoffman. "Buds and Berries." Rings. Sterling silver and colored enamels. The bud on the left ring is 18k gold. *Photo, George Post*

◄ Barbara Minor and Christopher A. Hentz. Architectural earrings. Transparent enamel over 24k gold foil on formed copper. 22k Chris's Cables. A creative use for cables. 3" high, 3" wide, 0.38" deep. *Photo, Ralph Gabriner*

► Lisa Hawthorne. Earrings. Cloisonné enamel, sterling silver, and fine silver. Fabricated. *Photo, Hap Sakwa*

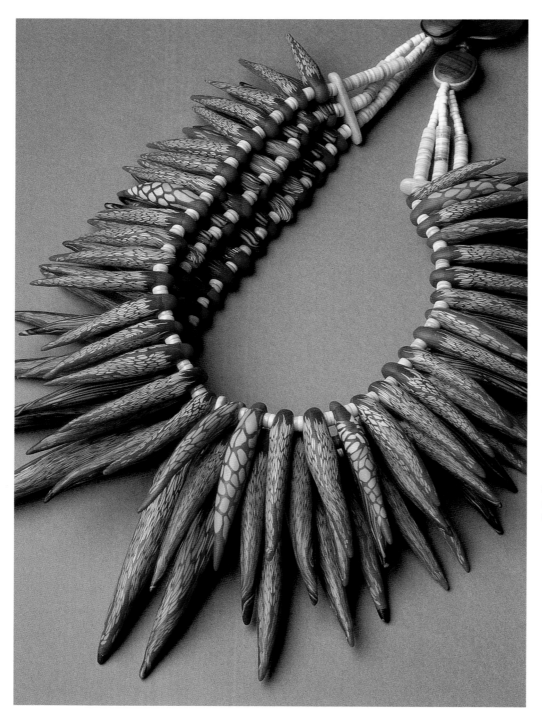

Cynthia Toops. "Feathers." Claw necklace. Polymer clay, shell, bone, and sterling silver. *Photo, Roger Schreiber*

Chapter 9
BEYOND TRADITION

Gold, silver, metals, gems, stones, these are the materials most people will mention when asked what comes to mind when they think of jewelry. Earlier chapters have illustrated jewelry using various objects and metals. But today's artists know no bounds. They delve into a tremendous assortment of materials to create jewelry. Traditional materials may be incorporated to unify other materials, or traditional materials may be used to generate untraditional concepts.

Here is a compilation of innovative and experimental projects. Some are the result of assignments to students who are encouraged to be as improvisational, flamboyant, and carefree as they dare. Some are made by teachers. Many are by professional jewelers whose quirky minds evolve wonderfully wild pieces.

One must look at the jewelry created by tribal celebrants for an idea of people who are not bound by conventional jewelry, as we know it. They work with materials they have available and improvise ways to use them. They have no jewelry supplier, no access to catalogs picturing hundreds of bead options that can be ordered by mail or a computer.

It's refreshing to observe how our contemporary jewelers use native adornments as inspiration for their own work. During a Papua New Guinea festival, celebrants rely on different shaped shells for decoration; shapes often emulated by today's jewelers. The Papuan native on the right wears the red painted half-moon shaped kina shell on his chest.

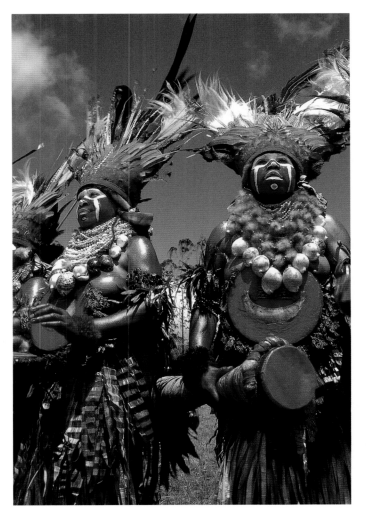

▶

Ceremonial body wear. Papua, New Guinea natives adorned in their finest jewelry for a special ceremony. Shells, feathers, and woven and straight grasses combine to provide spectacular inspiration for contemporary jewelers. *Photo, Bushnell-Soifer*

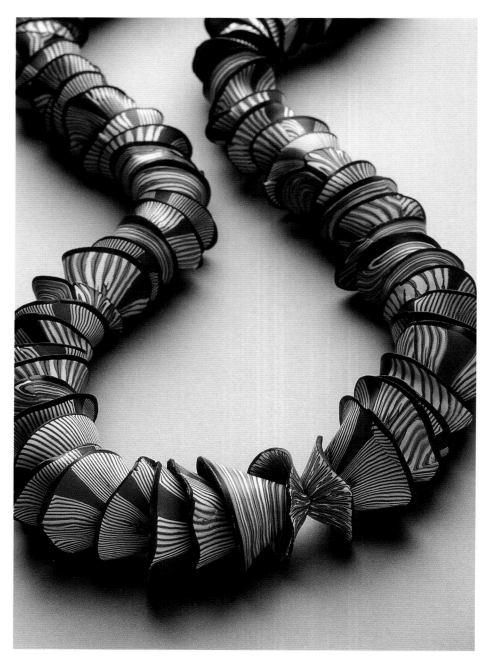

Cynthia Toops. "Barnacles." Necklace. Polymer clay. Inspired by an Indonesian shark rattle pictured in a travel guide of Indonesia. *Photo, Roger Schreiber*

Cynthia Toops. Drawings from Cynthia Toops' art journal was the precursor to the "barnacles" necklace and pieces with a similar theme. The source was an Indonesian shark rattle pictured in a travel guide. *Photo, Daniel Adams*

Cynthia Toops' *Feathers* is a triple strand necklace that echoes the look of ethnic jewelry with its all around the neck layered strands of beads. She replicates tooth or claw shapes in polymer clay. The canes used in each element are inspired by bird feathers.

Toops' husband and partner, Dan Adams, creates glass beads for their jewelry. The couple looks to tribal inspiration for much of their work. Their pieces rely on repetitious patterns developed in polymer clay and in glass, the glass often echoing the designs of the clay beads.

Toops and Adams find ideas in photos in travel books, and from museums. Each piece is carefully planned with sketches before they begin so each knows what the other must do. The photo of Toops' sketchbook is a revelation in how she thinks, plans, and works out their creations.

The ideas and materials shown in other pieces in this chapter are highly individual. Each finished piece required someone's idea of art jewelry, thought, time, and patience to create. The examples defy an overall generalization. Each must be studied for what it contains, its inspiration, and its final appearance. Someone had to gather and prepare materials such as eggshells, butterfly wings, children's toys, rubber inner tubing, paper, plastic, or fur, and plan its function as body adornment.

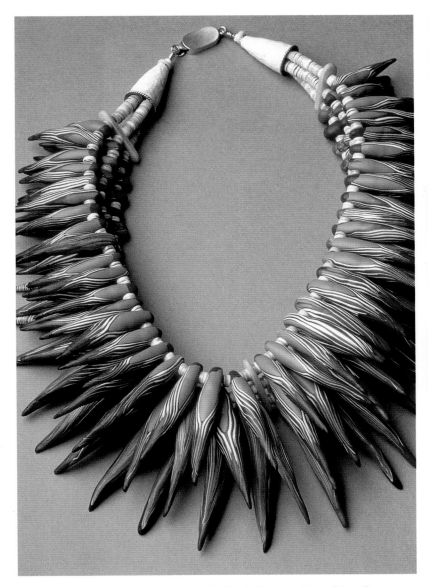

Daniel Adams and Cynthia Toops. Untitled claw necklace (detail). Polymer clay, shell, bone, and silver. *Photo, Roger Schreiber*

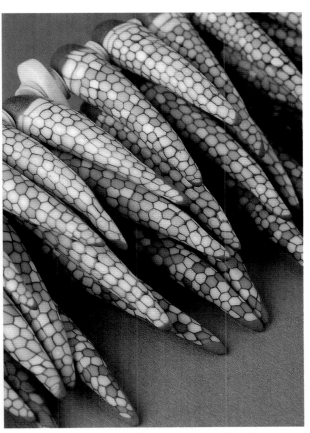

◄
Daniel Adams and Cynthia Toops. "Of Butterfly Wings and Special Things." Bracelet. Polymer clay. *Photo, Robert Liu*

Whether the result is something you would or would not wear isn't the criterion. One might look at such art for the ideas it represents, and see the strengths in it to understand why it was selected to go beyond tradition and represent art jewelry today.

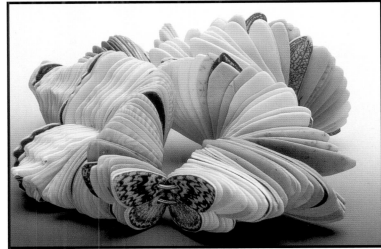

Cynthia Toops. "Agave." Necklace of polymer clay, shell, bone, and silver. *Photo, Roger Schreiber*

223

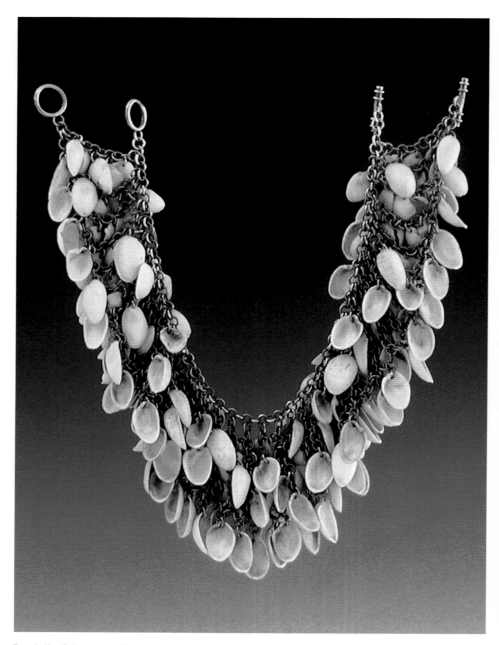

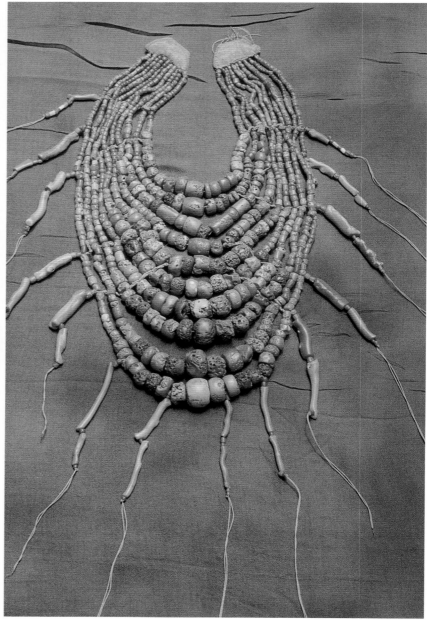

Danielle Crissman. "Consumed by One." Necklace. Sterling silver, pistachio shells, Mexican fire opals. 14" long. *Photo, Ericka Crissman*

Kandioura Coulibaly. Clay beads are symbolic of an ancestral heritage for an ethnic society. Coulibaly has been collecting beads as a defender of the preservation of the Malian and African cultures where beads are important as adornment, but more so as ceremonial, and mystical objects. Janet Goldner Gallery. *Photo, Janet Goldner*

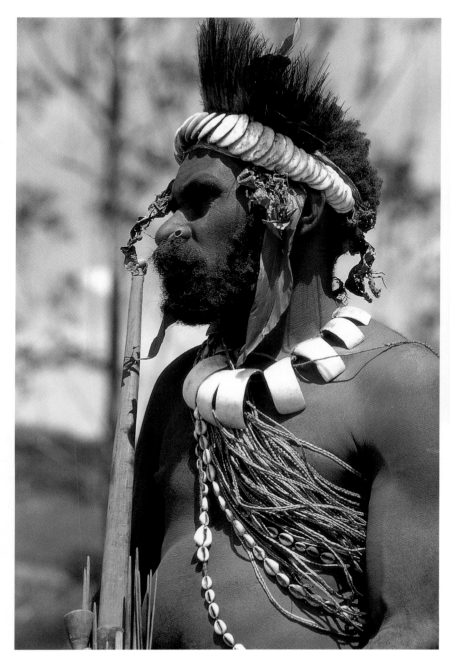

Papua New Guinea. Large shells on the headband and neckpiece are combined with a cowry shell neckpiece for this dancer's costume. *Photo, Bushnell-Soifer*

Jeffrey Clancy. "Round." Neckpiece. Silver, resin, gold leaf, eggshell. 12" high, 6" wide, 0.5" deep. *Photo, Jeffrey K. Brady*

Jeffrey Clancy. Detail of "Round" pendant illustrates the texture and pattern that can be achieved with broken eggshells. The shell pieces are set with resins that have been colored with powdered enamel. *Photo, Jeffrey K. Brady*

Jennifer Trask. "Wings." Necklace. (Detail.) 18k and 22k gold, with dragonfly, damselfly wings, and other wings under a watch crystal. Total necklace length is 20". *Storm Photo*

Jennifer Trask. "Pavo." Necklace. (Detail.) Peacock feathers in 18k and 22k gold, verdigris, and various pigments. *Storm Photo*

Lulu Smith. Various bracelets. Sterling silver and pigmented epoxy resin. *Photo, Roger Brunn*

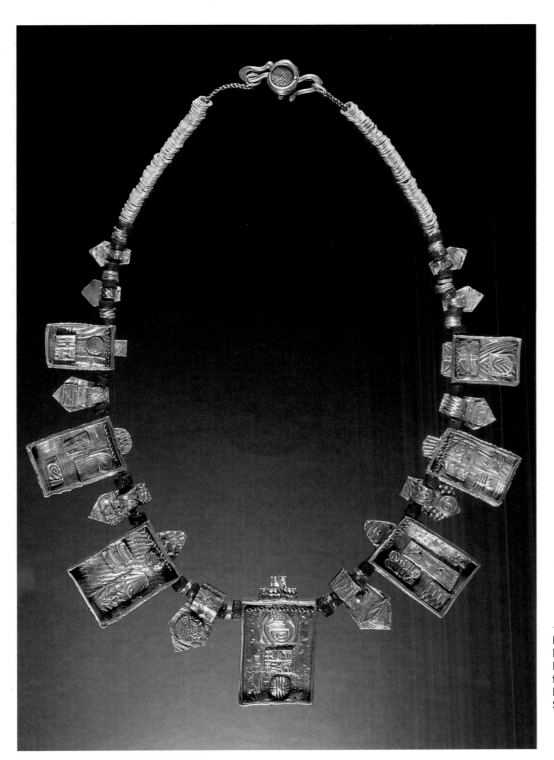

◄

Linda Kaye-Moses. "Enchiridion."
Necklace. Sterling silver and fine silver,
Precious Metal Clay, soldering, and
forging. 21" long, Largest pendant is 2"
high, 1" wide, 0.38" deep. Plumdinger
Studio. *Photo, Evan J. Soldinger*

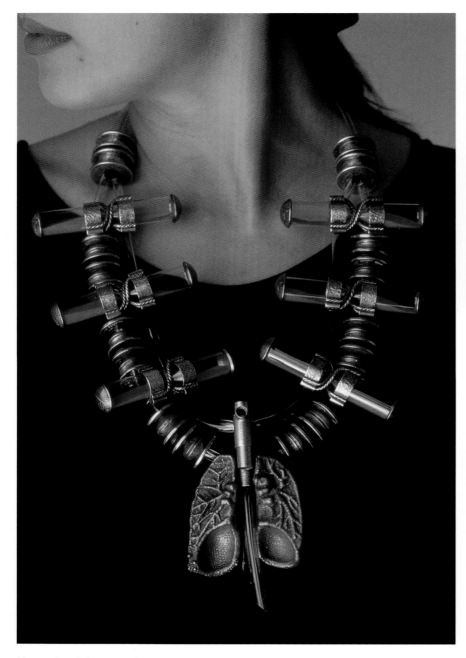

Nancy Lee Worden. "Buying Time." Necklace. Silver, copper brass, horn, glass, and plastic. Making this piece provided a personal catharsis after the death of the artist's mother. 6.5" long, 4.5" wide, 1.5" deep. Helen Drutt Gallery. *Photo, Rex Rystedt*

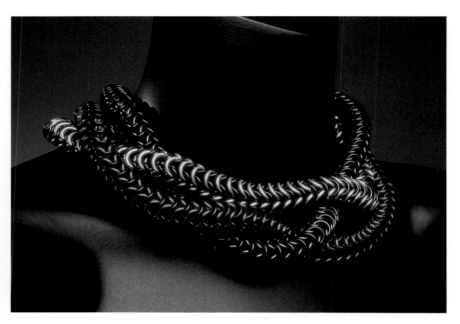

Annie Publow. "Beginnings." Necklace. Anodized aluminum and rubber. By using aluminum with rubber, the piece has fluidity and a soft industrial feel. 8" diameter, 1.5" high. *Photo, Taylor Dabney*

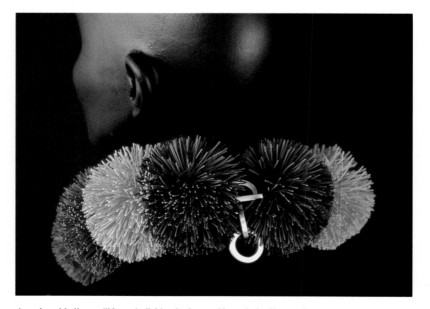

Jessica Heikes. "Koosh." Neckpiece. Koosh balls and silver. 10" diameter, 8" high. *Photo, Rhona Shand*

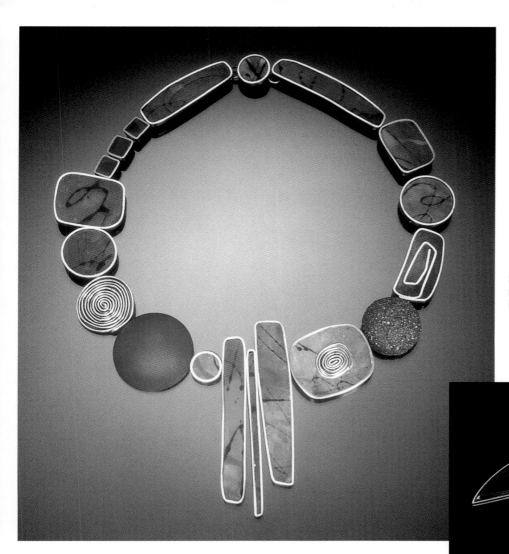

◄
Susan Kasson Sloan. Neckpiece. Epoxy
resin with pigments, and sterling silver. 8.5"
long, 7" wide. *Photo, Ralph Gabriner*

►
Shirley Miki De Moraes. "City Map." Bracelet. Wood
inlay and silver construction. Maple, paela, padauk,
cocobolo, and sterling silver. Woods are chosen for
their natural colors and textures. They are designed
to create an illusion of chiaroscuro and/or color
transparency. They are assembled as in a puzzle, then
coated with polyurethane. *Photo, Larry Sanders*

Emiko Oye. "Lionize." Collar from her "Patent Pending" collection. Recycled plastic, transparencies, steel, and sterling silver. 7" diameter, 4" high. *Photo, artist*

Roy. "Sports Page." Neckpiece. Sterling silver, copied sports page, and 0-rings. *Photo, Dean Powell*

Peggy Eng. "Grass." Brooch. Carved aluminum anodized and dyed. Pieces begin with a sketch, than are carved directly and laboriously out of aluminum. Color is layered on in several washes to achieve depth and richness. *Photo, Ralph Gabriner*

Stephen Bondi. "Conchiglia #1." Bracelet. Constructed and fabricated of styrene plastic sheet, formed hot, and hand colored. 2.5" high, 3.5" wide. The piece represents a fascination with the world beneath the sea. The artist is interested in the use of the material and its "plastic quality," but the shapes and concepts come from the sea and its life forms. *Photo, artist*

Bondi— Second view

Barbara Sperling. "Water lily." Brooch. Polymer clay with millefiori cane work, mokumé gané, variegated metal leaf, gold leaf, gold fill wire, and a freshwater pearl. *Photo, Robert Diamante*

Boris Bally. "Worry Bead." Silver chain. Bead is made of rubber bands, brass, and bass string. Fabricated, wrapped, and crimped. Bead 3" diameter. Julie Artisan's Gallery. *Photo, Dean Powell*

Boris Bally. "Double Layered Diatom." Brooches. Recycled traffic signs and placards with hand fabricated, hand pierced, swaged, and riveted sterling silver. Largest size is 7" long, 1.6" wide, 0.5" deep. Julie Artisan's Gallery. *Photo, Dean Powell*

233

Donald Friedlich "Interference Series." Brooch. Slate, 18k gold, and sterling silver. Friedlich has contrasted the rough black of a common stone, slate, against the smooth brilliance of the precious material, gold. Both materials are treated with the same care and attention to detail. Says Friedlich, "This establishes an equivalency between the two materials: the slate is elevated in its stature to the level of gold." 2.25" high, 2.5" wide, 0.38" deep. *Photo, James Beards*

Bernard Francois. Pendant. Anodized aluminum. Layered, punched, and fabricated. High tech materials combine to create a high tech look. Contrasting colors and shapes in unusual combinations result in a dramatic look in a 3-dimensional sculptural arrangement. *Photo, Jaues Vanderberg*

Jill Goodson. "Inertia." Bracelet with ball bearing attachment. Sterling silver, rubber, and stainless steel. Inertia was designed to activate with the movement of the wearer. The ball bearing is held in place with four pistons, and when worn the bearing is set into motion, by the wearers kinetic energy. 5.25" diameter, 1.25" high. *Photo, Doug Yaple*

Linda Kaye-Moses. "All the Stars that Round the Sun Burn." Fibula and nesting case. The nesting case is assembled from wood, paper, ink, photo transfer, found objects, antique ivory, and fine silver. 12.25" high, 8.5" wide, 11.5" deep. *Photo, Evan J. Soldinger*

Linda Kaye-Moses. "All the Stars that Round the Sun Burn." Fibula alone out of its nesting case. The fibula is sterling and fine silver, 14k gold, vitreous enamels, fluorite, tourmaline, and Precious Metal Clay. 5" high, 3.5" wide. *Photo, Evan J. Soldinger*

Jana Brevick. "Puzzle Guts." Neckpiece. Fabricated and cast. Articulated like a human form in sterling silver, 18k and 24k gold, steel, plastic, and polymer clay. The face opens to show the thinking in process, with a little help from a spin of the ears. 8" high, 2" wide, 1" deep. Facérè Jewelry Art Gallery. *Photo, Doug Yaple*

Jane E. Carpenter and Edward W. Heiple. "Tattoo Man." Pin. Carved resin, carved and reverse painted Lucite, mahogany, lapis lazuli, and embossed sterling silver. 4" high, 2.25" wide, 0.5" deep. *Courtesy, artists*

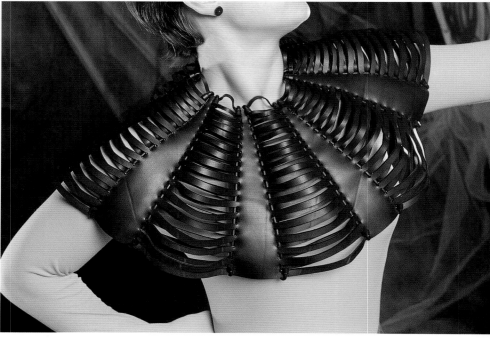

Elizabeth Hake. "Broader Collar." Rubber. Working with rubber affords a spontaneity compared to metals. Most of the sheet rubber is picked up along the roadside and combined with parts found in a store selling outdoors items. *Photo, Woodward and Rick*

Lonna Keller. "Extreme." Neckpiece. Rubber and plastic zip ties. 25" high, 20" wide. *Photo, Michael Kreiser*

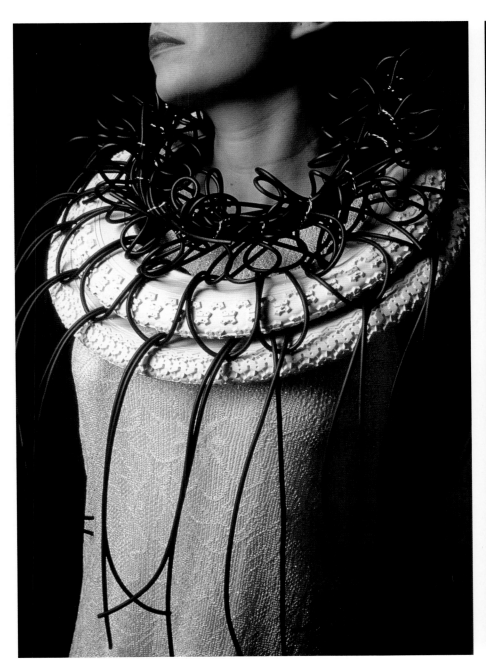

Lonna Keller. "Spider." Neckpiece. Rubber and fine silver. 28" high, 15" wide. *Photo, Michael Kreiser*

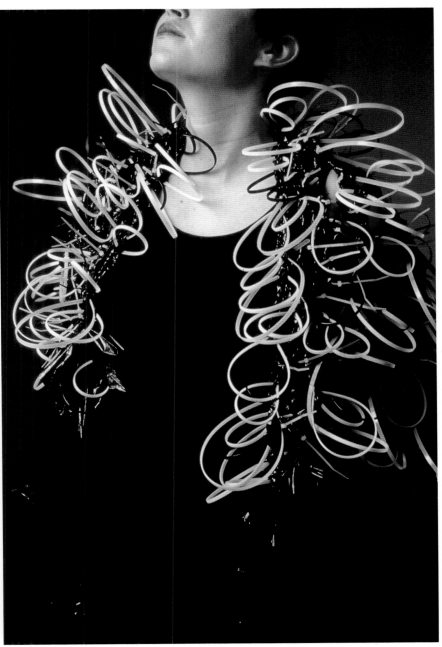

Lonna Keller. "Fur." Neckpiece. Plastic garbage bags and zip ties. *Photo, Michael Kreiser*

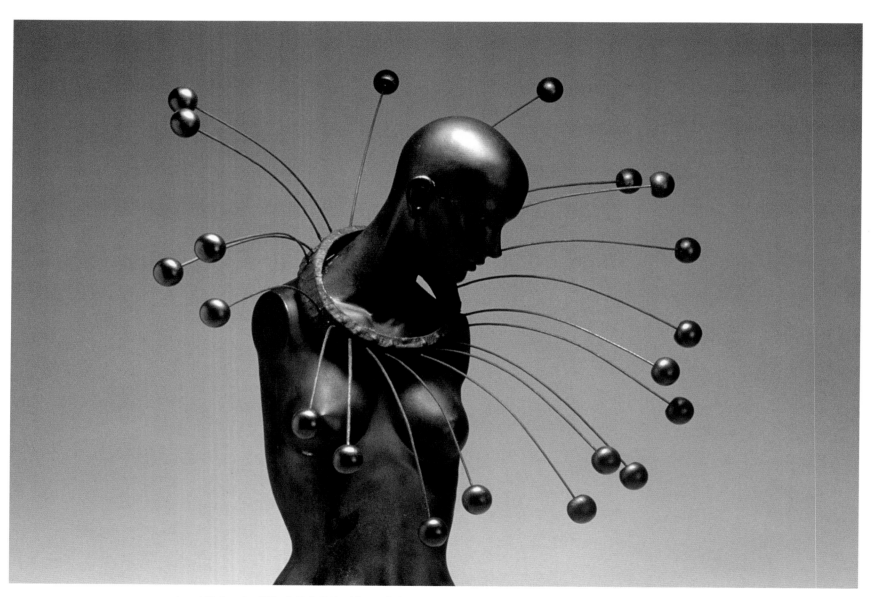

Janet K. Lewis. "Black Orb." Necklace. Painted wood and wire. The wire is flexible, yet sturdy enough to support the weight of the wooden balls at the ends. The weight of the balls pulling at the wires, and the wires springing back in response make the balls bounce around the head and shoulders as the wearer moves. 10" diameter, 18" spokes. *Photo, Gary Pollmiller*

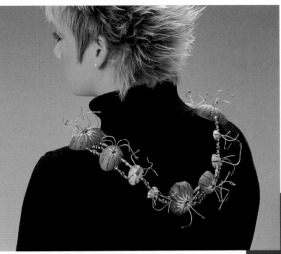

◄
Kathlene Kliewer. "Pulsating Necklace." Wood,
copper, hematite, and acrylic 2.5" high, 15.5"
wide, 11.5" deep. *Photo, Gary Pollmiller*

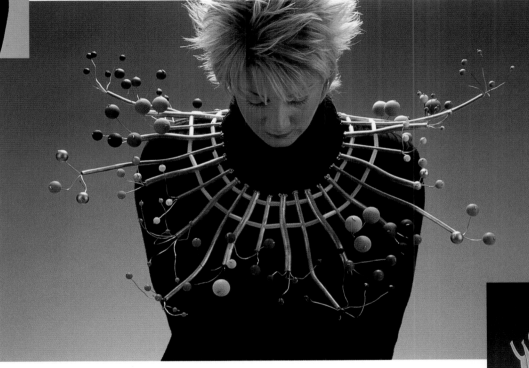

Kathlene Kliewer. "Cosmic Realms." Necklace. Copper,
wood, plastic, and acrylic. *Photo, Gary Pollmiller*

▶
Kathlene Kliewer. "Self Portrait." Brooch. Copper.
6" high, 4" wide, 1" deep. Viewing the artist/model
in the previous photos, it's easy to relate to her
self-portrait pin. *Photo, Gary Pollmiller*

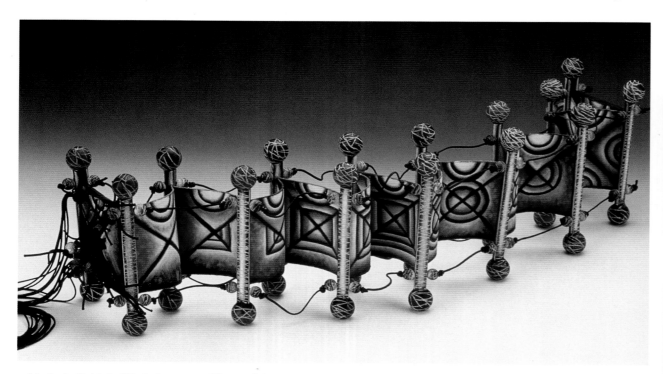

Marjorie Schick. "Variations on a Theme." Necklace/sash in the form of an accordion folded book. Painted canvas, wood, and cord. 36" long, 7" wide, 4" deep. *Photo Gary Pollmiller*

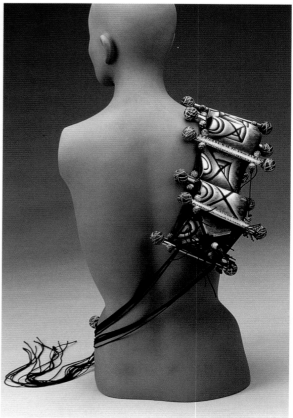

Marjorie Schick. (Detail.) "Variations on a Theme." Shown draped on a mannequin. *Photo, Gary Pollmiller*

◄

Phil Carrizzi. "Squeeze." Neckwear. Sterling silver, stainless steel, found objects, formed and fabricated. Collection, Roland Crawford. *Photo, Doug Yaple*

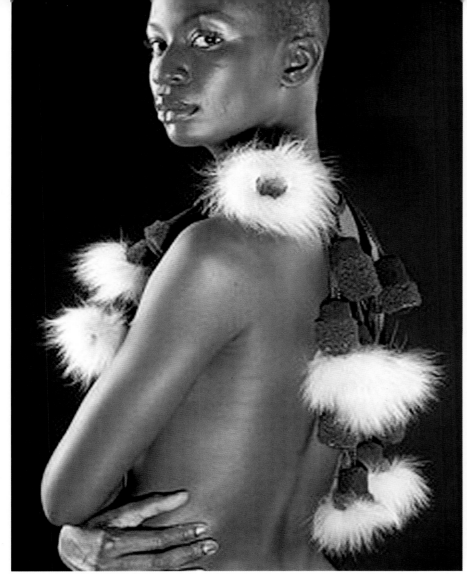

Tina Rath. "White Fox Hanging Wrap." Neckpiece. Mink, velvet, cord, and sterling silver collar. 19" long. *Photo, Mike Lewis*

Tina Rath's foray into fur as jewelry began when she was in Holland in the winter and found that wearing jewelry under heavy clothes was difficult. She thought about the preciousness and adornment qualities of fur and jewelry. Why not mix the two? Rath says, "The collection plays with the ideas of 'wrapping oneself' in soft and warm collars and necklaces. The pieces play between the lines of jewelry, accessory, and clothing; acting as ornamentation in each manifestation."

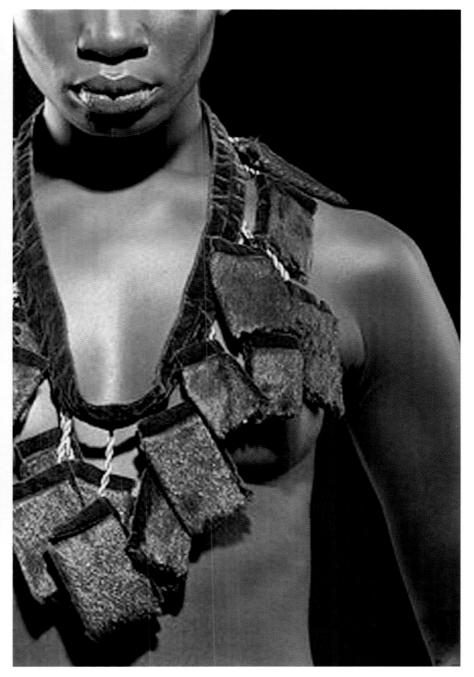

Tina Rath. "Black Seal Hanging Neckpiece." Seal, velvet, cord, and sterling silver. 32" long. *Photo, Mike Lewis*

Dallae Kang. "Do You Like Rain? I Don't." Headpiece.
Silver wires are inserted into holes punched in the
plastic banding. 12" high. *Photo, Helen Shirk*

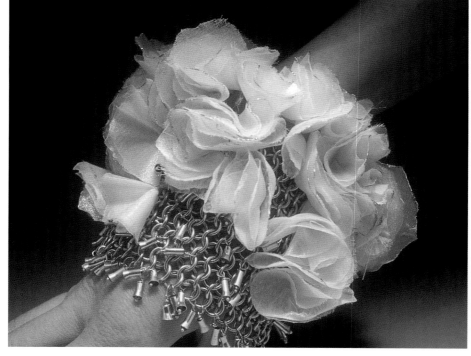

Michelle Pajak. "Luster." Bracelet. Sterling silver, glass beads,
and georgette. Fabricated. *Photo, Mary Brigid Hanna*

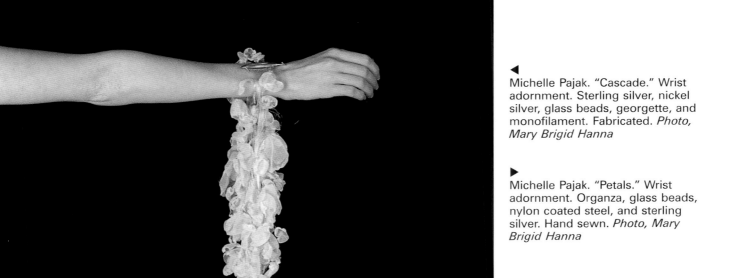

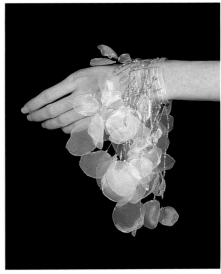

Michelle Pajak. "Cascade." Wrist adornment. Sterling silver, nickel silver, glass beads, georgette, and monofilament. Fabricated. *Photo, Mary Brigid Hanna*

Michelle Pajak. "Petals." Wrist adornment. Organza, glass beads, nylon coated steel, and sterling silver. Hand sewn. *Photo, Mary Brigid Hanna*

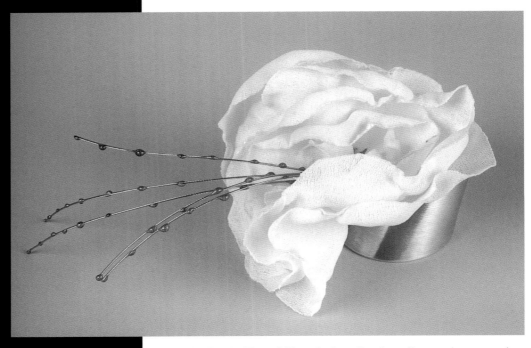

Michelle Pajak. "Posy." Thumb ring. Sterling silver, nylon coated steel, and georgette. Fabricated. *Photo, Mary Brigid Hanna*

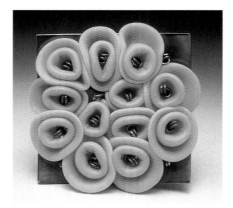

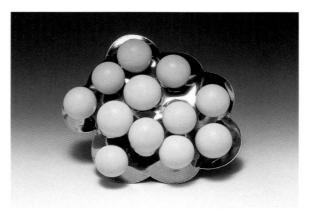

Sofia Calderwood. "Lapel Posey." Brooch. Sterling silver, and rubber earplugs. *Photo, artist*

Sofia Calderwood. "Disk Florets." Brooch. Sterling silver, foam ear plugs. 2" high, 1.5" wide, 1.5" deep. *Photo, artist*

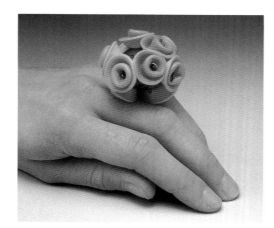

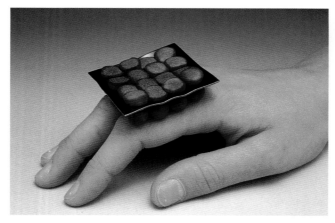

Sofia Calderwood. "Posey." Ring. Sterling silver and rubber earplugs. 2.25" high, 1.5" square. *Photo, artist*

Sofia Calderwood. "Contact." Sterling silver and dyed earplugs. 2.25" high, 1.5" square. *Photo, artist*

Sofia Calderwood. "Carpels I." Sterling silver, dyed earplugs, and perfume. 4" diameter, 1.5" deep. *Photo, artist*

Dee Fontans. Bracelet. Acrylic sheet and silk threads. *Photo, Charles Lewton-Brain*

Barbara Stutman. Bracelet. Crocheted vinyl lacing, artistic wire, steel wire, and pearls. Influenced by royal jewelry combined with ethnic influences. *Photo, Paul Fournier*

◄
Marjorie Schick. "Fluted Harmonics." Necklace. Papier-mache and rubber. 29" long, 9" wide, 2.6" deep. *Photo, Gary Pollmiller*

247

Felieke van der Leest. "Frog Legs."
Brooch. Textile (viscose) and metal,
crocheted. 3.8" high. *Courtesy, artist*

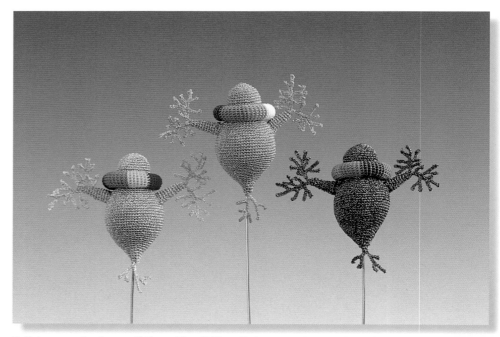

Felieke van der Leest. "Water Flea." Pins. Polyester, viscose threads,
felt, and gold wire crocheted. Each is 5.2" high. *Courtesy, artist*

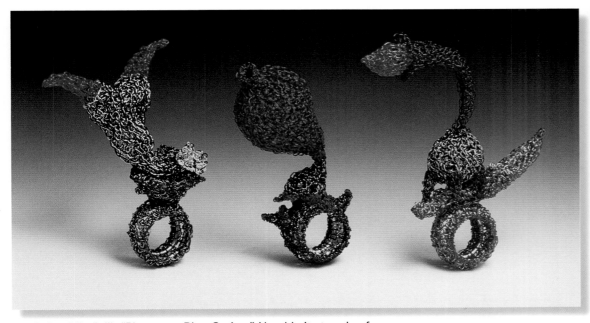

Reina Mia Brill. "Phantasm Ring Series." Hand knit strands of coated copper wire and stainless steel wire. *Photo, artist*

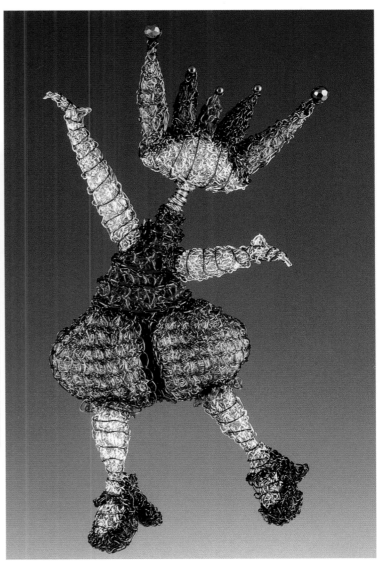

Reina Mia Brill. "Succulence III." Neckpiece. Copper mesh and painted metals. Mainly knitted and assembled. 7" high, 18" wide, 13" deep. *Photo, artist*

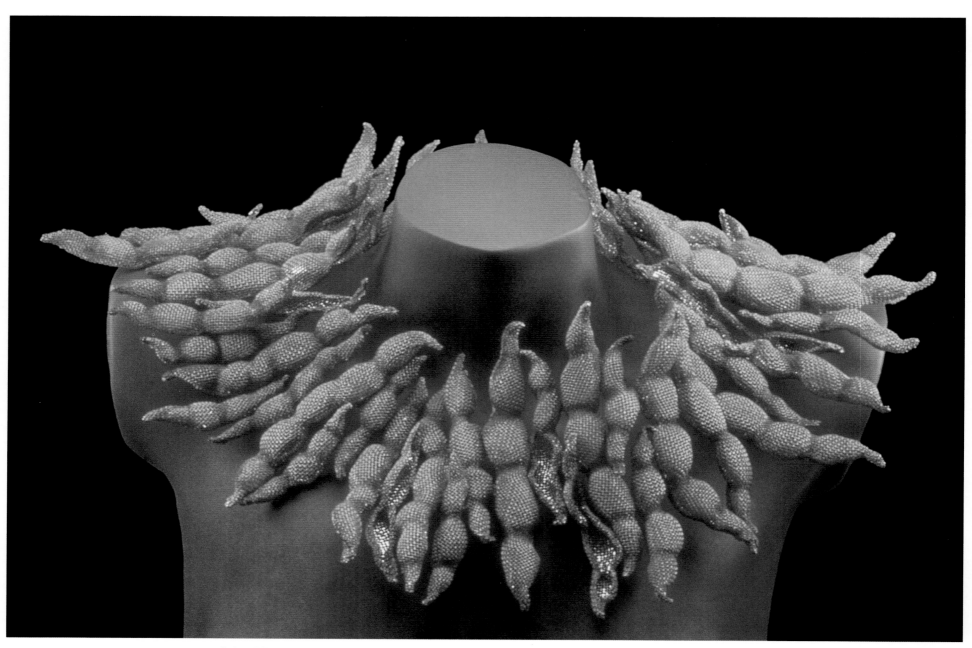

Reina Mia Brill. "Falooty No.22." Brooch. Hand knit coated copper wire with nickel accents and onyx. Beads are on the toes. Very fine knitting needles are used. Pieces are knit separately, sewn together, and attached to the metal ring. 5.5" high, 3" wide, 1.5" deep. *Photo, artist*

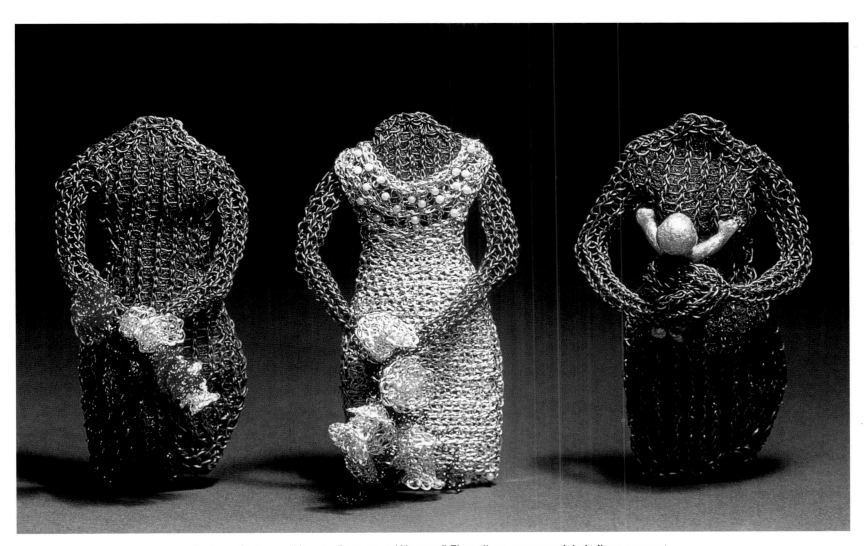

Barbara Stutman "How to Become a Woman." Fine silver, copper, nickel silver, magnet wire, coated wire, polyurethane, 24k gold leaf, seed pearls, and plastic. The brooches in this 3-piece set present a limited vision of what women are and what they are capable of being. The image that sparked the piece was used in a perfume ad that linked a woman's desirability with a portrayal of her in bondage. *Photo, Pierre Fauteux*

BIBLIOGRAPHY

Borel, France. *The Splendors of Ethnic Jewelry.* New York, New York: Harry Abrams, Inc., 1944.

Choate, Sharr. *Creative Gold-and Silversmithing.* New York, New York: Crown Publishers, 1970.

Codina, Carles *The Complete Book of Jewelry Making.* New York, New York: Lark Books, American Edition, 2000.

Cohen, Karen L. *The Art of Fine Enameling.* New York, New York: Sterling/h Publishing Co., Inc., 2002.

Eberle, Bettina. *Creative Glass Techniques.* Ashville, North Carolina: Lark Books, 1987.

English, Helen Drutt and Peter Dormer. *Jewelry of our Time.* New York, New York: Rizzoli International Publications, Inc., 1995.

Fahr-Becker, Gabriele. *Art Nouveau.* Germany: Konnemann Verlag, 1997.

Fisch, Arline M. *Textile Techniques in Metal.* New York, New York: Lark Books, 1966.

Heiniger, Enst A., and Jean. *The Great Book of Jewels.* Lausanne, Switzerland: New York Graphic Society, 1974.

Kohler, Lucartha. *Glass, An Artist's Medium.* Iola, Wisconsin: Krause Publications, 1998.

Lewin, Susan and others. *One of A Kind—American Art Jewelry Today.* New York, New York: Harry N. Abrams, 1994.

Liu, Robert K. *Collectible Beads, A Universal Aesthetic.* Vista, California. Ornament Inc. 1995.

MacNeil, Linda. *Linda MacNeil.* Atglen, Pennsylvania. Schiffer Publishing, Ltd. 2002.

Margetts, Martina, Ed. *International Crafts.* London, England: Thames and Hudson Ltd., 1991.

McAleer, Patricia A. *Metal Corrugation Surface Embellishment and Element Formation for the Metalsmith.* San Clemente, California: Out of the Blue Studio, 2002.

McCreight, Tim. *Jewelry, Fundamentals of Metalsmithing.* Madison, Wisconsin: Hand Books Press, 1997.

McCreight, Tim, and Nicole Bsullak. *Color on Metal.* Madison, Wisconsin: Guild Publishing, 2001.

McGrath, Jinks. *The Encyclopedia of Jewelry-Making Techniques.* Philadelphia, Pennsylvania: Quarto Inc., 1995

Meilach, Dona Z. *Ethnic Jewelry,* New York, New York: Crown Publishers, 1978.

Morton, Phillip. *Contemporary Jewelry.* New York, New York: Holt, Rhinehart and Winston, 1976.

Oldknow, Tina. *Pilchuck, A Glass School.* Seattle, Washington: University of Washington Press, 1996.

Peter, Francis Jr. *Beads of the World.* Atglen, Pennsylvania. Schiffer Publishing Ltd., 1994.

Schmundt, Ulrike von Hase-, Christianne Weber, Ingeborg Becker. *Theodor Fahrner Jewelry; Between Avant Garde and Tradition.* Atglen, Pennsylvania: Schiffer Publishing Ltd., 1991

SOFA Chicago, Chicago, Illinois: Expressions of Culture, Inc., 2001.

SOFA New York, Chicago, Illinois: Expressions of Culture, Inc., 2001.

Turner, Ralph. *Jewelry in Europe and America.* London, England: Thames and Hudson Ltd., 1996.

Untracht, Oppi. *Metal Techniques for Craftsmen.* Garden City, New York: Doubleday & Co., 1975.

Resources

Magazines, Organizations, Artists

The following publications and organizations can be found by entering the name in your Internet browser's search engine. Many artists whose work is shown maintain Web sites. Enter their name in the browser; often there will be a biography, new designs, and contact information. Products mentioned and suppliers are also available on the Internet. Most will provide links to other resources.

American Craft
Bead Journal
Beadwork
Glass on Metal
Lapidary Journal
Metalsmith
Ornament
The Enamelist's Magazine

Organizations

American Craft Council
Artist-Blacksmith Association of North America
Crafts Council of Great Britain
Ganoksin
Polymer Clay
Polymer Metal Clay
Society of American Silversmiths
The Canadian Guild of Crafts
The Enamelist Society
The Society of North American Goldsmiths

INDEX